Contents

Introduction in English 7

Wprowadzenie po polsku 8

Einführung auf Deutsch 9

Введение на русском 10

Introducción en español 11

한국어 소개 12

Introduction en français 13

日本語序文 14

Introduzione in italiano 15

中文简介 16

Introdução em português 17

Websites 19–352

Index of Designers 353–360

Index of URLs 361–368

Free CD inside back cover

Layout by Günter Beer & Sigurd Buchberger
www.webdesignindex.org
Cover and book design by Pepin van Roojen
CD Master by Sigurd Buchberger

Introduction by Pepin van Roojen and Kevin Haworth

With special thanks to Reese Lee, chasingwords.nl and LocTeam
for translations

Web Design Index 9

ISBN 978 90 5768 149 3
The Pepin Press | Agile Rabbit Editions
Amsterdam & Singapore

Cover Image

Front cover illustrations used courtesy of creativepeople,
Moscow – cpeople.ru (see page 131).

The Pepin Press BV

P.O. Box 10349
1001 EH Amsterdam
The Netherlands

Tel +31 20 4202021
Fax +31 20 4201152
mail@pepinpress.com
www.pepinpress.com

10 9 8 7 6 5 4 3 2 1
2016 15 14 13 12 11 10

Manufactured in Singapore

Web Design Index 9

Compiled & Edited by Günter Beer

The Pepin Press

AMSTERDAM & SINGAPORE

The growth of social networks and a move towards storing and managing data on the web are changing the way we use the Internet and design web pages. Even though important advances were made in the technology of web design, an important trend this year has been a move away from the use of technology as a novelty and towards a balance between design, ease of use and technology. PNG transparency, for example, has given designers a range of new possibilities for incorporating images into their work. Better browser support for fonts (@font-face, sIFR) has also allowed designers to use typography – especially large, bold and novelty typefaces – to add personality and clarity.

The URL is indicated for each website. The names of those involved in the design and programming of the sites are listed as follows:

design	D
coding	C
production	P
designer's contact address	M

A CD containing all the pages, arranged in the same order as the book, can be found inside the back cover. It allows you to view each page on your computer with a minimum of loading time, and to access the Internet in order to browse the selected pages.

Submissions & recommendations

Each year, The Pepin Press publishes new editions of two leading reference books in web design: **Web Design Index** and **Web Design Index by Content**. If you would like to submit or recommend designs for consideration, please complete the submissions form at **www.webdesignindex.org**

The Pepin Press

For more information on The Pepin Press or to order from our selection of publications on design, fashion, popular culture, visual reference and ready-to-use images, please visit **www.pepinpress.com**

Wprowadzenie

Rozwój sieci społecznościowych i tendencja do przechodzenia w stronę zapisywania i zarządzania danymi w sieci zmieniają sposób, w jaki korzystamy z Internetu i kreujemy strony internetowe. Pomimo rozwoju ważnych technologii w dziedzinie opracowywania stron internetowych, tegoroczny ważny trend postuluje odejście od technologii jako elementu nowatorskiego i przejście w stronę odpowiedniego wyważenia zagadnień projektowych oraz łatwości obsługi. Przezroczystość formatu PNG, na przykład, umożliwiła projektantom zastosowanie całej gamy nowych rozwiązań, które opierają się na zastosowaniu tych właśnie obrazów. Lepsze wsparcie przeglądarek dla czcionek (@font-face, sIFR) umożliwiło również projektantom zastosowanie typografii – szczególnie dużych, wytłuszczonych i nowoczesnych fontów – w celu dodania charakteru i przejrzystości.

Do każdej strony internetowej podawany jest adres URL. Nazwiska osób zaangażowanych w projektowanie i programowanie stron internetowych podawane są następująco:

D **projektowanie**
C **kodowanie**
P **wykonanie**
M **adres email projektanta**

Na tylnej stronie okładki znajduje się CD zawierający wszystkie strony, które ułożone są w takiej samej kolejności jak w książce. Tym sposobem możecie Państwo poprzez jedno kliknięcie przeglądać każdą stronę na Państwa ekranie lub wywoływać wybrane strony z Internetu.

Propozycje i rekomendacje

Każdego roku wydawnictwo The Pepin Press publikuje nowe edycje dwóch książek z zakresu projektowania stron internetowych: **Web Design Index** oraz **Web Design Index by Content**. Jeśli chcieliby Państwo przedłożyć lub polecić nam projekt, proszę wypełnić odpowiedni formularz na stronie internetowej **www.webdesignindex.org**

Wydawnictwo The Pepin Press

Więcej informacji o licznych publikacjach wydawnictwa The Pepin Press na temat projektowania, mody, kultury, referencji wizualnych oraz gotowych do bezpośredniego użycia obrazów znajdą Państwo na stronie internetowej **www.pepinpress.com**

Die Zunahme sozialer Netze und eine Entwicklung in Richtung Speicherung und Verwaltung von Daten im Web wirken sich auf die Nutzung des Internets und das Design von Webseiten aus. Wenn auch wichtige Fortschritte in der Webdesigntechnik erzielt wurden, ist der aktuelle Trend dieses Jahr: weg von der Nutzung der Technik als Neuheit, hin zum Gleichgewicht zwischen Design, Benutzerfreundlichkeit und Technik. PNG-Transparenz zum Beispiel bietet Webdesignern eine ganze Palette neuer Möglichkeiten, Bilder in ihre Arbeit zu integrieren. Eine bessere Browserunterstützung der Schriftarten (@font-face, SIFR) erlaubt es Webdesignern, die Typografie – insbesondere große, „fette" und neuartige Schriftarten – so zu nutzen, dass sie mehr Persönlichkeit, Deutlichkeit und Präzision bekommen.

Für jede Website wird die URL angegeben. Die Angaben zu den für Design und Programmierung Verantwortlichen sind nach folgenden Codes sortiert:

Design	**D**
Code	**C**
Produktion	**P**
Kontaktadresse	**M**

In der hinteren Umschlagseite befindet sich eine CD mit allen abgebildeten Webseiten. Die Reihenfolge entspricht der Anordnung im Buch. So können Sie mit minimaler Ladezeit jede Seite auf dem Bildschirm betrachten oder die ausgewählten Seiten im Internet aufrufen.

Vorschläge und Empfehlungen

Pepin Press bringt jedes Jahr eine neue Ausgabe seiner führenden Nachschlagwerke zum Thema Webdesign heraus: **Web Design Index** und **Web Design Index by Content**. Wenn Sie eine Website für unsere zukünftigen Publikationen vorschlagen oder empfehlen möchten, verwenden Sie bitte das entsprechende Formular auf **www.webdesignindex.org**

The Pepin Press

Weitere Informationen zu den zahlreichen Veröffentlichungen von Pepin Press — in den Bereichen Design, Mode und Popkultur, mit visuellem Referenzmaterial und sofort verwendbaren Bildern für Designer — finden Sie auf unserer Website **www.pepinpress.com**

Введение

Развитие социальных сетей, а также переход к хранению данных и управлению ими по сети изменяет само использование Интернета и дизайн веб-страниц. Несмотря на то, что в технологии создания веб-страниц достигнуты значительные успехи, важной тенденцией этого года был отход от применения технологических приемов как некоего новшества и стремление к балансу между дизайном, простотой и технологичностью. Например, появление формата полупрозрачной переносимой сетевой графики (PNG) предоставило дизайнерам ряд новых возможностей по внедрению в их работы изображений. Лучшая поддержка браузерами шрифтов (@font-face, sIFR) позволила использовать и печатное оформление – в особенности крупные, полужирные и новейшие гарнитуры – для придания выразительности и четкости.

Для каждого сайта, приведенного в книге, указывается его адрес (URL). Фамилии людей, принимавших участие в проектировании и создании сайтов, отмечены следующим образом:

- D дизайн
- C программирование
- P производство
- M контактный адрес дизайнера

В конце книги Вы найдете компакт-диск, включающий веб-страницы в той же последовательности, в которой они представлены в книге. С помощью этого диска Вы сможете рассмотреть все детали интересующих Вас веб-страниц, а также осуществить быстрый доступ в Интернет для просмотра содержания соответствующих сайтов.

Подача на рассмотрение заявок и рекомендации

Каждый год The Pepin Press публикует новые издания книг по веб-дизайну: **Web Design Index** и **Web Design Index by Content**. Если вы желаете подать на рассмотрение заявку или порекомендовать какой-либо дизайн, заполните, пожалуйста, бланк заявки на сайте **www.webdesignindex.org**

Издательство The Pepin Press

За дополнительной информацией об основных публикациях издательства The Pepin Press по дизайну, моде, современной культуре, визуальным справочникам и библиотекам высококачественных изображений, готовых к непосредственному использованию, обращайтесь на сайт **www.pepinpress.com**

El crecimiento de las redes sociales y la tendencia actual a almacenar y gestionar datos en la web están cambiando la manera de utilizar Internet y de crear páginas web. A pesar de los importantes avances que ha experimentado la tecnología del diseño de páginas web, la gran tendencia de este año en este campo ha sido el alejamiento por primera vez de su utilización como elemento novedoso en pos de un equilibrio entre diseño, facilidad de uso y tecnología. Así, por ejemplo, las transparencias de PNG han puesto a disposición de los diseñadores todo un abanico de nuevas posibilidades para incorporar imágenes en sus trabajos. Además, la mejora de la compatibilidad de los navegadores con las tipografías (@font-face, sIFR) también les ha permitido utilizar tipos de letra distintos (especialmente innovadores, en negrita y de gran tamaño) para dar personalidad y claridad a sus páginas.

Se indica la URL de cada sitio que aparece en el libro. El nombre de las personas que han participado en el diseño y la programación de dichos sitios se recoge del modo siguiente:

diseño	**D**
codificación	**C**
producción	**P**
dirección de contacto del diseñador	**M**

En el interior de la contracubierta encontrará un CD que contiene todas las páginas web, ordenadas según aparecen en este libro. Si lo desea, puede verlas en su ordenador (el tiempo de carga es mínimo) y acceder a Internet para explorar en su totalidad las páginas seleccionadas.

Propuestas y recomendaciones

Cada año, The Pepin Press publica nuevas ediciones de sus dos libros de referencia en materia de diseño de páginas web: **Web Design Index** y **Web Design Index by Content**. Si desea proponer o recomendar un diseño para que se tenga en cuenta en próximas ediciones, rellene el formulario que figura en: **www.webdesignindex.org**

The Pepin Press

Para obtener más información acerca de las numerosas publicaciones de The Pepin Press sobre diseño, moda, cultura popular, referencia visual e imágenes listas para utilizar, visite: **www.pepinpress.com**

소셜 네트워크의 성장과 웹에 데이터를 저장하고 관리하는 방향으로의 움직임이 우리가 인터넷을 사용하고 웹페이지를 디자인하는 방법을 변화시키고 있습니다. 웹디자인 기술에 중요한 진전이 이루어졌어도, 올해의 중요한 흐름은 신기술의 사용에서 디자인, 사용의 편이성과 기술 사이의 균형으로 움직이고 있습니다. 예를 들어, 디자이너들은PNG 투명도를 활용하여 이미지를 작품에 통합시키는 새로운 가능성을 얻었습니다. 폰트에 대한 더 나은 브라우저 지원(@font-face, sIFR)으로 또한 디자이너들은 타이포그라피 특히, 크고 굵으며 특이한 서체를 사용하여 개성과 선명성을 추가할 수 있게 되었습니다.

책에는 각 사이트의 URL이 표시되어 있습니다. 사이트의 디자인 및 프로그래밍 관련 명칭은 다음과 같이 표기되어 있습니다.

D **디자인**
C **코딩**
P **제작**
M **디자이너 연락처**

모든 페이지가 수록된 CD는 책에 수록된 순서와 같은 순서로 배열되어 있으며, 책 뒤의 덮개 안에 부착되어 있습니다. 사용자는 자신의 컴퓨터에서 최소의 로딩 시간으로 각각의 페이지를 볼 수 있으며, 선택한 페이지를 찾고자 인터넷에 접속할 수도 있습니다.

제안 및 추천

해마다 Pepin Press는 웹 디자인의 두 가지 주요 참고 서적, Web Design Index (웹 디자인 인덱스) 및 Web Design Index by Content (내용별 웹 디자인)를 새로운 버전으로 출판합니다. 생각하고 있는 디자인을 제출하거나 추천하시려면 www.webdesignindex.org에서 제출 양식을 작성하시기 바랍니다.

The Pepin Press

디자인, 패션, 대중문화, 영상 자료 및 기성 이미지와 관련된 수많은 Pepin Press의 출판물 및 주문에 대한 자세한 내용은 www.pepinpress.com을 방문하시기 바랍니다.

L'émergence des réseaux sociaux et l'évolution vers un stockage et une gestion des données sur le Web changent notre manière d'utiliser Internet et de concevoir des pages Web. Bien que des avancées technologiques majeures aient été accomplies en matière de conception graphique Web, cette année la tendance prédominante a été marquée par le passage de l'utilisation de la technologie comme nouveauté vers un équilibre entre la conception, la facilité d'utilisation et la technologie. La transparence PNG, par exemple, a offert aux concepteurs toute une gamme de nouvelles possibilités permettant d'incorporer des images dans leur travail. Grâce à des polices mieux supportées par les navigateurs (@font-face, sIFR), les concepteurs peuvent désormais utiliser la typographie – en particulier les caractères grands, gras et fantaisie – pour ajouter de la personnalité et de la clarté.

L'URL de chaque site est indiquée. Les noms des personnes ayant participé à l'élaboration et à la programmation du site sont classés comme suit :

design	**D**
programmation	**C**
production	**P**
adresse du concepteur	**M**

La quatrième de couverture contient un CD présentant l'ensemble des pages Web, dans le même ordre que le livre. Il permet de charger rapidement chaque page pour les consulter à l'écran et d'accéder à Internet pour naviguer sur les sites choisis.

Suggestions et recommandations

Chaque année, The Pepin Press publie de nouvelles éditions de ses deux ouvrages de référence en matière de conception virtuelle : **Index de modèles de sites web** et **Index de modèles de sites web par contenu**. Si vous avez des modèles à nous suggérer ou à nous recommander, veuillez remplir le formulaire de suggestion qui se trouve à l'adresse **www.webdesignindex.org**

The Pepin Press

Pour en savoir plus sur The Pepin Press ou pour commander un ouvrage parmi notre sélection de publications consacrées au design, à la mode, à la culture pop, aux références visuelles et aux images prêtes à l'emploi, rendez-vous sur notre site Web **www.pepinpress.com**

序文

ウェブ上でのソーシャルネットワークの成長とデータを格納し管理するという動きが、私達がインターネットやデザインウェブページを使用する方法に変化を与えています。ウェブデザインに関する技術は重要な進歩をしましたが、今年の重要動向は、新規の技術の使用へと変化し、デザインや使いやすさと技術間でのバランスへと移行しています。例えば、PNGの透明性は、作品にイメージを組み込むために幅広く新しい可能性をデザイナーに与えました。また、フォント(@font-face、sIFR)に対するより優れたブラウザサポートによって、デザイナーが個性を発揮し、わかりやすい大きく太く新しいタイプフェイスをはじめとする活字印刷文字を使用できるようになりました。

本書には、各サイトのURL、及びデザイナーとプログラマーの名前も載せています。表記方法は以下のとおりです。

D デザイン
C コーディング
P プロダクション
M デザイナーの連絡先

裏表紙の内側ポケットに挿入されたCD-ROMには、同書の全ページがページ順に収録されています。このCD-ROMをお客様のコンピューターでご使用になれば、各ページを簡単に見ることができます。また、同書に掲載されているウェブ・ページにも、簡単にアクセスできます。

ウェブサイトの自薦・他薦

Pepin Pressは、ウェブデザイン業界の人気参考書、「Web Design Index」と「Web Design Index by Content」の改訂版を毎年出版しています。自分のウェブサイトを掲載ご希望の場合、また推薦なさりたいサイトがある場合には、www.webdesignindex.orgにアクセスしてお申し込みください。

The Pepin Press

Pepin Pressは、デザインやファッション、ポップ・カルチャーなどについて多様な出版物や、すぐにそのまま使えるイメージ素材などを出版しています。当社の出版物やイメージ素材について、詳しい情報をお知りになりたい方、あるいは当社の商品をご注文なさりたい方は、www.pepinpress.comにアクセスしてください。

La crescita dei social network e la tendenza a immagazzinare e gestire dati in rete stanno cambiando il modo in cui usiamo internet e le pagine web grafiche. Sebbene siano stati riscontrati progressi notevoli nella tecnologia del web design, quest'anno si è verificato un cambiamento importante: la tecnologia non è più vista esclusivamente coma una novità in sé, ma viene integrata armoniosamente al design e alla facilità di utilizzo. La trasparenza PNG per esempio ha offerto ai designer diverse nuove possibilità per incorporare le immagini nel loro lavoro. Un migliore supporto browser per i caratteri (@font-face, sIFR) ha permesso ai grafici del web di fare uso della tipografia (soprattutto caratteri grandi, in grassetto o con uno stile innovativo) per conferire personalità e chiarezza alle pagine.

Per ogni sito è indicato l'URL corrispondente. I nomi delle persone che hanno collaborato al design e alla programmazione dei siti sono riportati come segue:

design	**D**
codificazione	**C**
produzione	**P**
contatti del designer	**M**

Un CD contenente tutte le pagine, collocate nella stessa maniera che nel libro, si trovano all'interno della copertina posteriore. Permette di visualizzare ogni pagina sul vostro computer con un tempo di scaricamento minimo, e di accedere a internet in modo da sfogliare le pagine selezionate.

Segnalazioni

Ogni anno The Pepin Press pubblica un'edizione aggiornata dei due punti di riferimento principali per il settore del web design: **Web Design Index** e **Web Design Index by Content**. Se desiderate inviare o segnalare un progetto grafico in particolare, compilate l'apposito modulo sul sito **www.webdesignindex.org**

The Pepin Press

Per ulteriori informazioni su The Pepin Press o per ordinare le nostre pubblicazioni dedicate a design, moda, cultura popolare, banca immagini e consultazione grafica, visitate il sito **www.pepinpress.com**

随著社交网页的急速发展以及使用互联网来储存和处理数据渐趋普及，我们对互联网的应用及网页设计的方向亦有所改变。虽然网页设计在技术上出现了重大的发展，本年度网页设计的一主要趋势却是在设计、易用程度及科技三者之间取得平衡，偏离了过往以技术作噱头的手法。以 PNG 便携式网络图像为例，这技术为网页设计师带来多种新的可能性，把图像融入设计作品内。像 @font-face 和 sIFR 这些技术为浏览器提供了更佳的支援，同时亦为网页设计师在选择字体（特别是大型、新款的字体）时带来许多方便，加添了个人风格及提高清晰度。

本书列出每个网页的统一资源定位符(URL)。网页的设计和编写程式的人员名单，分列如下：

D **设计**
C **编码**
P **制作**
M **设计人员的联系地址**

CD光盘放在封底，它包含所有的网页，并按照本书的顺序进行排列。光盘可以让你利用你自己的计算机，在最短的加载时间内对各个网页进行阅览，并登录互联网浏览精选的网页。

投稿及推荐

Web Design Index(网页设计索引) 及 Web Design Index by Content (网页设计索引 – 主题篇) 这两部参考书籍，在网页设计业内带著领导的地位。The Pepin Press每年均会为这两部书推出新订版。若阁下有意把设计投稿或作推荐，请到www.webdesignindex.org填写投稿表格。

The Pepin Press

若阁下需要更多关于The Pepin Press的资料，或想订购本社有关设计、时装、流行文化、视觉参考及现成图像的刊物，请到www.pepinpress.com查阅本社的网页。

O crescimento das redes sociais e os progressos no sentido do armazenamento e da gestão de dados na Web estão a mudar a forma como usamos a Internet e concebemos as páginas Web. Ainda que tenham sido obtidos importantes avanços no campo da tecnologia de Web design, uma tendência importante deste ano foi o abandono da utilização da tecnologia como novidade em favor de um equilíbrio entre design, facilidade de utilização e tecnologia. As transparências PNG, por exemplo, deram aos designers um leque de novas possibilidades para incorporação de imagens no seu trabalho. Um melhor suporte dos programas de navegação em relação aos tipos de letra (@font-face, sIFR) também permitiu que os designers usassem a tipografia – especialmente tipos de estilo grande, em negrito e inovadores – para maior personalidade e clareza.

É indicado o URL de cada sítio na Web presente no livro. Os nomes das pessoas envolvidas na concepção e programação dos sítios na Web são indicados da seguinte forma:

design	D
codificação	C
produção	P
endereço de contacto do designer	M

No interior da contracapa do livro, encontrará um CD contendo todas as páginas, organizadas pela mesma ordem do livro. Este permite-lhe visualizar cada página no seu computador com um tempo de transferência mínima e aceder à Internet para navegar pelas páginas seleccionadas.

Propostas e recomendações

Todos os anos, a The Pepin Press publica novas edições de dois livros de referência no âmbito do Web design: **Web Design Index** e **Web Design Index by Content**. Para propor ou recomendar designs à nossa avaliação, aceda ao formulário de propostas em **www.webdesignindex.org**

The Pepin Press

Para obter mais informações sobre a The Pepin Press ou para efectuar encomendas das nossas obras sobre design, moda, cultura popular, referências visuais e imagens prontas a usar, visite **www.pepinpress.com**

g

Portfolio

Cotton, Inc. Interactive Annual Report
NxtUp Philly
Mind Over Chatter
Fireworks
Hudson Yards Annual Report
Branches of Science
Gozo Gothic

Lowercase letters designed in a week-long workshop
with James Montalbano of Terminal Design.

Waste
Continuum Health Partners Annual Report
Interface Intersection
Letterforms
Frame Network Identity
Structure

About

Résumé

Contact

abcdefgh
ijklmnopqr
stuvwxyz

www.gabriellegozo.com
D: gabrielle gozo **C:** gabrielle gozo
P: gabrielle gozo **M:** gabrielle@gabriellegozo.com

NADINE ZIEHN //
MOBILE TIERHEILPRAXIS FÜR PFERDE UND HUNDE //
TIERHEILPRAKTIKERIN UND TIERVERHALTENSTHERAPEUTIN //

Profil
Behandlungsablauf
Naturheilkundliche Therapie
Tierverhaltenstherapie
Futterberatung / Futterverkauf
Pflegeprodukte
Kontakt
Impressum

Zu meinen Therapieverfahren gehören die Homöopathie,
Bachblüten und Schüßler Salze.

Bei diesen Therapieverfahren ist das Wichtigste die ganz-
heitliche Betrachtung , d.h. es wird der ganze Patient mit allen
körperlichen und psychischen Gegebenheiten wie
Charaktereigenschaften, Vorlieben & Abneigungen, Verhalten in
bestimmten Situationen, Auffälligkeiten und ggf. bisherige
Schwierigkeiten gesehen.

Nur so kann die Behandlung erfolgversprechend und vor allem
dauerhaft helfen und genau das ist mein Ziel.

www.tier-couch.de
D: christoph blank **C:** christoph blank
P: nadine ziehn **M:** info@blank-intergroup.com

ARTPROPHETS

Identity
Adam / CI / New
Artprophets / CI / New
Brands / Collection
BuntBunt / Logo
Dual / CI
DJ Armin MC / Logo
Freinorm / CD
Freiraum / CD
Specht / CI
Vinum / CD

Motion
3D Lines
AP.ID_09 / New
Bubble Formation
GL2: Reel
Move / Promo
Reel Distortion
Showreel 2009
TCAAT Movie / B.A.

Unsorted
ausliebeprotzen / Web
Bitlurk
Ceratizit / Ad
Cultural Mindmap
DLS / Folder
Helvetica / Poster
Los Logos 4
Screendesign / Collection
Semi Permanent
Three Cheers and a Tiger / B.A.

Information
Blog
About
CV

Ja, ich
mache auch
etwas mit
Gestaltung.

www.artprophets.at
D: stefan hornof **C:** stefan hornof
P: stefan hornof **M:** info@artprophets.at

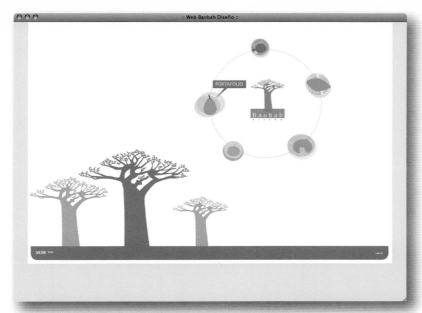

www.baobabdiseno.cl
D: maria jose martinez, antonia hordern
M: contacto@baobabdiseno.cl

www.phoenixdesign.com
D: phoenix design
P: phoenix design M: info@phoenixdesign.de

www.archiware.nl
D: b. kwaaitaal, l. schuurkamp, r. harrington C: archiware
P: archiware M: info@archiware.nl

www.oqueeufiznasferias.com.br
D: ricardo dexheimer
M: contato@dexdesign.com.br

www.sinela.es
D: dostintas - sandra dostintas, sandra martinez C: www.dostintas.es
P: sinela gallery M: andres@dostintas.es

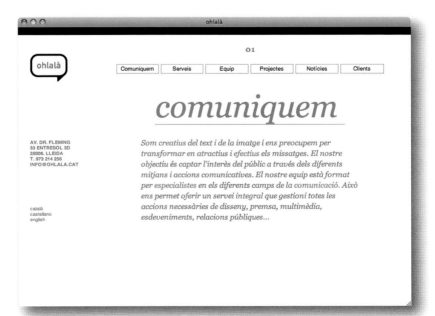

www.ohlala.cat
D: coral piferrer, ohlala C: sergi bach
P: ohlala M: cpiferrer@ohlala.cat

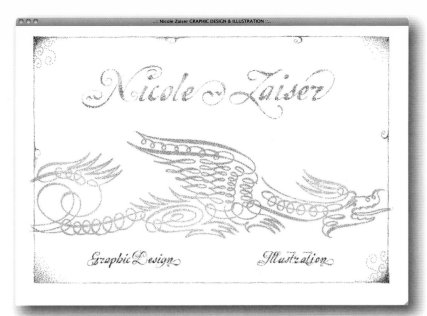

nicole.osx.at
D: nicole zaiser C: nicole zaiser
P: nicole zaiser M: nicole.zaiser@chello.at

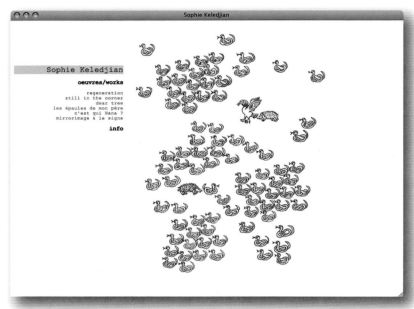

sophiekeledjian.net
D: bertrand planchon C: bertrand planchon
P: bertrand planchon M: bertrand.planchon@gmail.com

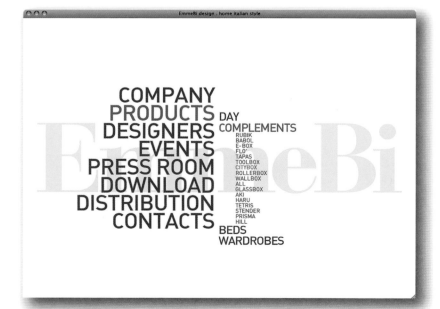

www.emmebidesign.com
D: neotokio! comunicazione visiva C: neotokio! comunicazione visiva
P: neotokio! comunicazione visiva M: info@neotokio.it

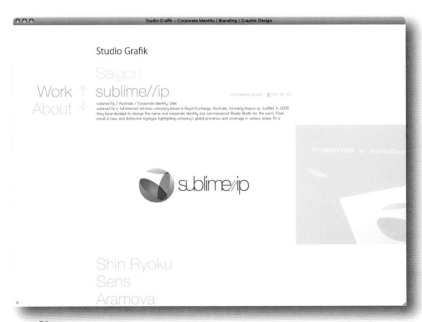

Joris Landman .com

Home Work Blog About

Home

JORIS LANDMAN *Independent Design & Internet Professional* Websites & Design, Amsterdam

Menu

Home	Work	Blog	About
	framerframed.nl		Profile
	jamarchitecten.nl		Clients
Language	www.keen.nl	RSS	Publications
English	lauraweeber.nl	English	Contact
Nederlands	blauw-architecten.nl	Nederlands	
	www.raminvisch.nl		Twitter
			Facebook
Login			Linkedin
Client	Keywords		
CMS	Graphic Design (15)		Legal
	Web Design (10)		
	Content Management System (4)		
Sitemap	Grid System (5)		
	Photography (8)		
	News (6)		

jorislandman.com
D: jorislandman.com C: jorislandman.com
M: information@jorislandman.com

sony style store competition
catalan assembly
student housing
sandwich restaurant
zambian orphanage
romanian retreat
writers studio
rotterdam art gallery
club & event location
family house
1 million masterplan
house in romania

architecture

design proposals and visulizations for various projects in professional practices in Germany, the UAE and the UK

a selection of university projects from the University of Bath, UK and the TU Delft, Netherlands

< @

www.tomradenz.com
D: tom radenz
P: bfs d M: tom@tomradenz.com

Studio Grafik

Saigon
Work sublime//ip
About www.sublime-ip.com 01 02 03 04

sublime//ip / Australia / Corporate Identity, Web
sublime//ip is full internet services company based in Royal Exchange, Australia, formerly known as JustNet. In 2005 they have decided to change the name and corporate identity and commissioned Studio Grafik for the work. Final result is new and distinctive logotype highlighting company's global presence and coverage in various areas. As a

sublime/ip

Shin Ryoku
Sens
Aramova

www.grafik.rs
D: vladimir mijatovic C: aleksandar gvozden
M: info@grafik.rs

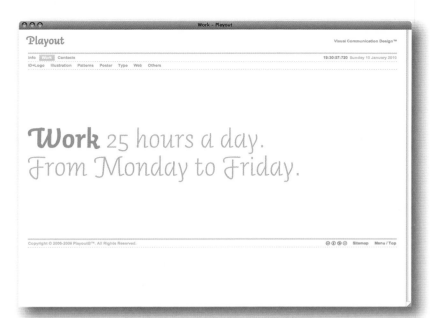

www.playout.pt
D: tiago machado
M: mail@playout.pt

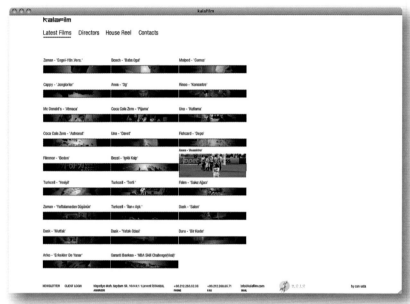

www.kalafilm.com
D: can usta C: can usta
P: kala film M: talkto@canusta.com

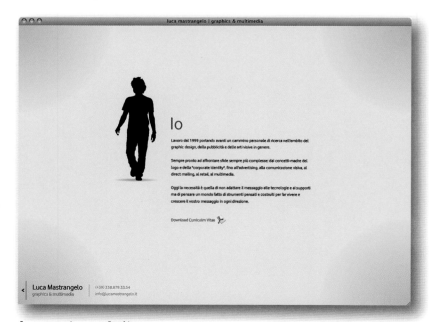

www.lucamastrangelo.it
D: luca mastrangelo C: luca mastrangelo
P: luca mastrangelo M: info@lucamastrangelo.it

Moltefacce. Graphic Design & Architecture.
We design new forms of perception
shaking even the most sophisticated minds.

Our Services.

Brand Identity
Creative Direction
Graphic Design & Illustration
Web Design & Positioning
Photography
Video Editing
Sound Design
Architectural & Interior Design

Contact Us.

e: info@moltefacce.com
p: +39 339 777 41 60

Address.

Moltefacce srl
via Avesella, 3. 40121 Bologna, Italy

C.F. P.I. Reg. Imp. di Bologna n: 02909561207
Capitale Sociale: 10.000,00 €, 6.000,00 v.
REA: BO-0476905

Newsletter.

Sign up to the Moltefacce Newsletter to be informed about updates and news. (L. n. 196/03)

Name: _____ Email: _____ Send.

www.isaiaquinta.com
D: moltefacce C: moltefacce
P: isa iaquinta M: krghettojuice@hotmail.com

www.bigelows-rvc.com
D: mamus C: mamus
P: bigelow's M: john@mamuscreative.com

www.doitdifferent.net
D: zoo studio C: zoo studio
P: divasa-farmavic M: info@zoo.ad

www.bee-creations.com
D: bee creations, ido zemach, eran bacharach C: elad ziv, fatlady
P: our creative home M: bee@bee-creations.com

www.remar.ru
D: alexander volkov C: alexander volkov
P: alex puchkovsky M: volk@frgroup.ru

www.foolcompany.it
D: antonio nocera, linfacreativa.com C: nocera antonio
P: fool company s.r.l. M: info@linfacreativa.com

www.jessewillmon.com

D: jesse willmon C: jesse willmon

P: jesse willmon M: jesse.willmon@gmail.com

www.dariosavarese.it

D: dario savarerse C: d. savarese

P: d. savarese M: info@dariosavarese.it

www.devia.be

D: duoh!

P: devia - stefaan lesage M: info@devia.be

www.underwires.net

D: aurélien aries C: aurélien aries
P: underwires M: aurelien@underwires.net

www.nexprochile.cl

D: cristian salinas
M: info@nexprochile.cl

www.mikikosatogallery.com

D: eddy salzmann, uniqrn.com C: tobias houfek, eins[23].tv gmbh
P: mikiko sato gallery M: e@uniqrn.com

www.montag-architekten.de

D: domeniceau C: domeniceau
P: montag architekten M: info@domeniceau.de

www.designfee.com

D: bianca werninghaus C: robin burrer
P: bianca werninghaus M: gestaltung@designfee.com

www.2kilo.nl

D: 2 kilo design C: 2 kilo design
P: 2 kilo design M: info@2kilo.nl

www.waynedeboer.co.uk

D: wayne deboer C: wayne deboer
M: info@waynedeboer.co.uk

www.inezborges.com

D: inez inezborges C: sergio sergio oliveira
P: inezborges M: inezborges@gmail.com

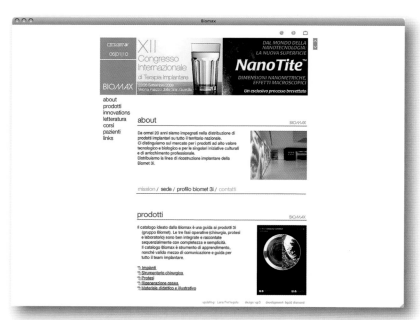

www.biomax.it

D: up3 C: samuel gentile
M: info@up3.it, samuel@liquiddiamond.it

Abbey Walk **Gallery**

Home Exhibitions Artists Workshops Contact Blog

Elaine & Gill welcome you to Abbey Walk Gallery

The Nature of Landscape II 16th MAR – 24th APR

Abbey Walk **Gallery** is Grimsby's newest art venue featuring an exciting and diverse rolling programme of contemporary art.

Gallery 1 exhibition space hosting shows from selected local national and international artists.

Gallery 2 exhibition space hosting art work from Abbey Walk Galleries resident artists. Workshop - varied programme of workshops exploring a wide variety of media.

Shop offering a broad range of professional and student quality art supplies.

Studios professional well equipped spaces to licence to artists

Click thumbnails to see previous examples of artists work.

Richard K. Webb, David Ainley & Jeremy Leigh – Open 9 am- 5pm Tuesday to Saturday
The Nature of Landscape II is the next in a series of Exhibitions that combine work by nationally renowned artists and academics with Abbey Walk Studio Artists and Degree students from the East Coast School of Art & Design: Visions and Distillations of Landscape & Place in a variety of media and styles. more info »

Exhibitions are free entry & all ages are welcome unless otherwise stated.

Get in touch **Social Links** **Useful Information**

Drop Us A Line: Email Us » Facebook: Add Us » Artwork Availability: Enquire » LOTTERY FUNDED

+44 (0)1472 241007 Twitter: Follow Us » Submission Form: Exhibit »

www.abbeywalkgallery.com
D: hoohaadesign C: hoohaadesign
P: abbey walk gallery M: james@hoohaadesign.co.uk

Contact Biography Nederlands

The most-used words in the writing of David Keuning, architecture journalist:

the (1371), of (651), a (390), to (490), in (464), and (424), that (320),

is (277), for (196), i (172), it (162), with (161), you (147), on (136), are (127), we (124), this (116), as (115), but (107), not (99), its (93),

have (92), they (90), an (89), building (84), at (83), was (83), by (81), be (73), he (71), which (70), his (66), architecture (66), about (66), all (64), very (63),
design (61), from (60), their (60), were (60), has (59), also (57), like (56), had (54), work (54), (53), what (49), do (49), can (48), way (47), so (46), our (46), there (45),
one (44), been (41), out (41), timo (41), architects (41), when (38), other (38), them (36), your (36), think (35), into (35), more (35), people (34), thats (34), buildings (33), if (33),
book (32), than (32), first (31), project (31), two (31), only (31), or (30), institute (30), new (29), would (29), up (29), make (28), did (28), own (28), these (28), same (27), dont (27),
who (27), me (27), says (26), netherlands (26), because (26), no (25), many (25), my (25), books (24), such (24), made (24), much (24), still (23), public (23), different (22), years (22), together (21),
good (21), after (21), riedijk (21), get (21), architect (21), something (20), space (20), even (20), how (20), most (20), glass (19), well (19), things (19), part (19), each (19), world (19), really (19),
some (19), van (19), office (19), projects (18), sound (18), lot (18), see (18), point (17), walls (17), used (17), any (17), say (17), working (17), between (17), side (17), name (17), does (17), vision (16),
city (16), archives (16), kind (16), school (16), could (16), just (16), images (16), history (15), through (15), designed (15), works (15), go (15), us (15), dutch (15), him (15), example (15), now (15),
important (14), form (14), come (14), china (14), want (14), culture (14), every (14), their (14), local (14), too (14), magazine (14), ru (13), those (13), practice (13), citroën (13), year (13), drupsteen (13),
seems (13), neutelings (13), large (13), façade (13), centre (13), idea (13), big (13), museum (13), around (13), makes (13), know (13), place (13), states (13), behind (13), united (12), number (12), fat (12),
always (12), sense (12), over (12), before (12), course (12), old (12), put (12), itself (12), floors (12), firm (12), whole (11), back (11), find (11), tafuri (11), art (11), society (11), view (11), american (11),
going (11), got (11), instance (11), start (11), magazines (11), want (11), mind (11), including (11), great (11), house (10), enough (10), she (10), without (10), another (10), youre (10), light (10),
nothing (10), paris (10), few (10), look (10), both (10), university (10), thing (10), clear (10), interior (10), everything (10), worked (10), client (10), possible (10), sometimes (10), little (10), read (10), mail (10)

www.davidkeuning.com
D: florian mewes
P: david keuning M: mail@gotoflo.eu

BLANKSCHMIDT GROUP

10 / 09

BlankSchmidt entwickelt Corporate Design für die Düsseldorfer Galerie Schütze

Am 30. September 2009 wurde die erste Ausstellung der Galerie Schütze "Ursula Schüllenbach: Flaschenpost2" im Obergeschoss (K-Forum) des NRW-Forums Düsseldorf eröffnet. BlankSchmidt entwickelte hierzu das neue Erscheinungsbild der Galerie.
mehr...

09 / 09

Kultur- und Kreativbranche ist Stützpfeiler der deutschen Wirtschaft

Laut einer Studie der Bundesregierung ist die Kultur- und Kreativbranche auch in Krisenzeiten einer der Stützpfeiler der deutschen Wirtschaft. Nach Angaben des Bundeswirtschaftsministeriums erziele die Branche im Jahr 2008 eine Bruttowertschöpfung von 63 Milliarden Euro.
mehr...

08 / 09

Design stärkt den Mittelstand

Im Rahmen der Initiative Kultur- und Kreativwirtschaft der Bundesregierung hat die Initiative Deutscher Designer gemeinsam mit dem Bundesministerium für Wirtschaft und Technologie eine Veranstaltung zum Thema "Design stärkt den Mittelstand" durchgeführt.
mehr...

PROFIL

Die BlankSchmidt Group ist eine Kooperationsgemeinschaft der Unternehmen Blank Intergroup Communication KG und Schmidt/Vormwerkstatt für strategische Beratung, Kommunikation und Design mit Sitz in Düsseldorf.

Seit 2006 beraten wir unsere Kunden aus Wirtschaft und Kultur in allen Fragen der strategischen Unternehmenskommunikation. Die Schwerpunkte unserer Tätigkeit liegen in den Bereichen Identitätsmanagement und visueller Kommunikation, der Beratung und Entwicklung identitätsstiftender Grundsätze und Visionen bis hin zur Konzeption und Kreation. Wir verstehen Kommunikationsdesign dabei als Werkzeug, komplexe Zusammenhänge und Strukturen auf das Wesentliche zu reduzieren, um Image, Inhalt und Information benutzerfreundlich zu transportieren.

Als interdisziplinäre Unternehmensgruppe implementieren wir strategische

REFERENZEN

Wirtschaft
Boss-Bus GmbH & Co.KG
Charité Berlin
Commerzbank AG
Deutsche Welle
Dr. Metz
DW-Akademie
Global Institut Immobilien GmbH
GOLLA Messemanagement
Hitachi
HoTt Gaststätten GmbH
Jase Livingber
Jo2Gs
Münstertherme
Ohlschläger
Pfeifer Kuhn Architekten
Rechtsanwaltskanzlei Scholzen
Restaurant La Lanterna
Schreinerei Galerie Meister HS
TR Plus Unternehmensgruppe
Unltd
Unlimited
Vereinigung ehemaliger Mitglieder des
Deutschen Bundestages und des Europäischen

BÜRO

BlankSchmidt Group
Volmerswerther Str. 21
D-40221 Düsseldorf
Telefon +49 [0] 211. 303 303 3
Telefax +49 [0] 211. 300 36 999
E-Mail info@blankschmidt.com

www.blankschmidt.com
D: christoph blank, christoph schmidt C: christoph blank, christoph schmidt
P: blankschmidt group M: info@blankschmidt.com

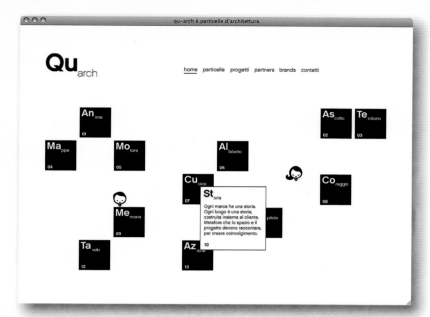

www.qu-arch.com

D: julia kleiner C: visualmade srl
P: quarch M: info@visualmade.it

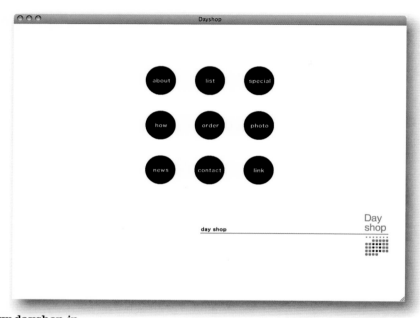

www.dayshop.jp

D: takeru kawai, noriko okamoto, toshikazu minatomura C: fumiaki hamagami, imaginary stroke, co.
P: hidetoshi kuranari M: isc@imaginarystroke.com

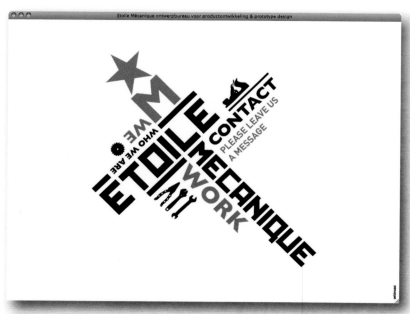

www.etoilemecanique.com

D: reg herygers, marian van de weerd C: reg herygers
M: info@undercast.com

bobo

porqué bobo descargas

01 barcelona
02 seguridad windows
03 semana sin JUEVES
04 el Limbo
05 san fermines
06 Fernando Alonso
07 Adiós Fidel?

www.consuma.es/bobo
D: frank pérez
M: hola@consuma.es

sofa + stoffa
ilpap
undefine arts
x/p aerakis
filippos
koroneou gallery
portalakis collection
kion architects
makeup artist
kosmima.gr
anninos
bnc
tikou tikou
orange boat
digicom
aeraki
new generation
fos se 5

logos | identities | invitations | printed | books | miscellaneous | web

www.aeraki.gr
D: despina aeraki C: danae stamataki
P: aeraki M: info@aeraki.gr

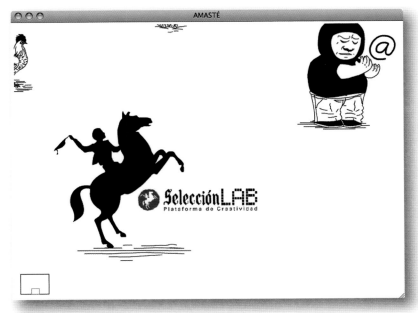

SelecciónLAB
Plataforma de Creatividad

www.amaste.com
D: amaste C: factoria norte crossmedia
M: ruben@factorianorte.com

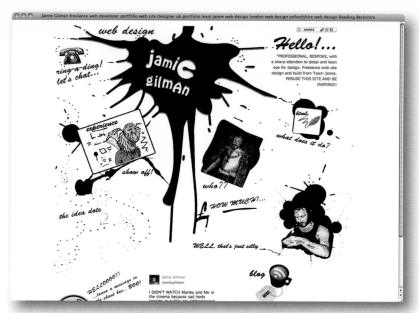

www.teamjamie.co.uk
D: jamie gilman C: jamie gilman
P: jamie gilman M: jamie@teamjamie.co.uk

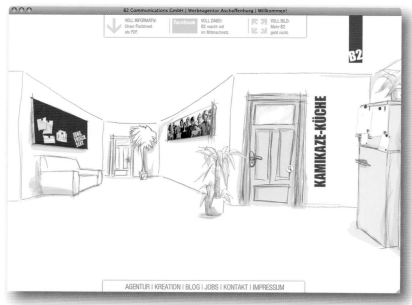

www.b2online.de
D: björn bock, kilian wilde C: felix schittig, tobias dühr
P: b2 communications gmbh | werbeagentur M: info@b2online.de

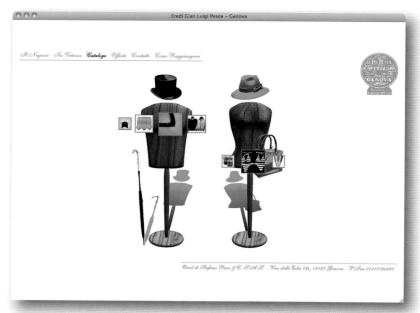

www.gianluigipesce.it
D: elena schiaffino C: benedetto bozano, andrea granero
P: eredi gianluigi pesce M: info@elenaschiaffino.it

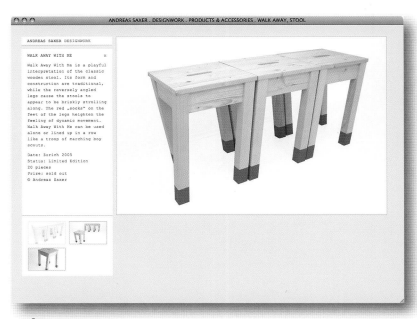

ANDREAS SAXER DESIGNWORK

WALK AWAY WITH ME

Walk Away With Me is a playful interpretation of the classic wooden stool. Its form and construction are traditional, while the reversely angled legs cause the stools to appear to be briskly strolling along. The red „socks" on the feet of the legs heighten the feeling of dynamic movement. Walk Away With Me can be used alone or lined up in a row like a troop of marching boy scouts.

Date: Zurich 2005
Status: Limited Edition
20 pieces
Prize: sold out
© Andreas Saxer

www.andreas-saxer.com
D: andreas saxer C: christoph dubach, marc rinderknecht
M: info@codama.ch

= Jana Elzenbeck

01 · 02 · 03 · 04 · 05 · 06 · 07 · 08 · 09

Produktdesign
Webdesign
Illustrationen <
Grafikdesign
Designstudien
Bilder

© 1996 Jana Elzenbeck

Zooschilder

Jahr: 1996
Projekt: Ideenskizzen für Zooschilder
Technik: Handskizzen

<< zurück zur Illustrationsübersicht

Home · Curriculum Vitae · Kontakt · Impressum

www.janaelzenbeck.de
D: jana elzenbeck C: jana elzenbeck
P: jana elzenbeck M: j.elzenbeck@freenet.de

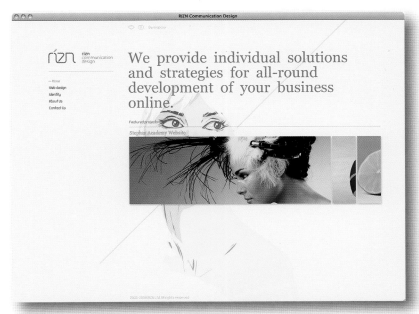

rizn communication design

— Home
Web design
Identity
About Us
Contact Us

We provide individual solutions and strategies for all-round development of your business online.

Featured projects
Stephan Academy Website

www.rizn.info
D: rizn design studio C: rizn design studio
P: rizn communications design studio M: info@rizn.info

www.acuisost.es

D: desoños C: alberto besbello
P: desoños M: multimedia@desonhos.net

www.thesize.es

D: desoños C: alberto besbello
P: desoños M: multimedia@desonhos.net

www.makelab.it

D: simone maletta, makelab studio, claudio fiorini, guido monfrini C: simone maletta
P: makelab graphic studio M: simone.maletta@gmail.com

www.mariafung.com
D: maria en ai fung
P: maria en ai fung M: maria@mariafung.com

www.edeas.hk
D: kelly sze C: peter au
P: gary wu M: info@edeas.hk

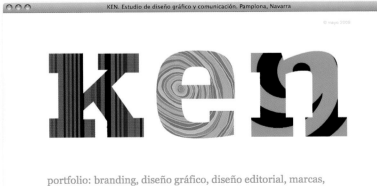

portfolio: branding, diseño gráfico, diseño editorial, marcas, packaging, multimedia, web, publicidad (prensa, radio, tv...), stands, exposiciones, congresos... | sobre ken | contacto: nueva 8, oficina 4. e-31192 mutilva alta, navarra. tel. +34 948 292 310 fax +34 948 292 311 info@ken.es | on-line shop

Acceso privado: escriba su clave de entrada

www.ken.es
D: ken, david alegria C: david alegria
P: ken M: info@ken.es

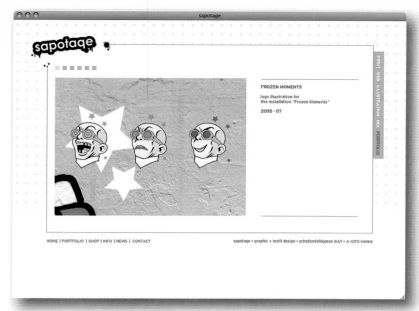

www.sapotage.at
D: sabine potuschak C: dan borufka
P: sabine potuschak M: office@sapotage.at

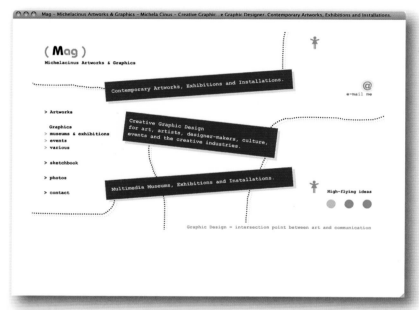

www.mag-online.it
D: michela cinus C: michela cinus
P: mag - michelacinus artworks & graphics M: info@mag-online.it

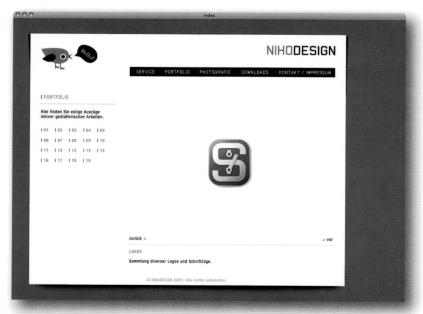

www.nihodesign.de
D: nina holinski C: nina holinski
P: nina holinski M: hello@nihodesign.de

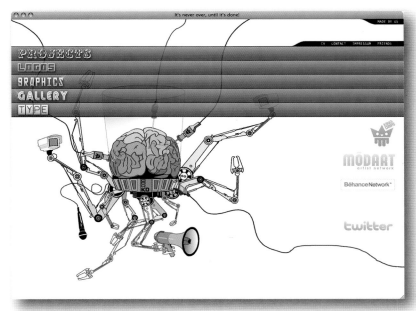

www.notoveruntilitsdone.com

D: .made [by us], lutz lindemann C: .made [by us], marcel bischoff
P: lutz lindemann M: hello@thiswasmadebyus.com

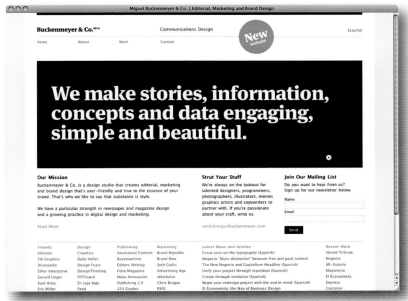

www.miguelbuckenmeyer.com

D: miguel buckenmeyer C: luis adrian zuluaga
P: buckenmeyer & co. M: mbcd@miguelbuckenmeyer.com

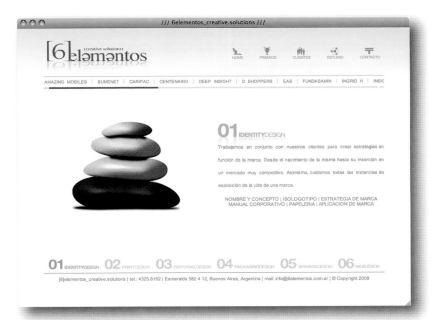

www.6elementos.com.ar

D: florencia sadous, santiago sadous C: santiago sadous
P: 6elementos_cs M: info@6elementos.com.ar

39

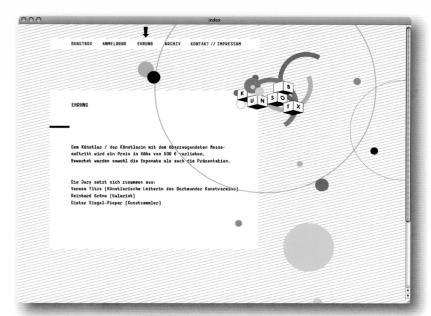

www.kunstbox.net

D: die transformer, martin schonhoff, michael thiele C: christoph kock
P: magdalen hamel M: info@die-transformer.de

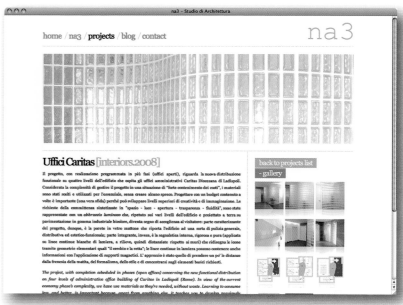

www.na3.it

D: giovanni carlo mingati
M: studio@na3.it

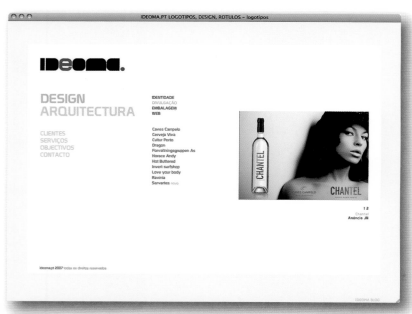

www.ideoma.pt

D: ideoma studio C: ideoma studio
P: ideoma studio M: estudio@ideoma.pt

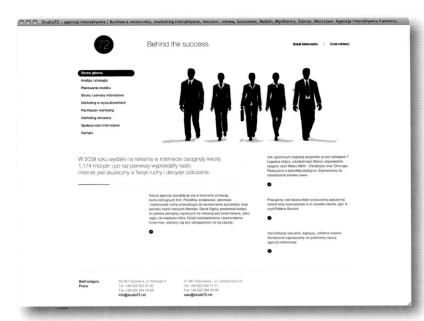

www.studio72.net
D: piotr biernawski C: tomasz kita
P: tomasz kita M: info@studio72.net

www.ag81designs.com
D: ag81designs C: ag81designs
P: andoni galarraga M: contact@ag81designs.com

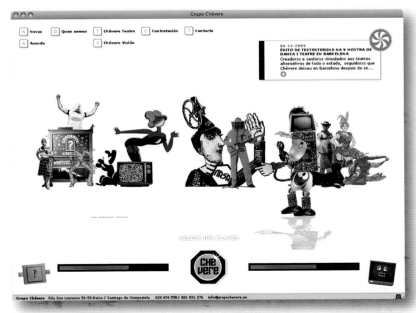

www.grupochevere.eu
D: desoños C: desoños
P: desoños M: jcarlos@desonhos.net

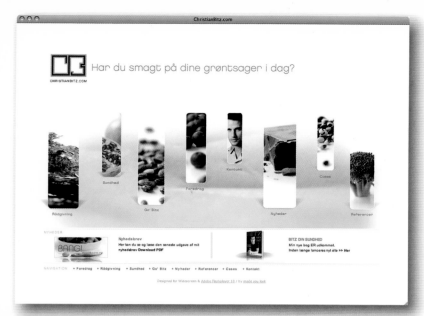

www.christianbitz.com

D: magnus packness C: magnus packness
P: magnus packness M: mp@myl-atyourscreen.com

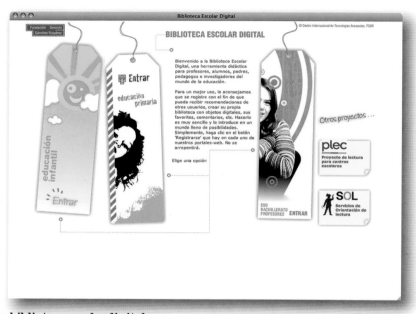

www.bibliotecaescolardigital.es

D: tatiana martins
P: centro internacional de tecnologías avanzadas. fgsr M: tatiana@fundaciongsr.es

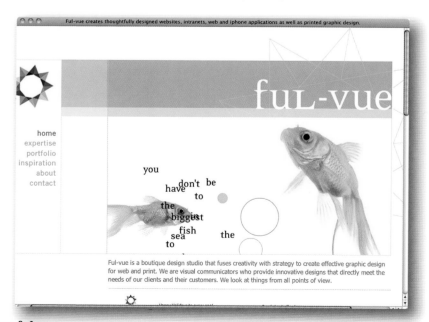

www.ful-vue.com.au

D: ful-vue C: ful-vue
P: ful-vue M: sol@ful-vue.com

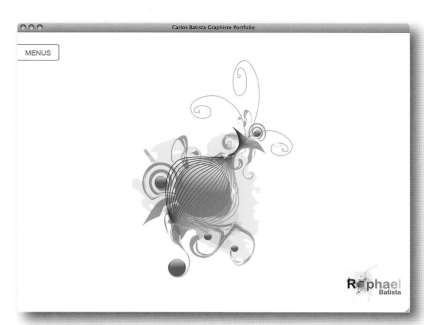

www.raphaelbatista.com
D: raphael batista C: thomas adams
P: www.raphaelbatista.com M: batist.raphael@gmail.com

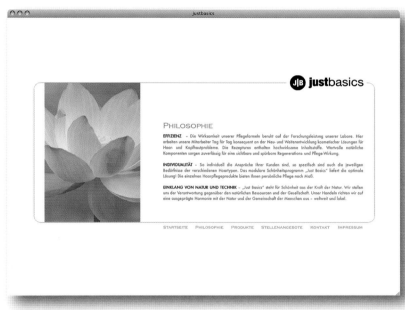

www.natural-basics.de
D: daniel jansen, jansen-design C: daniel jansen
P: natural basics M: info@natural-basics.de

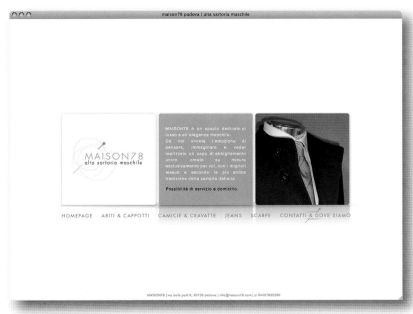

www.maison78.com
D: davide g. aquini
P: maison78 M: info@ad-g.it

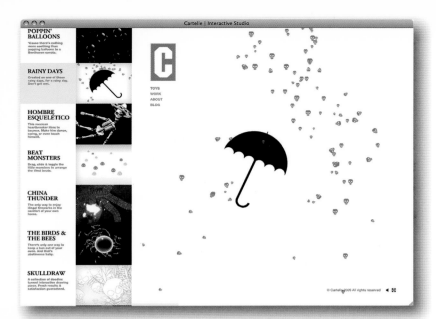

www.cartelle.nl
D: stevijn van olst C: johnny slack
P: cartelle interactive studio M: stevijn@cartelle.nl

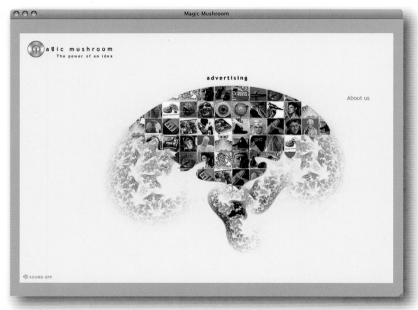

www.magicmushroom.co.in
D: candy singh, chandan ray, kanwaljeet sodhi C: webshree, kanwaljeet sodhi
P: arvind pal singh M: singhcandy@gmail.com

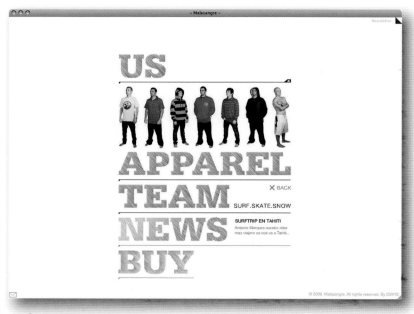

www.malasangre.com
D: héctor artiles C: héctor artiles
P: malasangre M: info@malasangre.com

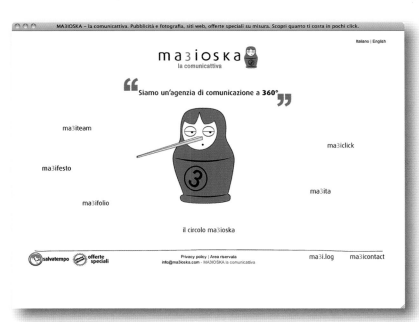

www.ma3ioska.com
D: ma3ioska C: ma3ioska
P: ma3ioska M: guglielmoparadisi@alice.it

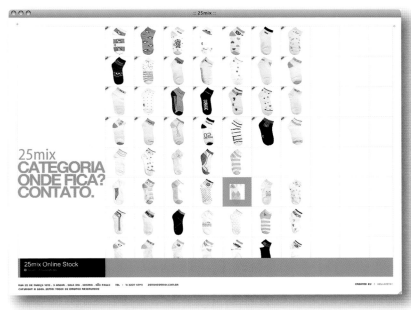

www.25mix.com.br
D: hellozeto!, jong hyuk lee C: hellozeto!, jong hyuk lee
P: 25mix M: zeto05@gmail.com

www.olevaca.com
D: jose zambrana lacueva C: victor salvador cortés
P: victor salvador, jose zambrana M: info@spider-multimedia.com

www.diginet.be

D: ballyhoo webdesign & flash C: ballyhoo
P: diginet M: laurent.bogaert@diginet.be

www.artentiko.com

D: marcin kaczmarek C: radosław skrzypczak
P: artentiko visual communication studio M: info@artentiko.com

www.passionpeople.de

D: roman heinrich, lars walter, silke sieler C: kenneth fraunhofer
M: mail@screenbow.de

www.whyatr.com
D: m. magimel C: b. garancher
M: contact@la-wip.fr

www.ideeinluce.it
D: samuele schiavo C: samuele schiavo
P: idee in luce M: info@samueleschiavo.it

www.gabrieleduenwald.com
D: gabriele duenwald C: gabriele duenwald
P: gabriele duenwald M: mail@gabrieleduenwald.com

www.ffyeah.gr

D: tasos protopapas C: tasos protopapas

P: ffyeah M: tasos@ffyeah.gr

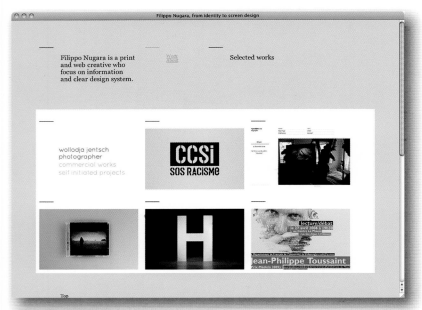

www.filipponugara.com

D: filippo nugara C: filippo nugara

P: filippo nugara M: info@filipponugara.com

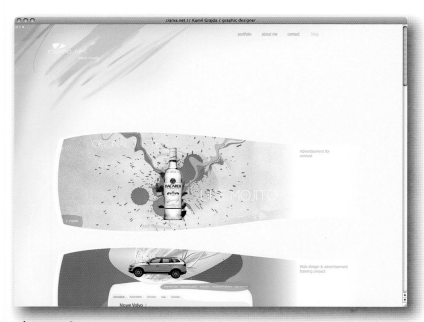

www.ciama.net

D: kamil grajda

M: mail@ciama.net

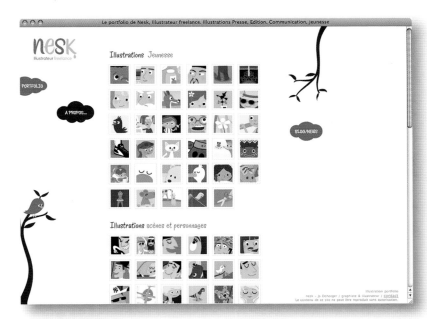

www.neskoncept.com

D: jean-sébastien deheeger C: jean-sébastien deheeger
P: www.neskoncept.com M: nesk@neskoncept.com

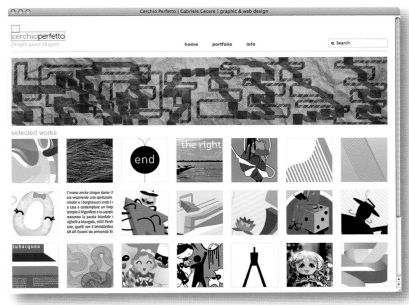

www.cerchioperfetto.it

D: cerchioperfetto C: cerchioperfetto
P: gabriele cecere M: mail@cerchioperfetto.it

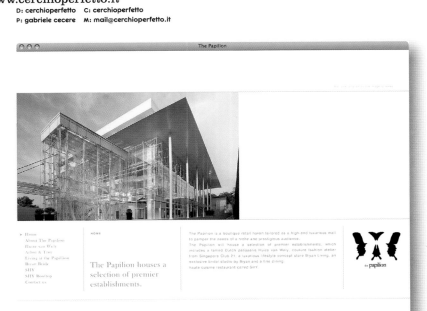

www.thepapilion.com

D: henricus linggawidjaja
M: henricus@artnivora.net

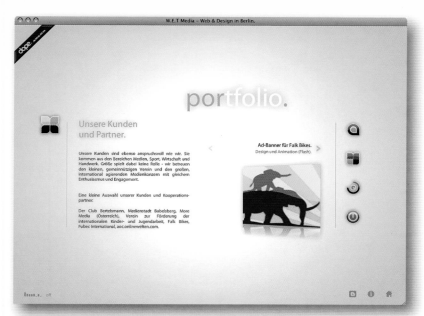

wet-media.de/wetsite
D: w.e.t media C: w.e.t media
P: w.e.t media M: hallo@wet-media.de

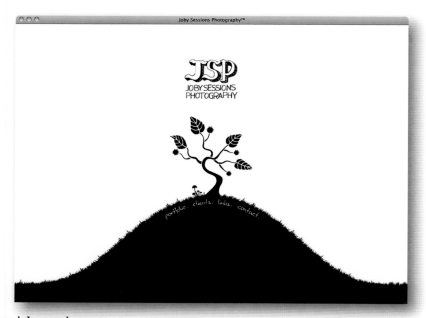

www.jobysessions.com
D: more air, tom vining C: more air, tom vining
P: joby sessions photography M: tom@withmoreair.com

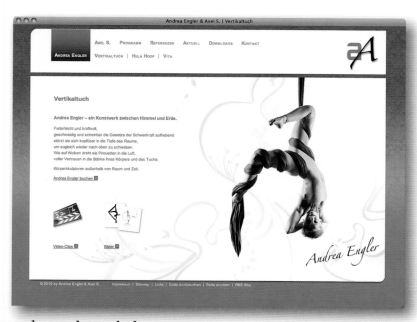

www.andreaengler-axels.de
D: mario perez leal C: mario perez leal
P: mario perez leal M: info@creacion.de

Terrecotte &
Ceramiche MC
le favolose

☐ Language select ☐ Home ☐ MC ☐ Retailers estimate ☐ Contacts ☐ Privacy

Retailers estimate list: 0 Articles

Catalogue

Christmas 2009

☐ Gift ideas
☐ Decorations
☐ Package-accessories

Wall articles

☑ Sky
☐ Sea
☐ Earth
☐ Sacrum

Garden forniture

☐ Animals
☐ Furniture complements
☐ Tanks
☐ Vases

Collection: Sky

Article A.LUNA.03

Crescent moon - second size
W. 17.00 cm. (6.69 inch)
H. 30.00 cm. (11.81 inch)

Add to estimate list
Quantity [] (Add)

Terrecotte e Ceramiche MC - P.Iva 02241420484 | Confinigrafici design

www.terrecottemc.it

D: orietta verdiani C: giuseppe tongiani
P: confinigrafici M: info@confinigrafici.it

View by discipline : Packaging / Branding & Logos / Literature / Ads & Direct Mail / Retail Graphics

Hear us out
See our work
Some awards
Recent clients
Talk to us

whole-heartedly with Franklin D. Roosevelt's view
that "The only thing we have to fear is fear itself".

We sell fearless creativity – because nobody
ever had a great creative idea by playing it safe.

www.taxistudio.co.uk

D: spencer buck, ryan wills, lindsay camp
M: sarah@taxistudio.co.uk

w&graphic » idee e soluzioni per il web e per la comunicazione

Home | Grafica | Web Technologies | Clienti | Contatti

marco dalumi
graphic design

yunior ochoa
graphic Design

copyright © 2009
Tutti i diritti riservati
per informazioni contattare:
clienti@orioneonline.it

Ci piace pensare e creare cose che ancora non esistono...

www.orioneonline.it

D: marco dalumi C: marco dalumi
P: marco dalumi M: clienti@orioneonline.it

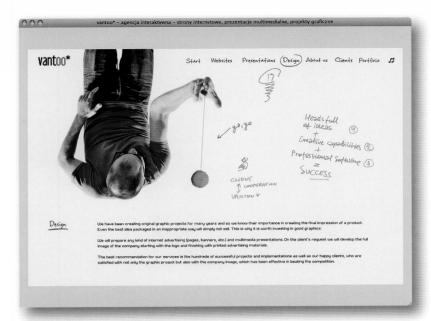

www.vantoo.com

D: dariusz roman, agnieszka tekieli C: vantoo

P: vantoo M: vantoo@vantoo.com

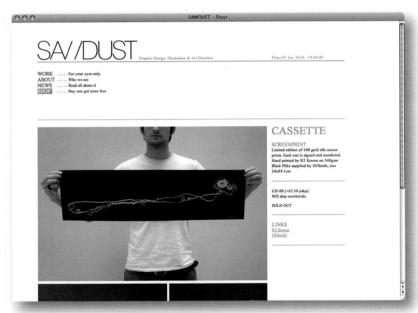

www.madebysawdust.co.uk

D: rob gonzalez, sawdust C: guy moorhouse, futurefabric

P: rob gonzalez / sawdust M: gmoorhouse@gmail.com

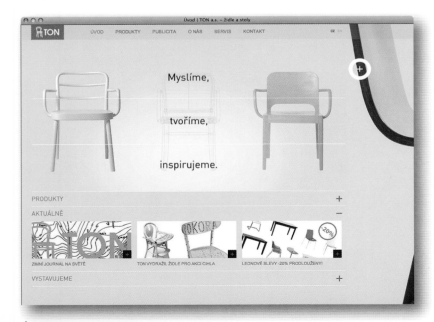

www.ton.cz

D: studio9 C: studio9

P: ton a.s. M: info@studio9.cz

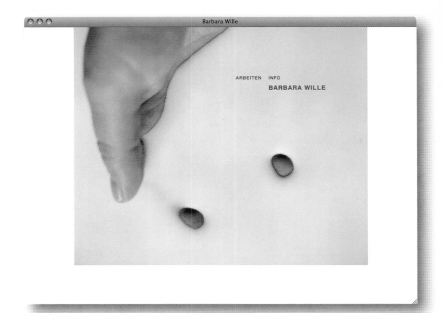

barbarawille.de
D: bruno dorn C: sascha brümmer
M: info@brunodorn.de

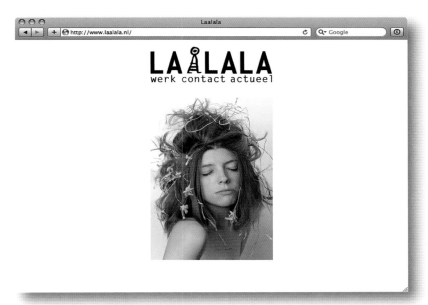

www.laalala.nl
D: irene cécile C: irene cécile
P: laalala M: irenececile@gmail.com

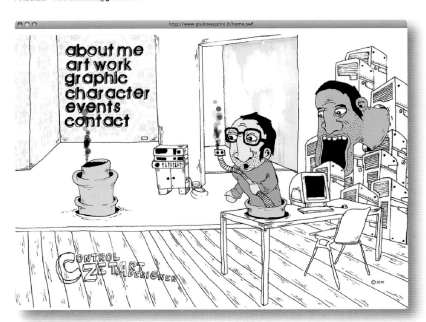

www.giuliovesprini.it
D: giulio vesprini C: federica tarchi, federica tarchi graphic&comunication
P: giulio vesprini_controlzeta-rt designer M: info@giuliovesprini.it

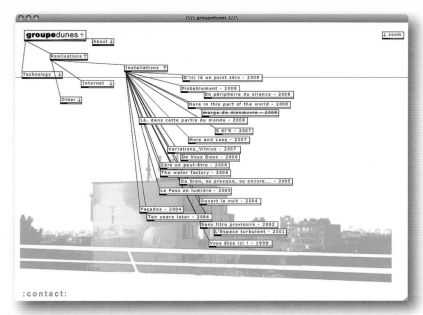

www.groupedunes.net
D: 627b C: 627b
P: 627b M: contact@627b.com

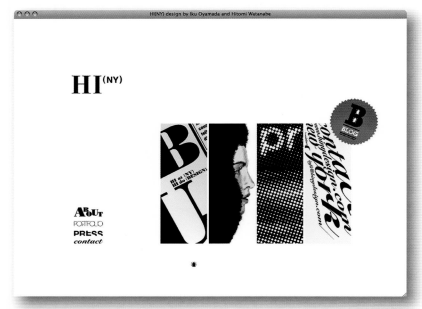

www.hinydesign.com
D: hi(ny)
P: hi(ny) M: info@hinydesign.com

www.rex.b92.net/bc/index.html
D: olivera batajic C: olivera batajic
P: cultural center rex M: oliveti@gmail.com

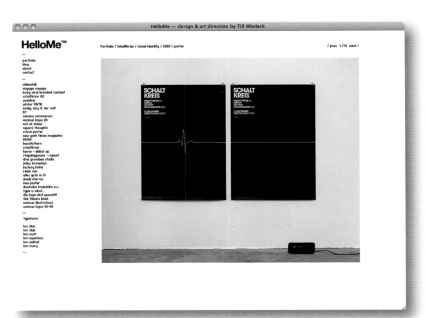

helloyou.de
D: till wiedeck C: malte müller
P: till wiedeck M: hello@tillwiedeck.com

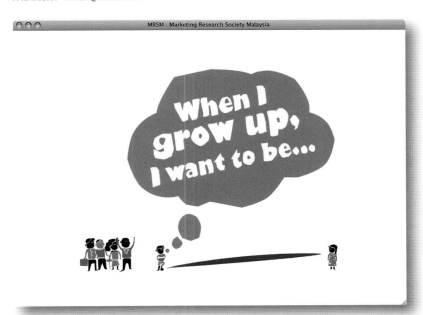

www.mrsm.org.my
D: john woo choong weng C: banirulanuar bin abd. latif
P: lisette scheer M: dropby@lascheersco.com

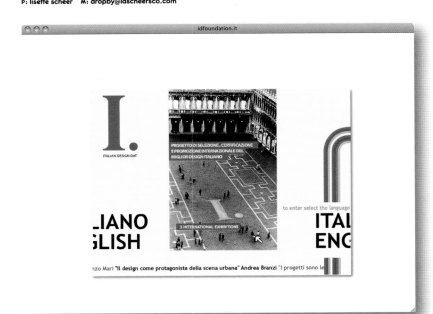

www.idfoundation.it
D: .claudioviscardi C: .claudioviscardi
P: idfoundation M: info@claudioviscardi.it

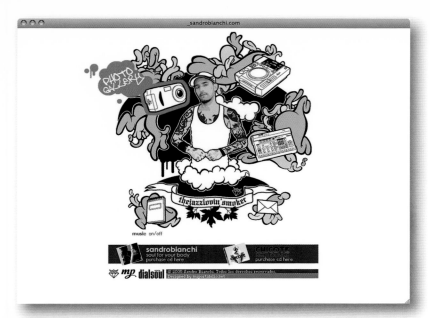

www.sandrobianchi.com

D: pep sanabra, grooph C: pep sanabra
P: pep sanabra M: grooph@gmail.com

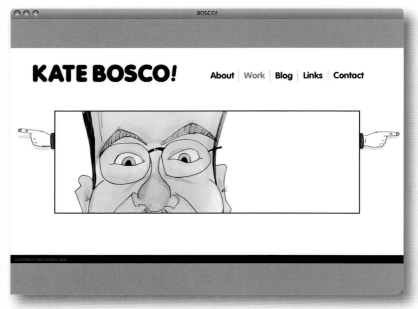

www.kboscodesign.com

D: kate bosco C: kate bosco
P: kate bosco M: kate@kboscodesign.com

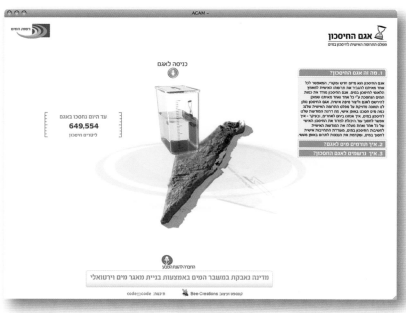

www.agam-israel.co.il

D: bee-creations, eran bacharach, ido zemach C: codemcode
P: israeli water authority M: eran@bee-creations.com

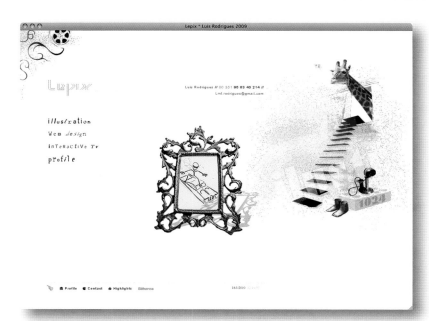

www.designexquis.com/luis
D: lepix C: lepix
P: lepix M: lmf.rodrigues@gmail.com

www.rgacom.com.br
D: maurício nunes C: joão guilherme, andré burgos
M: felipe@cappen.com

www.bartrainingcenter.com
D: 2fresh C: 2fresh
P: 2fresh M: contact@2fresh.com

www.akzente-raumbegruenung.de

D: petra suchard C: gestalterhuette.de
P: suchard design M: info@suchard-design.de

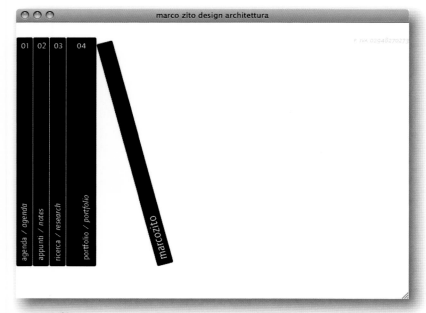

www.raumfabrikweil.de

D: laurent vonach C: pascal antoinet
P: laurent vonach M: contact@expresso-studio.com

www.marcozito.com

D: gianfranco vasselli, marco zito C: gianfranco vasselli, matteo saran
P: studio marco zito M: mail@marcozito.com

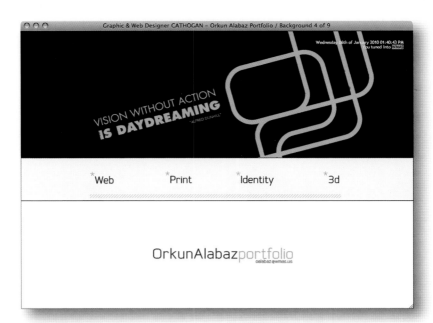

www.wmas.us
D: orkun alabaz C: orkun alabaz
P: orkun alabaz M: oalabaz@wmas.us

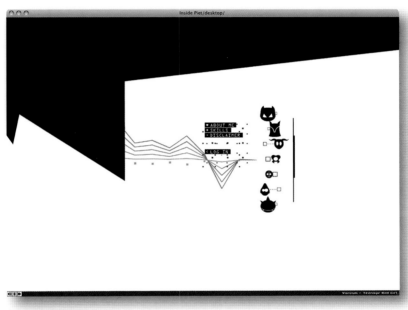

www.insidepiet.com
D: piet dewijngaert C: piet dewijngaert
M: piet.dewijngaert@gmail.com

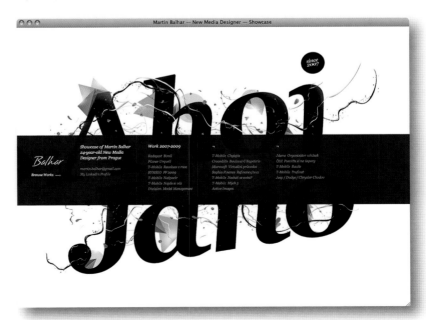

www.balhar.com
D: martin balhar
M: martin.balhar@gmail.com

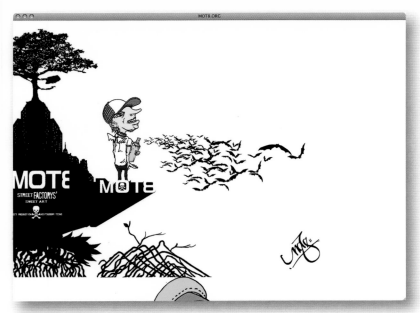

www.mot8.org

D: giuseppe caruso C: renato caruso
P: giuseppe caruso M: info@lab77.it

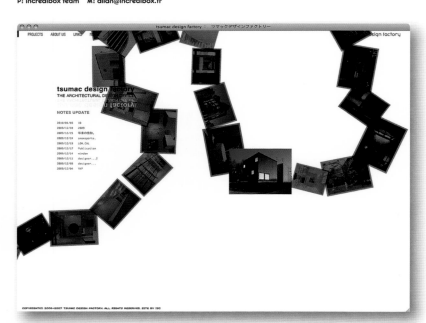

www.incredibox.fr

D: allan durand, romain delambily, paul malburet C: allan durand
P: incrédibox team M: allan@incredibox.fr

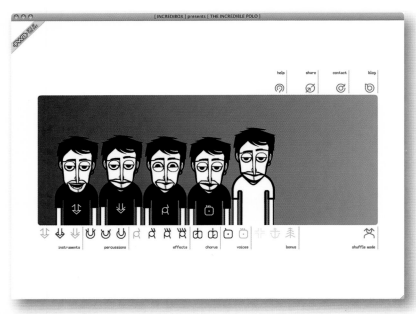

www.tsumac.jp

D: fumiaki hamagami, imaginary stroke, co. C: fumiaki hamagami, imaginary stroke, co.
P: shinji tsumakura, tsumac design factory M: isc@imaginarystroke.com

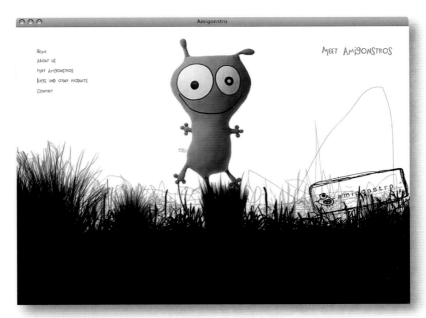

www.amigonstro.com

D: patricia roque C: pedro coutinho
P: amigonstro M: patriciaroque.lopes@gmail.com

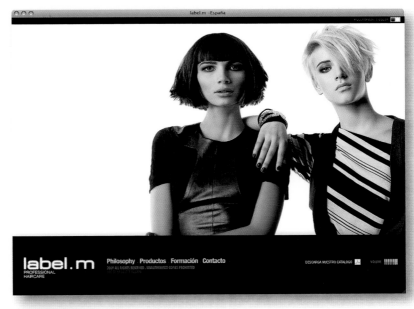

www.labelm.es

D: danilo marinaccio
P: label.m spain M: info@labelm.es

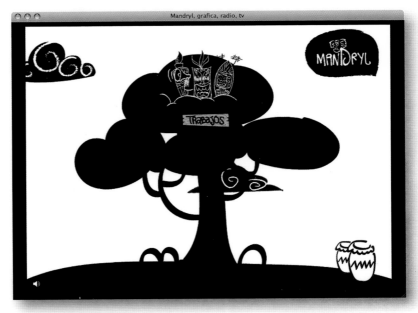

www.mandryl.cl

D: alexis avalos C: alvaro parrague ayala
P: alvaro parrague ayala M: alvaro@ddw.cl

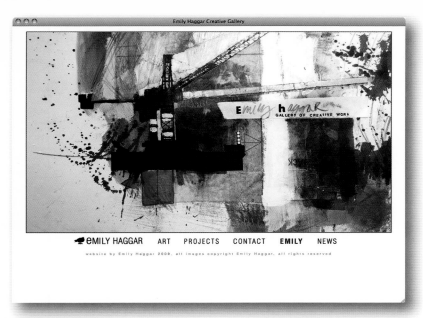

www.emilyhaggar.com
D: emily haggar C: emily haggar
P: emily haggar M: emily@emilyhaggar.com

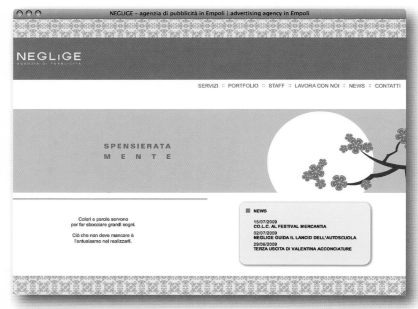

www.neglige.it
D: lucia polini C: francesco porrà
P: massimo mecca M: info@neglige.it

www.jamel.pl
D: jamel interactive C: jamel interactive
P: jamel interactive M: biuro@jamel.pl

www.dextrum.es
D: jordi monedero gonzález, karnival creative management C: jesús monedero gonzález
P: dextrum M: info@karnival.es

www.visualbytes.gr
D: nontas ravazoulas C: nontas ravazoulas
P: nontas ravazoulas M: info@cubeweb.gr

www.nugg.ad/en/products/flash.html
D: joern alraun, franka futterlieb C: joern alraun, franka futterlieb
P: nugg.ad ag M: reception@urbn.de

www.kontoreins.com

D: jan persiel C: kontor eins digital
P: kontor eins digital M: info@kontoreins.com

www.beb-deum.com

D: agnès balavoine
P: beb-deum M: contact@st-xix.com

www.emmeffeonline.it

D: emanuele truffa C: emanuele truffa
P: emmeffe M: et@ensof.it

www.sambroadbent.co.uk
D: sam broadbent C: sam broadbent
M: sam@sambroadbent.co.uk

www.hellozeto.com
D: hellozeto, jong hyuk lee C: jong hyuk lee
P: hellozeto! M: hello@hellozeto.com

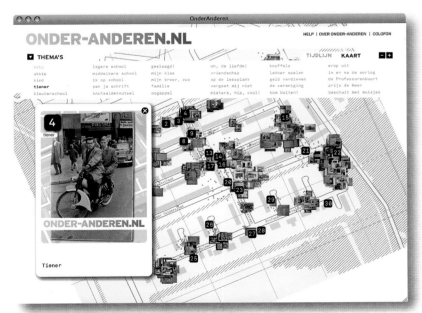

www.onder-anderen.nl
D: richard vijgen, thomas kopperschlaeger C: richard vijgen
P: huijbers en agelink M: mail@richardvijgen.nl

www.loadingdesign.net
D: nelson caldeira, nuno carvalho, diana romão C: loading ideas
P: loading ideas M: geral@loadingdesign.net

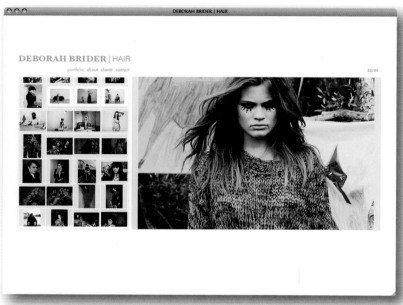

www.deborahbrider.com
D: pierre vincent C: pierre vincent
P: deborah brider M: mail@byvincent.com

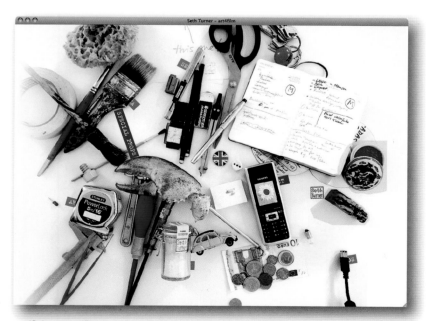

www.sethturner.de
D: eddy salzmann, uniqrn.com C: eddy salzmann, uniqrn.com
P: seth turner M: e@uniqrn.com

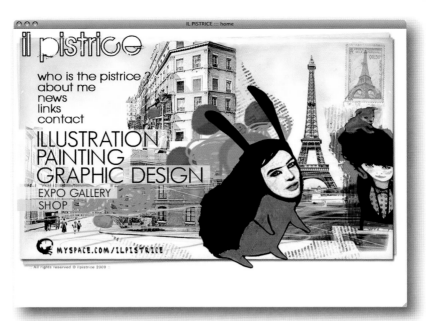

www.ilpistrice.com

D: francesca protopapa C: francesca protopapa
P: francesca protopapa M: ilpistrice@gmail.com

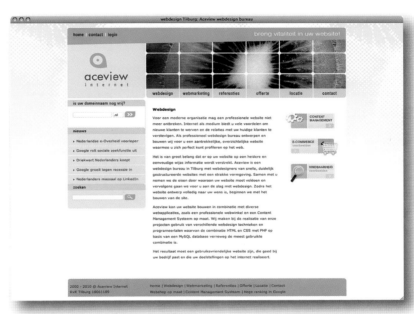

www.aceview.nl

D: bas van der schoot C: sander baas
P: roy van lieshout M: info@aceview.nl

www.lab-au.com

D: lab[au] C: lab[au]
P: lab[au] M: lab-au@lab-au.com

67

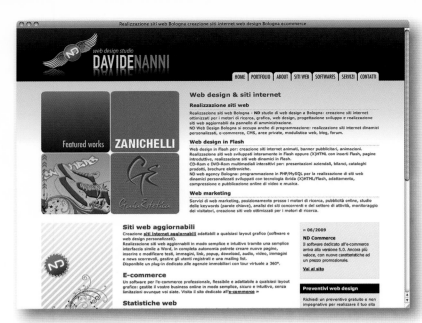

www.davidenanni.com
D: davide nanni C: davide nanni
P: davide nanni M: info@davidenanni.com

www.lafactoriagrafica.com
D: gontzal esteban C: gontzal esteban
P: la factoría gráfica M: info@lafactoriagrafica.com

www.pugcreative.com
D: danyelle parke
P: danyelle parke M: info@pugcreative.com

www.irenececile.com

D: irene cécile C: irene cécile

P: irene cécile M: irenececile@gmail.com

www.natxomartinez.com

D: natxo martínez ballesteros C: natxo martínez ballesteros

P: natxo martínez M: nacxo@yahoo.com

www.suelen.org

D: suelen C: factoria norte

M: ruben@factorianorte.com

www.aemde.ch

D: michael dornbierer C: michael dornbierer
P: aemde photography M: info@aemde.ch

www.bigbossstudio.com

D: christophe starace C: eric di filippo
P: eric di filippo M: contact@bigbossstudio.com

www.magneticfotostudio.com

D: luca de bellis C: luca de bellis
P: luca de bellis M: info@magneticfotostudio.com

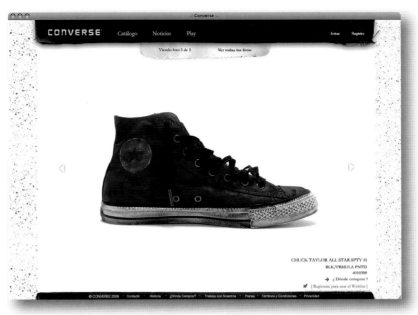

www.converse.es
D: on click creative studio C: on click creative studio
P: converse M: info@onclick.es

www.loudegg.com
D: joe maracic C: joe maracic
P: loudegg M: joe@loudegg.com

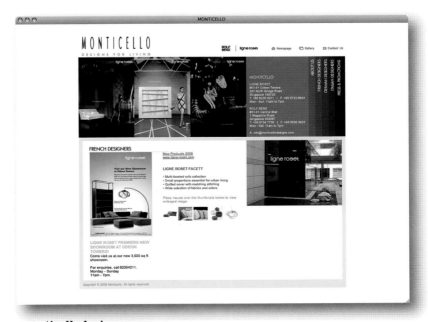

www.monticellodesigns.com
D: adrian wee, vi ee lau, vinz tay C: flava design
P: monticello M: enquire@flava.sg

www.lnfdesign.com
D: you, chang jae
M: gta18@naver.com

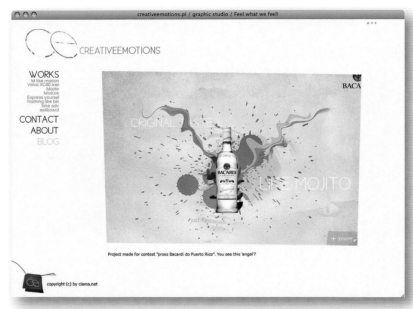

creativeemotions.pl
D: kamil grajda C: kamil grajda
P: ce M: kamil@ciama.net

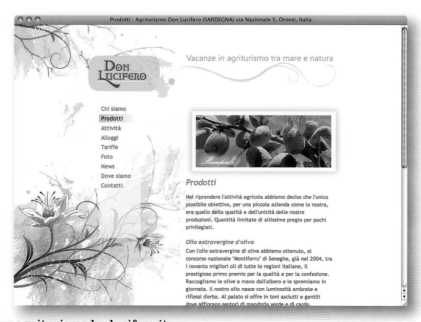

www.agriturismodonlucifero.it
D: stefania boiano C: marco sors, giuliano gaia
M: marketing@invisiblestudio.it

**Push&Destroy
Push&Create!!**

2009
Blog
Contact
Shop
2009.pdf

www.pushcollection.com
D: sergio gómez caballero
P: www.pushcollection.com M: info@pushcollection.com

UArchitects is fascinated by the interplay of different levels of scale and thinking : the scale of the city and that of mankind; thinking in abstraction and thinking in tangibility. The cohesion of these levels is not to be found in one compulsive, dogmatic theme but rather in different concepts and concrete projects. The exploring attitude is not to find definitive answers but to raise questions in order to continue the reflective working method with regard to the assignment and to UArchitects

State Secretary Albayrak opens new building of UArchitects in the Maasberg Overloon

UArchitects | Klokgebouw 233 5617 AC Eindhoven | the Netherlands E: info@uarchitects.com | P: +31 40 2366535

www.uarchitects.com
D: daan dijkmeijer, dijkmeijer visuele communicatie C: rian rietveld, rrwd web development
P: uarchitects eindhoven M: info@uarchitects.com

www.stefanbauerdesign.com
D: stefan bauer C: stefan bauer
P: stefan bauer M: stef.bauer@gmx.net

SARAH BERNHARD
Photography

— traffic

← 17 / 21 →

Information
Imprint

sarahbernhard.de
D: malte müller C: malte müller
P: sarah bernhard M: ultraviolett82@gmail.com

anothergraph

CONTACT US
tel 02 492 3093 . e-mail mgoo@anothergraph.com

Portfolio

the
road a
-head

Dong-A University Brochure
+DETAIL VIEW 4/51

ON GOING **PROJECT** anothergraph.com open

COMPANY INFO DOWNLOAD

www.anothergraph.com
D: anothergraph C: anothergraph
P: anothergraph M: mgoo@anothergraph.com

MENTAL RECORDS

Bild | 1 | 2 **BRIAN USER'S EVOLUTION,** Naturhistorisches Museum, Berlin 1999
Das computerbearbeitete Video entstand zunächst als »Brain User's Guide« im Kontext
der Arbeit »Mindmapping«. Unterlegt mit Musik und Stimme sowie mit eingeblendeten
Merksätzen zitiert die Selbstperformance mit Datenhelmattrappe populäre Konzepte
zum Hirntraining und wendet sich als Anleitung zum »Schöner Denken« direkt an den... **Seite** | 1 | 2

silvia beck HOME WORK—RELATED INFO

QUARTIER | 200X | MANAGEMENT OF VISIONS | DIE VIOLA-KAMP-STORY | ARSENAL | GLOBAL LOOP VERS.2 | WANDLER |
WORLDWIDE | PHANTOM FLASH | GLOBAL LOOP VERS.1 | SERVICE BLOCK | **BRIAN USER'S EVOLUTION** | MINDMAPPING |
EXTENDER |

silviabeck.de
D: bruno dorn C: marit schreiber-bartsch
M: info@brunodorn.de

www.halilakdeniz.com
D: omer balyali, omer durmaz
P: prof. dr. halil akdeniz M: omerbalyali@gmail.com

www.coaching-wegen.com
D: brennpunkt design, marlon gengler C: brennpunkt design
P: stanka wegen // ctv M: mail@brennpunkt-design.com

www.outsideincompany.com
D: danny burnside C: chris sees, george medve
P: adam pilarski, stella jordan M: info@sqcircle.com

www.barbarasobanska.pl

D: barbara sobańska C: barbara sobańska
P: barbara sobańska M: barbara.sobanska@onet.pl

www.steirischerherbst.at

D: erwin wagner, wukonig.com C: matthias koplenig, wukonig.com
P: steirischer herbst - international festival of contemporary art M: office@wukonig.com

www.ihookcreative.com

D: ihook creative C: tarik assagai
P: ihook creative M: info@ihookcreative.com

www.henricsuuronen.com

D: henric suuronen C: henric suuronen
M: info@henricsuuronen.com

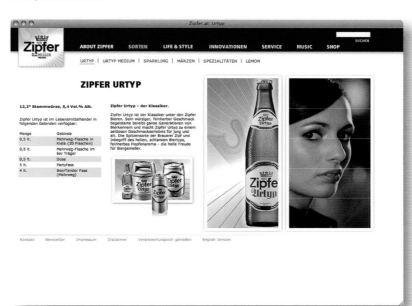

www.zipfer.at/index.php?id=167

D: marko malle C: nullstar
M: vienna@draftfcb.com

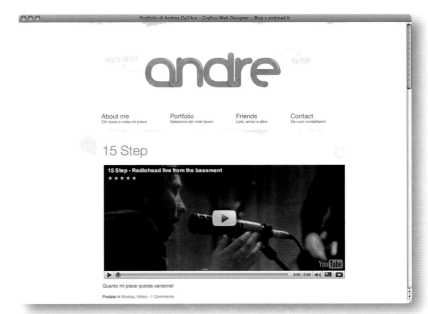

www.andread.it

D: andrea dall'ara C: andrea dall'ara
P: andrea dall'ara M: andread@andread.it

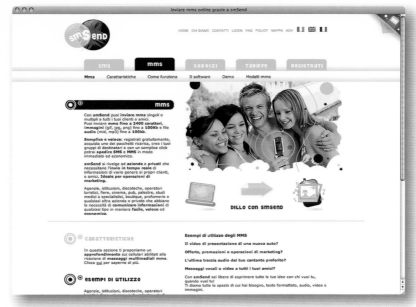

www.smsend.it

D: dunp s.c.p.l. C: dunp s.c.p.l.
P: dunp s.c.p.l. M: info@dunp.it

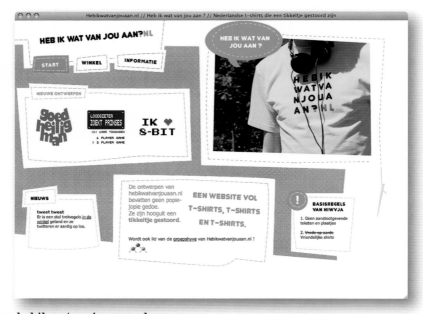

www.hebikwatvanjouaan.nl

D: erik van kranenburg C: keloid media
P: hebikwatvanjouaan.nl M: erik@keloidmedia.nl

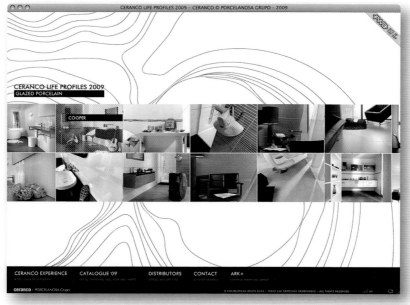

www.ceranco.com

D: pixelinglife C: pixelinglife
P: pixelinglife M: info@pixelinglife.com

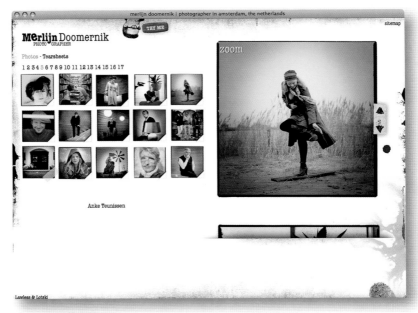

www.doomernik.com

D: lawless & lotski C: lawless & lotski

P: merlijn doomernik M: info@lawlesslotski.nl

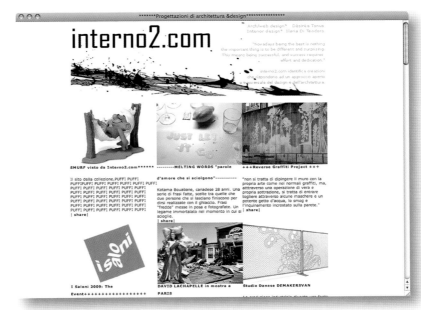

www.interno2.com

D: dèsirèe tonus C: dèsirèe tonus

P: dèsirèe tonus architect M: dtonus@tiscali.it

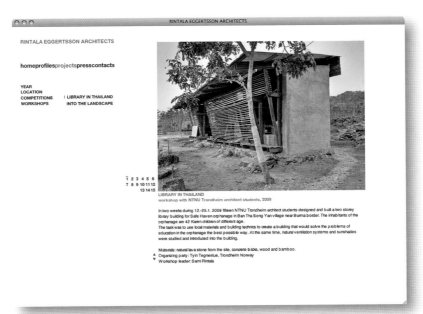

www.rintalaeggertsson.com

D: paolo dell'elce C: paolo dell'elce

P: sami rintala, dagur eggertsson M: paolo@paolodellelce.com

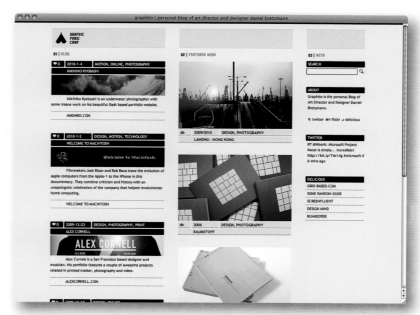

www.graphito.net
D: daniel bretzmann C: daniel bretzmann
P: graphito.net M: input@eyegix.com

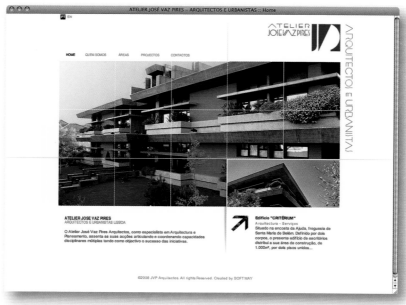

www.jvparquitectos.pt
D: softway.net C: softway.net
P: atelier josé vaz pires M: softway@softway.pt

www.karencatering.com
D: santi sallés
M: info@santisalles.com

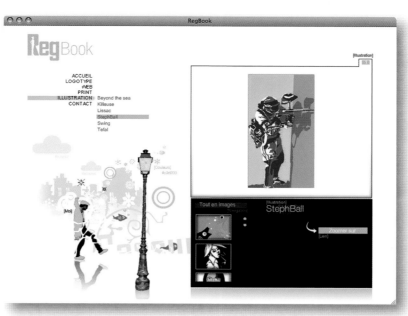

www.reg-book.com
D: réginald cassius C: réginald cassius
P: réginald cassius M: regcassius@gmail.com

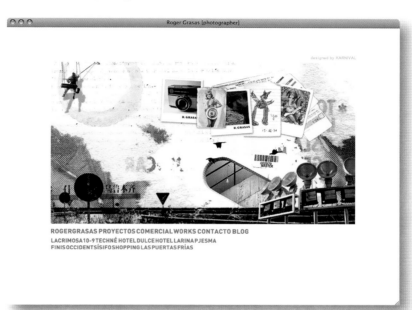

www.rogergrasas.com
D: jordi monedero gonzález, karnival creative management C: jordi monedero gonzález
P: roger grasas [photographer] M: info@karnival.es

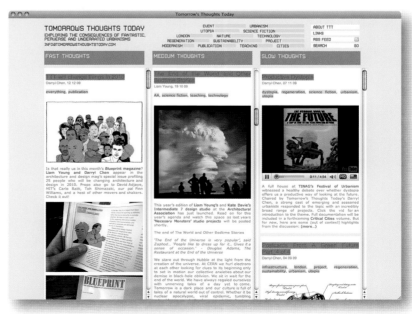

www.tomorrowsthoughtstoday.com
D: liam young, darryl chen, adan macintosh C: adan macintosh
P: liam young, darryl chen M: info@tomorrowsthoughtstoday.com

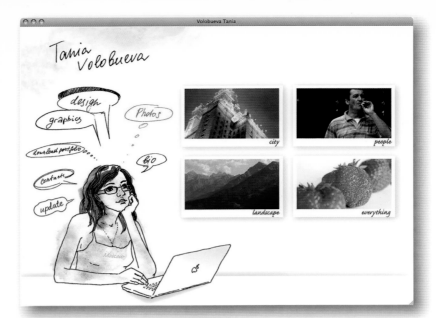

www.taniavolobueva.ru

D: volobueva tania C: olga shletser

M: tanka.volobueva@gmail.com

www.olicole.com

D: oli cole C: oli cole

P: oli cole M: oli@olicole.com

www.baldonsera.com

D: guillermo arroyo C: www.cafecontinuo.com

P: bal d'onsera M: info@cafecontinuo.com

www.nunoguitana.com
D: nuno guitana **C:** nuno guitana
P: nuno guitana **M:** nuno_guitana@sapo.pt

www.tensheep.nl
D: ten sheep **C:** ten sheep
P: ten sheep **M:** info@tensheep.nl

digitalnusantara.com.my
D: muid latif **C:** muid latif, ariel flesler
P: digital nusantara **M:** communicate@digitalnusantara.com.my

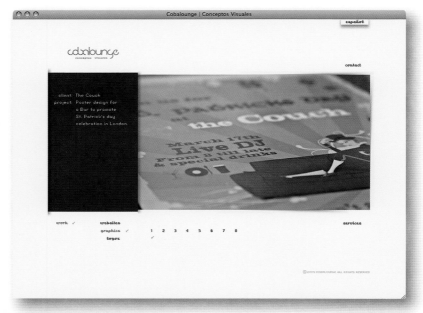

www.mullervantol.nl
D: florian mewes C: vincent de waal
P: florian mewes M: mail@gotoflo.eu

www.barcenayzufiaur.com
D: gontzal esteban C: maximiliano eguaras
P: barcena y zufiaur arquitectos M: info@lafactoriagrafica.com

www.cobalounge.com
D: gabriel gonzalez C: gabriel gonzalez
P: www.cobalounge.com M: gabriel@cobalounge.com

www.adrianopace.it
D: **giuseppe caruso** C: **renato caruso**
P: **giuseppe caruso** M: **info@lab77.it**

www.r-art.dk
D: **kaare roager** C: **kaare roager**
P: **kaare roager** M: **kaare@r-art.dk**

www.franziskadonath.com
D: **filippo nugara** C: **filippo nugara**
P: **franziska donath** M: **info@filipponugara.com**

devonsproule.com

D: jpd studio C: jpd studio

P: devon sproule M: design@jpdstudio.com

www.samueleschiavo.it

D: samuele schiavo C: samuele schiavo

P: samdesign M: info@samueleschiavo.it

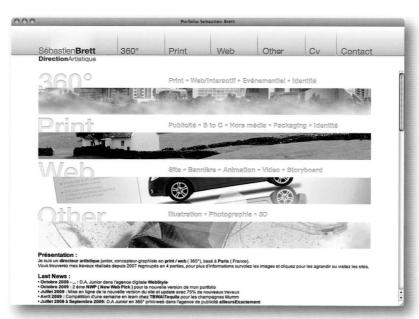

www.sebastienbrett.com

D: sebastien brett C: sebastien brett

M: sebastien.brett@gmail.com

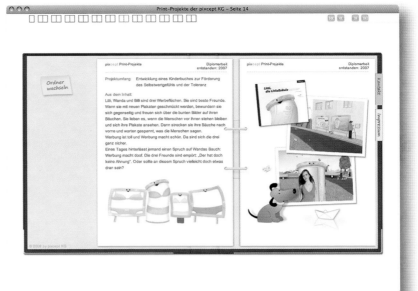

www.pixcept.de
D: kerstin burkard C: marius cramer
M: info@pixcept.de

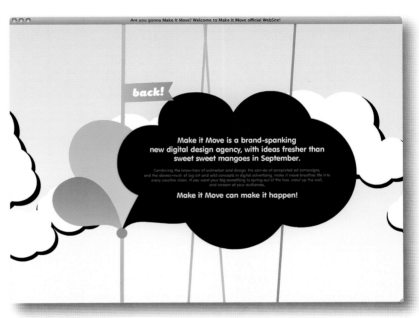

www.makeitmove.com.au
D: make it move, webwork studio
P: make it move M: shoot@makeitmove.com.au

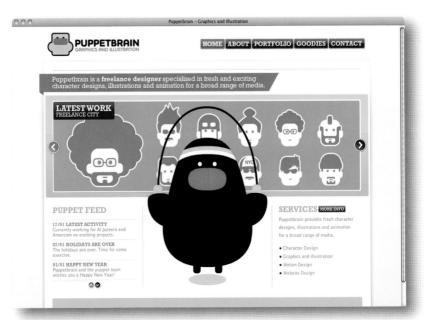

www.puppetbrain.com
D: benny chew, jenneke choe C: benny chew
P: jenneke choe M: info@puppetbrain.com

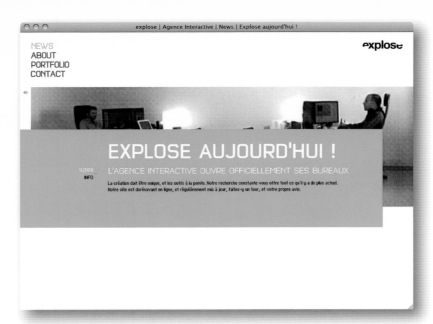

www.explose.lu

D: sli nourddine C: brisson romuald
M: info@explose.lu

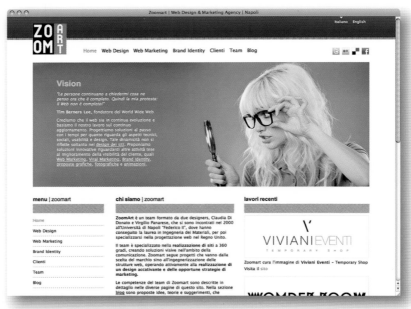

www.zoomart.net

D: virgilio panarese, claudia di donato C: virgilio panarese, claudia di donato
P: zoomart web design agency M: info@zoomart.net

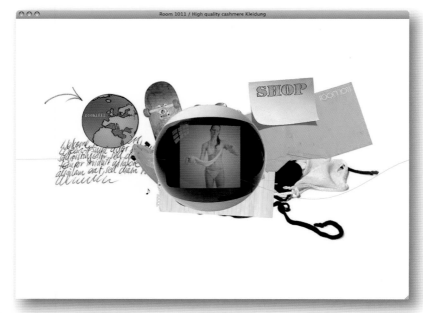

www.room1011.com

D: siteseeing interactive media, markus schaefer C: alexander feyerke
P: room 1011 M: info@siteseeing.de

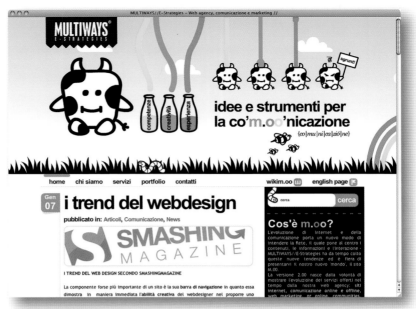

www.multiways.com

D: multiways//e-strategies C: multiways//e-strategies
P: multiways//e-strategies M: gruso69@multiways.com

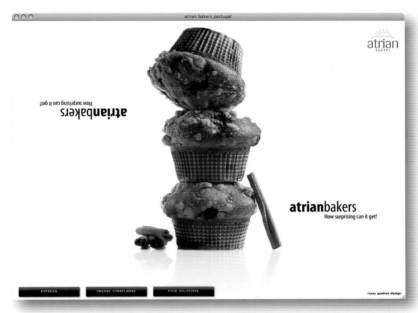

www.atrian.pt

D: nuno queirós
P: atrian bakers portugal M: nuno@nunoqueiros.com

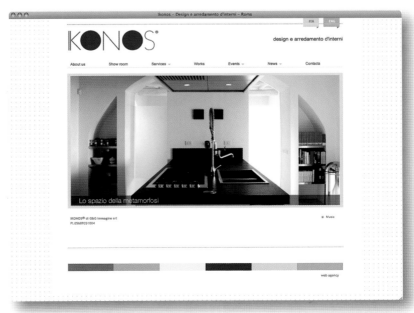

www.ikonos-design.com

D: gaia zuccaro C: gaia zuccaro
P: ikonos design, roma M: gaia.zuccaro@gmail.com

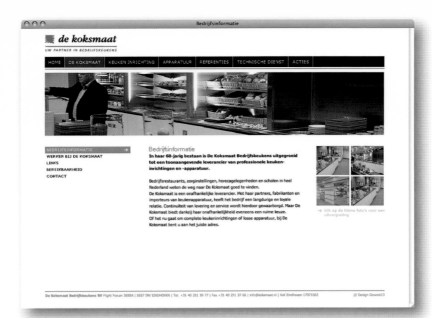

www.koksmaat.nl
D: tom eele, gewest13 C: gilles van den hoven
M: info@gewest13.nl

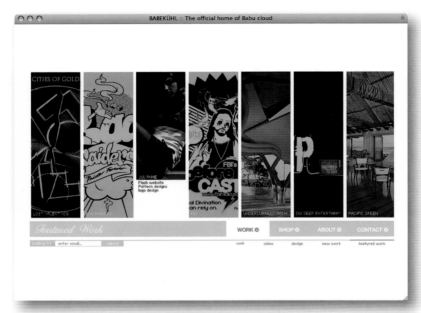

www.babekuhl.com
D: babekuhl
M: design@babekuhl.com

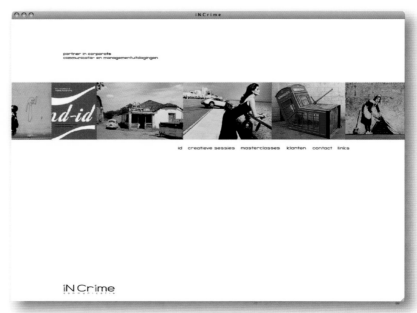

www.incrime.nl
D: elske de korver, peter bust C: elske de korver, peter bust
M: info@peterbust.nl

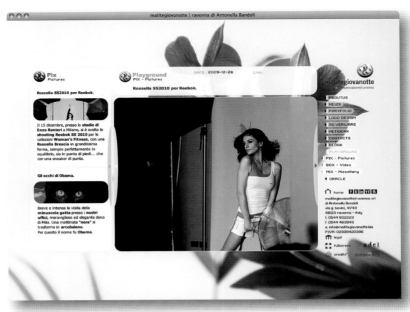

www.matitegiovanotte.biz
D: matitegiovanotte.ravenna, artedopera **C:** e-nica, melandri
P: matitegiovanotte.ravenna **M:** info@matitegiovanotte.biz

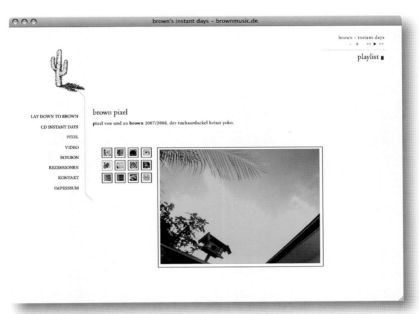

www.brownmusic.de
D: stefan hajduga **C:** oliver stradins
P: brown **M:** grafik@hajduga.de

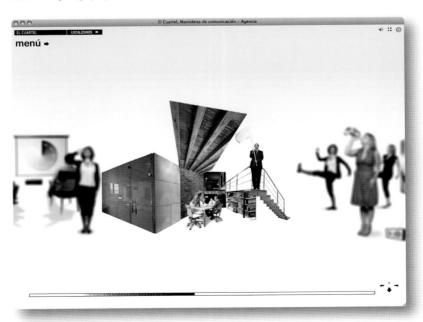

www.elcuartel.es
D: pilar ruiz, carmen frías **C:** oscar montañez
P: el cuartel **M:** info@elcuartel.es

www.vanessabenellimosell.com

D: ubyweb&multimedia C: ubyweb&multimedia
P: vanessa benelli mosell M: ubaldoponzio@ubyweb.com

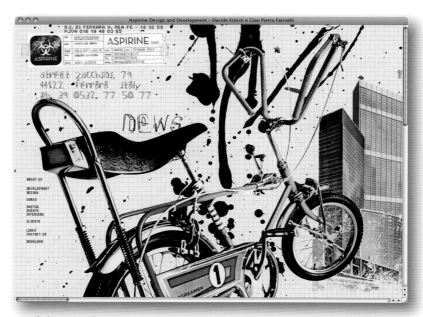

www.aspirine.co.uk

D: gian pietro farinelli, aspirine C: gian pietro farinelli, aspirine
P: aspirine M: pietro@aspirine.co.uk

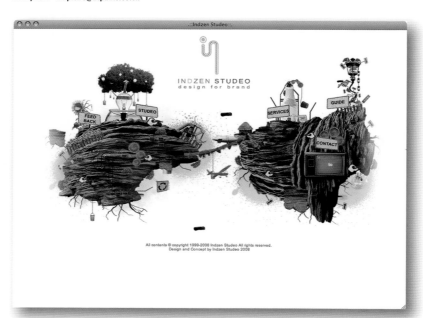

www.indzen.com

D: danny yeong, seven attach design lab C: danny yeong
P: indzen studeo M: danny@7attach.com

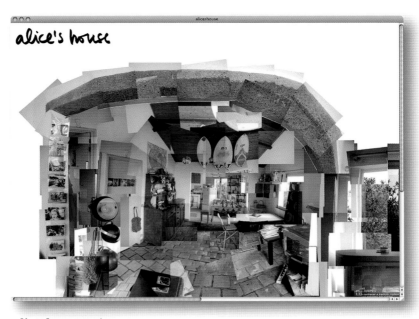

www.aliceshouse.net
D: júlia garcia, andré laranjinha
M: andre@aliceshouse.net, julia@aliceshouse.net

www.theminimart.com
D: marc hagan-guirey C: ben sharp, arthur tindsley, james wilson-jennings
M: info@theminimart.com

www.studio13.fr
D: gaëtan lebaron, romain portier C: gaëtan lebaron, romain portier
P: www.studio13.fr M: contact@studio13.fr

www.komodelar.es

D: probalear C: probalear
P: komodelar M: creativos@probalear.info

chrismiolla.com

D: chris miolla C: chris miolla
P: chris miolla M: info@chrismiolla.com

www.kevadamson.com

D: kev adamson C: kev adamson
P: kev adamson M: kev@kevadamson.com

www.pirolab.it
D: diego valobra C: diego valobra
M: diegovalobra@gmail.com

www.gary-web.com
D: gary paitre C: gary paitre
P: gary paitre M: info@gary-web.com

www.duelpurpose.com
D: brian simpson C: graph paper press
P: duel purpose M: brian@duelpurpose.com

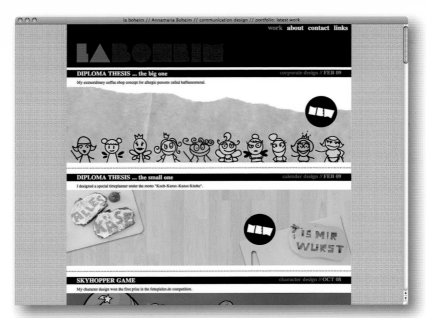

www.laboheim.com

D: annamaria boheim C: annamaria boheim
P: annamaria boheim M: vive@laboheim.com

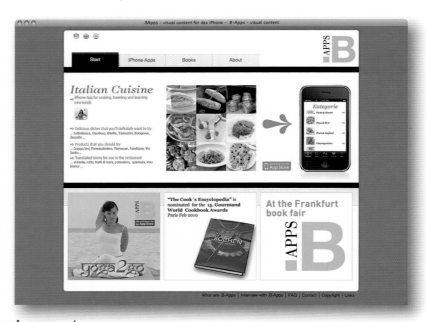

www.b-apps.net

D: sigurd buchberger C: sigurd buchberger
P: buenavista studio s.l. M: beer@buenavistastudio.com

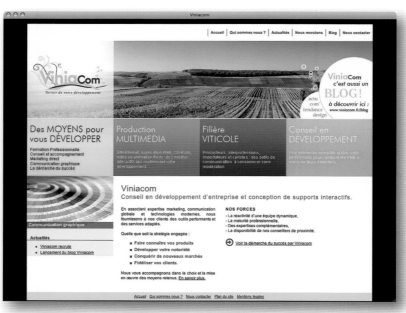

www.viniacom.fr

D: emilie policand, viniacom C: emilie policand, viniacom
P: viniacom M: emilie.policand@viniacom.fr

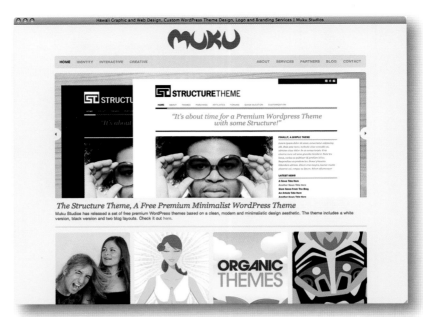

www.mukustudios.com

D: muku studios, david morgan C: muku studios
P: muku studios M: muku@mukustudios.com

paravelinc.com

D: paravel C: paravel
P: paravel M: trent@paravelinc.com

www.damaged-duchess.com

D: ana duarte C: indexhibit.org
P: damaged duchess M: info@damaged-duchess.com

www.capicoiadesign.com

D: mauro talamonti, capicoia C: francesco prosperi, | blank |
P: capicoia M: info@capicoiadesign.com

www.imjonas.com

D: jonas eriksson C: jonas eriksson
P: jonas eriksson M: hello@imjonas.com

www.sogam.ch

D: orane schick C: orane schick
P: orane M: orane.schick@gmail.com

un.titled.es
D: ricard rovira C: ricard rovira
M: un@titled.es

blog.joeldelane.com
D: joel delane C: joel delane
P: joel delane M: info@joeldelane.com

squarefactor.com
D: sean hartman, anthony delaura C: bill evans, shawn makinson, o'donnell
P: squarefactor M: info@squarefactor.com

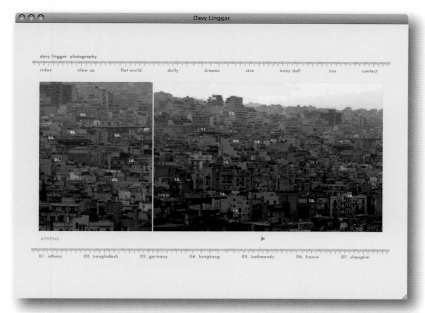

www.davylinggar.com

D: henricus linggawidjaja
M: henricus@artnivora.net

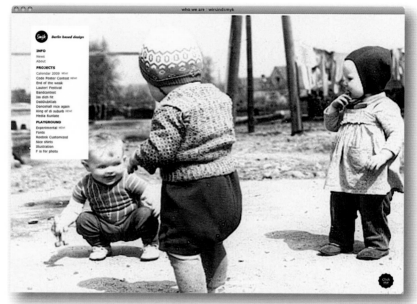

www.wirsindsmyk.de

D: stephan junghanns, kai nicolaides C: stephan junghanns
P: smyk M: studio@wirsindsmyk.de

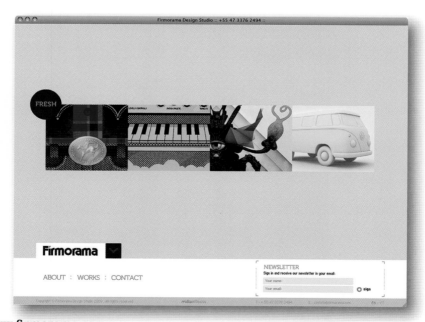

www.firmorama.com

D: firmorama design studio, jackson peixer, john karger C: midia effects, lucas motta
P: firmorama design studio M: contato@firmorama.com

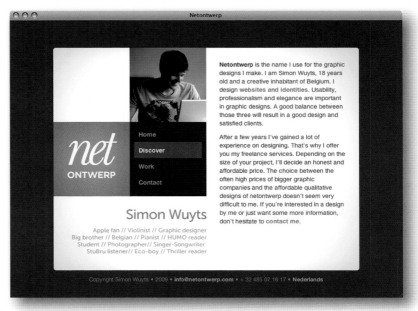

www.netontwerp.com/index_en.htm
D: simon wuyts
P: netontwerp M: info@netontwerp.com

www.atccompany.com
D: neon comunicazione, renato rossi C: neon comunicazione, silvano aldà
P: www.atccompany.com M: info@grupponeon.com

www.gettingcrazy.info
D: fabio paoleri C: fabio paoleri
M: fabio@gettingcrazy.info

www.ristorantefalalella.com
D: riccardo calce
P: ristorante falalella M: riccardo.calce@quidp.com

www.medium.com.ar
D: ana paula cascardo, mariano a. di camillo C: ana paula cascardo
P: medium M: info@medium.com.ar

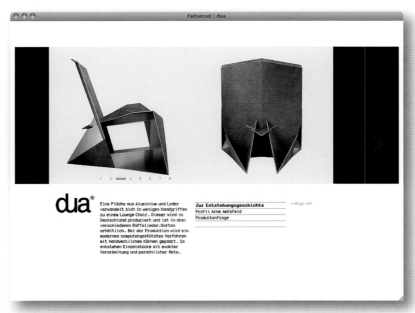

www.dua-collection.com
D: büro für grafik design, raffael stüken, tanja evers C: raffael stüken
P: dua collective. alexander esslinger M: post@raffaelstueken.de

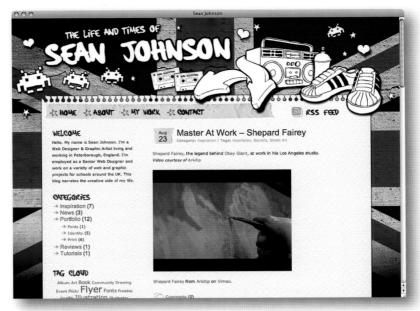

www.seanjohnson.net
D: sean johnson C: sean johnson
M: yo@seanjohnson.net

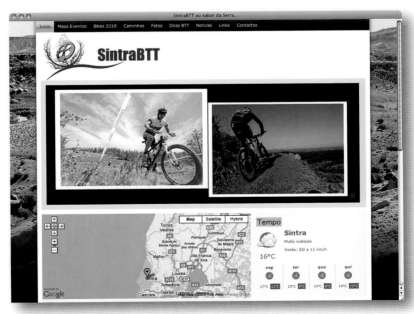

www.imchar.com
D: carlos moreno C: carlos moreno
P: i'm char M: carlosmorenoruiz@gmail.com

WWW.SintraBTT.com
D: rui freitas, rui freitas C: rui freitas, rui freitas
P: olasweb.net M: ruimiguelfreitas@gmail.com

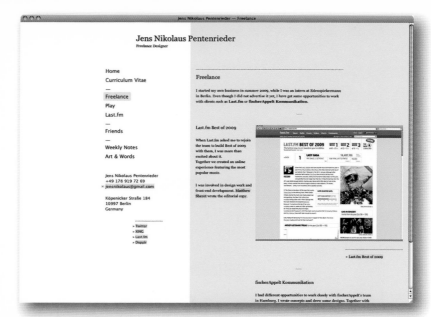

www.jensnikolaus.co.uk

D: jens nikolaus pentenrieder C: jens nikolaus pentenrieder
M: jensnikolaus@gmail.com

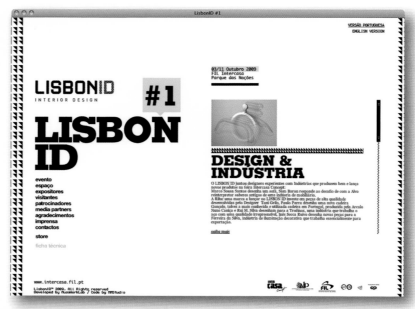

www.lisbonid.com

D: musaworklab C: mmstudio
P: lisbon id M: info@musaworklab.com

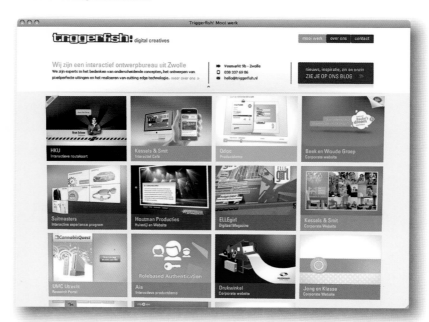

www.triggerfish.nl

D: sander van den dries C: peter coolen
P: triggerfish! digital creatives M: hello@triggerfish.nl

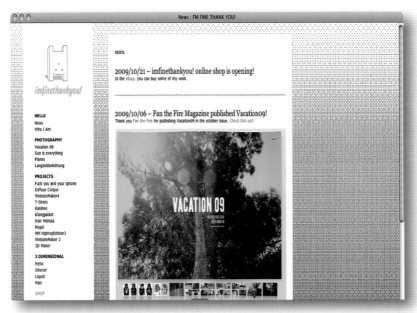

www.imfinethankyou.de
D: hüseyin yilmaz C: hüseyin yilmaz
P: imfinethankyou M: h.yil.maz@hotmail.de

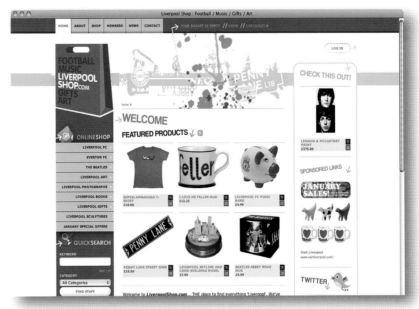

www.liverpoolshop.com
D: kev adamson C: graham davies
P: peter M: info@liverpoolshop.com

www.sjvonline.nl
D: sietse-jan visser C: sietse-jan visser
P: sietse-jan visser M: sietse_visser@live.com

inexor.se
D: pierre vanderpol, inexor C: emilia wällenhoff, inexor
P: inexor M: pierre@inexor.se

www.ahernlab.com
D: christina lauer C: christina lauer
P: christopher ahern M: chrisahern@gmail.com

www.ksqrdesign.com
D: ohsome inc, jen ohs, kim karon C: ethan kemp
P: ksqrdesign M: jen@ohsomeinc.com

www.pradal.ch
D: marc rinderknecht C: marc rinderknecht
P: ariana pradal M: mr@kobebeef.ch

www.tomscholte.com
D: fraai webdesign C: fraai webdesign
P: scholte personal branding M: info@fraai-webdesign.nl

www.seniorenwohnwelt-meine.de
D: saskia pierschek C: pierraadesign werbeagentur gmbh
P: seniorenwohnwelt meine M: pierschek@pierraa-design.de

www.spiritofecstasy.cc
D: spirit of ecstasy, arthur chantrenne, samuel bailhache C: spirit of ecstasy, guillaume maggi
P: spirit of ecstasy M: arthur@spiritofecstasy.cc

www.jmfernandez.de
D: kai d. thomas, josé m. fernández C: kai d. thomas
M: info@jmfernandez.de

www.lahuellasonora.com
D: avanti avanti C: quadrícula web + media
P: la huella sonora M: lhs@lahuellasonora.es

www.lauramujico.com
D: laura mujico C: laura mujico
M: laura.mujico@gmail.com

www.clinicario.pt
D: mário santos C: mário santos
P: slingshot M: mario.santos.17.04.81@gmail.com

www.krizalidstudio.com
D: jean-sébastien gardin C: jean-sébastien gardin
P: jean-sébastien gardin M: info@mypixelworld.be

www.respireliberdade.com.br
D: ricardo dexheimer, guilherme machiavelli C: matias causa
M: contato@dexdesign.com.br

www.mintsmind.com
D: artrivity disseny
P: mints mind M: info@artrivity.com

www.artist-in-design.de
D: anja tinter, artist in design C: anja tinter, artist in design
P: anja tinter M: info@artist-in-design.de

110

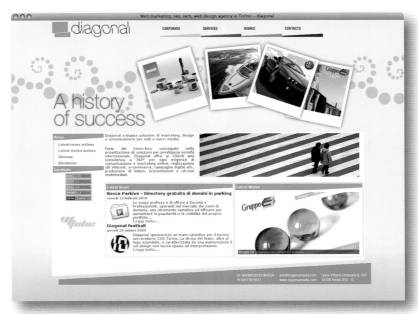

www.diagonalmedia.com
D: diagonal, marco reddavid C: diagonal, marco reddavid
P: diagonal M: info@diagonalmedia.com

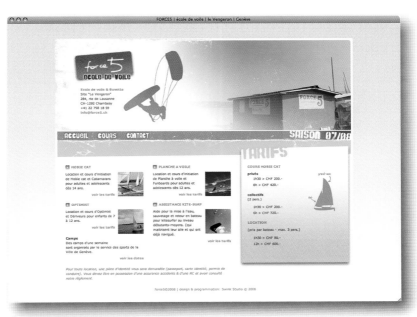

www.force5.ch
D: brian cuttaz C: christophe tournaire
P: force5 - ecole de voile M: info@swinkstudio.ch

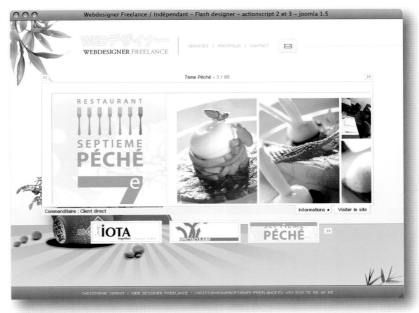

www.webdesigner-freelance.eu
D: christophe verdot C: christophe verdot
M: christophe@webdesigner-freelance.eu

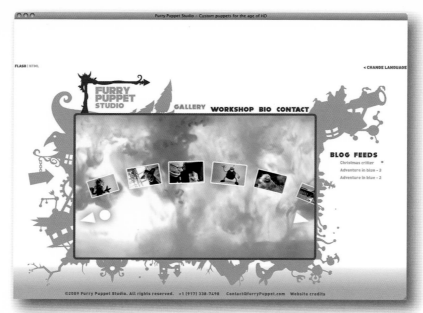

www.FurryPuppet.com

D: zack buchman C: arkadiusz milek
P: furry puppet studio M: zack@furrypuppet.com

www.iconestudio.es

D: juan carlos sierra martín C: juan carlos sierra martín
P: iconestudio M: info@iconestudio.es

www.creativeforward.com

D: creative forward C: creative forward
P: creative forward M: info@creativeforward.com

www.hoohaadesign.co.uk

D: hoohaadesign, james-lee rudd C: hoohaadesign, marilena rudd
P: hoohaadesign M: info@hoohaadesign.co.uk

www.net-e-be.fr

D: blaiseau laetitia C: blaiseau laetitia
P: orange M: blaiseau@gmail.com

midiaeffects.com.br

D: firmorama, john karger, jackson peixer C: midia effects, lucas motta
P: midia effects M: hello@midiaeffects.com.br

www.tienditaelencanto.cl

D: claudia valiente C: claudia valiente
P: tiendita taller el encanto M: voy@tienditaelencanto.cl

www.e2sproduccions.com

D: cristina chumillas C: cristina chumillas
P: els sala M: nuriasala@e2sproduccions.com

sushiandrobots.com

D: jina bolton C: jina bolton
P: jina bolton M: jina@sushiandrobots.com

www.ioadv.it

D: alessandro vigo C: fabio demarchi
P: io adv M: daniele@ioadv.it

www.thirdway.it

D: giovanni meroni C: giovanni meroni
P: thirdway M: giovanni@thirdway.it

www.verloopinnovatie.com

D: merijn klerx, blend & blink C: blend & blink
P: verloop innovatie M: studio@blendblink.nl

www.idity.nl

D: jeroen schoonderbeek C: jeroen schoonderbeek

P: idity M: jeroen@meeq.nl

www.afishinsea.co.uk

D: a fish in sea ltd C: a fish in sea ltd

P: michael mursell M: info@afishinsea.co.uk

www.fraai-webdesign.com

D: fraai webdesign C: fraai webdesign

P: fraai webdesign M: info@fraai-webdesign.nl

www.iconnewmedia.de

D: henning willecke, iconnewmedia C: tim-oliver schulz, iconnewmedia

P: iconnewmedia M: spiros.tzanetatos@iconnewmedia.de

www.glamupeventi.com

D: massimiliano autiello, francesca autiello C: massimiliano autiello, francesca autiello

P: glamup eventi M: info@autandaut.it

www.krailing.com

D: webwerk.ch C: webwerk.ch

P: tom krailing M: info@krailing.com

www.achtnullvier.com
D: 804© graphic design, helge rieder C: °visualcosmos, michael zirlewagen
P: 804© graphic design M: rieder@achtnullvier.com

www.studiobecom.net
D: studio graphique becom C: nathalie erb
P: studio graphique becom M: n.erb@studiobecom.net

www.philipprugger.at
D: philip prugger C: gecoweb graz, raphael copony, germann
P: philip prugger grafikdesign M: office@geco-web.at

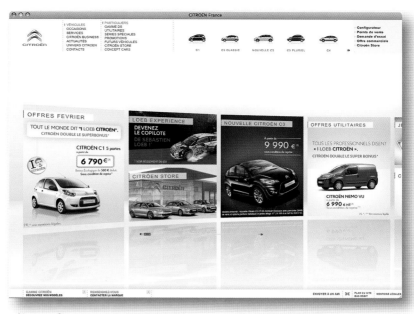

www.citroen.fr
D: dagobert C: dagobert
P: citroën M: guillaume.gartioux@dagobert.fr

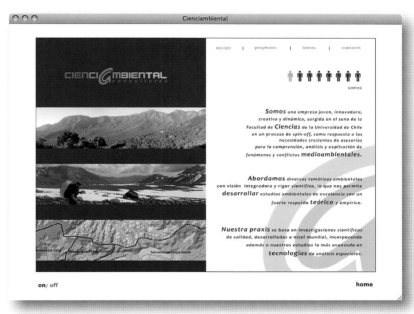

www.cienciambiental.cl
D: claudia valiente C: claudia valiente
P: cienciambiental M: contacto@cienciambiental.cl

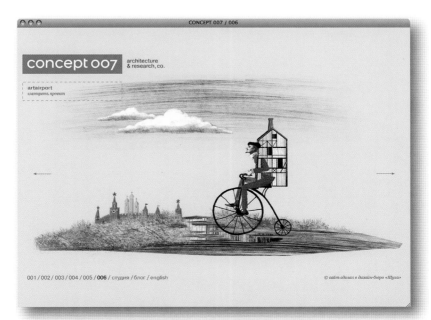

www.concept007.ru
D: dising studio "shuka" C: dising studio "shuka"
P: nikolay pereslegin, concept007 M: pereslegin@gmail.com

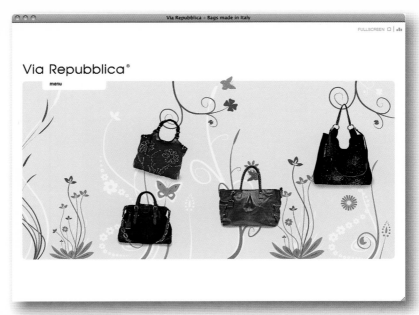

www.via-repubblica.com
D: alfdesign C: raffaele turci, laura libici
P: via repubblica / zanotti pelle srl M: info@alfdesign.com

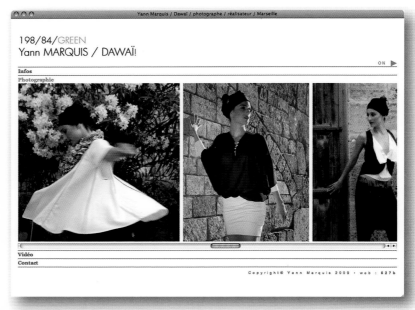

www.yannmarquis.com
D: 627b C: 627b
P: 627b M: contact@627b.com

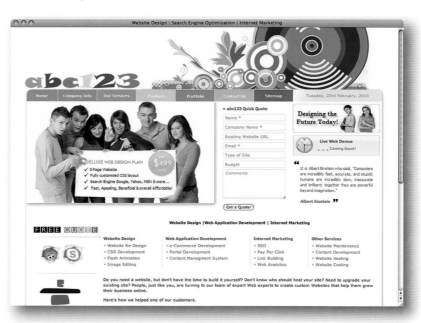

www.abc123webdesign.com
D: abc123 web design C: abc123 web design
P: rob cavalear M: robc@abc123webdesign.com

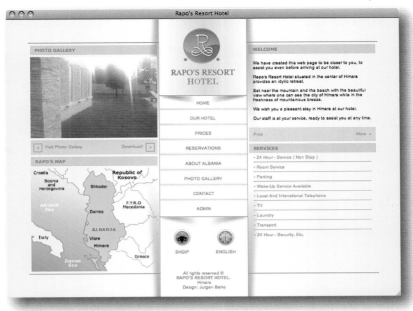

www.raposresorthotel.com
D: mediaplan studio C: jurgen baho
P: thanas rapo M: info@mediaplanstudio.com

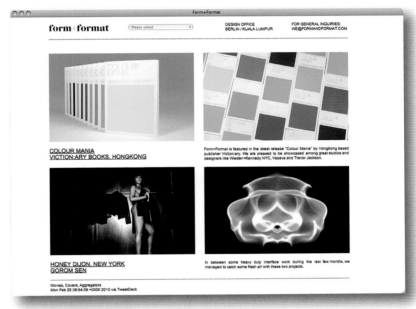

www.formandformat.com
D: form+format C: form+format
P: form+format M: we@formandformat.com

www.shoppingcuritiba.com.br
D: house cricket C: vega
M: bleite@housecricket.com.br

www.jamusmarquette.com

D: jamus marquette C: desmond morris
M: jamusss@gmail.com

www.totalcreation.nl

D: rob hamerlinck
P: total creation M: info@totalcreation.nl

www.seminaregraf.de

D: prof. johannes graf C: christoph kock
P: prof. johannes graf M: office@graf-design.de

www.weise.eu
D: querformat gmbh & co. kg C: querformat gmbh & co. kg
P: weise gmbh M: kontakt@querformat.info

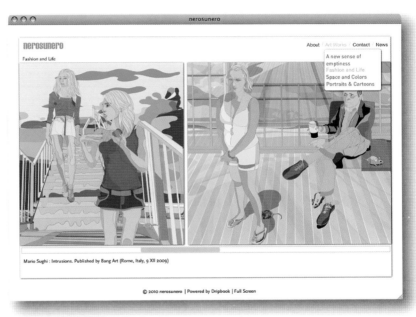

www.nerosunero.org
D: mario sughi C: mario sughi
P: mario sughi M: nerosunero@nerosunero.org

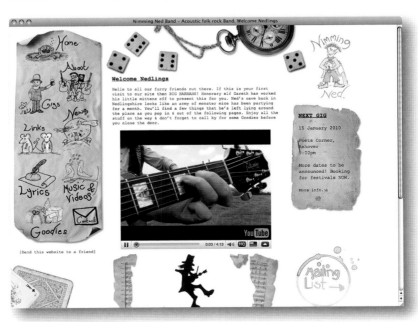

www.nimmingned.com
D: gareth roberts C: gareth roberts
P: nimming ned M: mail@rgdesign.co.uk

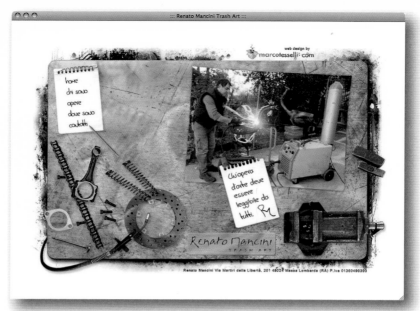

www.renatomancini.com

D: marco tesselli C: marco tesselli
P: renato mancini trash art M: info@marcotesselli.com

www.marialujan.es

D: maría luján C: luis luján, maría luján
P: maría luján M: maria@marialujan.es

www.davidhellmann.com

D: david hellmann C: david hellmann
P: david hellmann M: davidhellmann.com@gmail.com

www.rebers-pflug.de

D: anne schneewolf C: querformat gmbh & co. kg
P: reber's pflug M: kontakt@querformat.info

stilwerk-living.de

D: käthe schomburg C: christian nowak
P: stilwerk living gmbh M: kontakt@stilwerk-living.de

www.redkitecreative.com

D: debbie campbell C: debbie campbell
P: red kite creative M: dac@redkitecreative.com

www.dijonmusic.com
D: form+format C: form+format
P: honey dijon M: we@formandformat.com

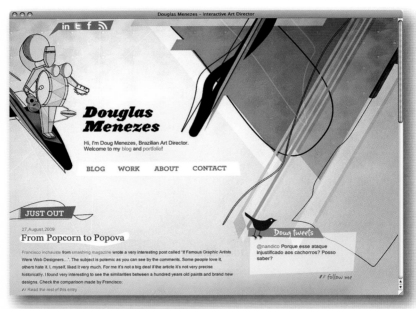

www.douglasmenezes.com
D: douglas menezes C: justcoded.com
P: douglas menezes M: dougmenezes@gmail.com

www.trippl-krippl.net
D: luboš král C: luboš král
P: trippl-krippl.net vjs M: email@krallik.com

www.dliteventi.it/dlite_eng.htm

D: lorenzo richiardi, elyron C: lorenzo richiardi
P: dlite eventi e congressi M: info@numeroquattro.com

www.damonbauer.com

D: damon bauer C: damon bauer
P: damon bauer M: damon@damonbauer.com

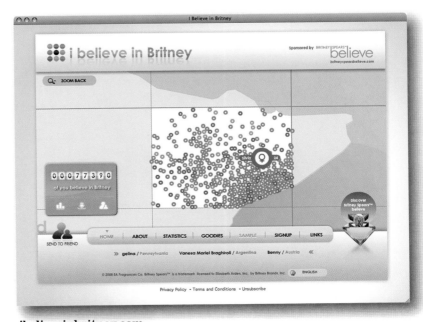

www.ibelieveinbritney.com

D: martial boulguy C: plot design
P: martial boulguy M: martial.boulguy@elizabetharden.com

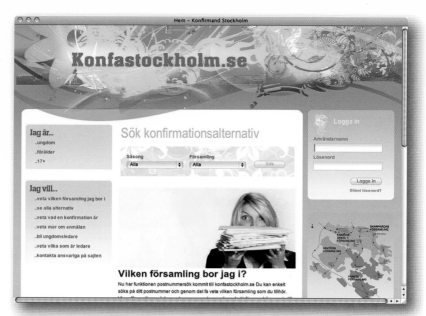

www.konfastockholm.se
D: pierre vanderpol, inexor C: emilia wällenhoff, inexor
P: konfa stockholm M: marcus.poll@svenskakyrkan.se

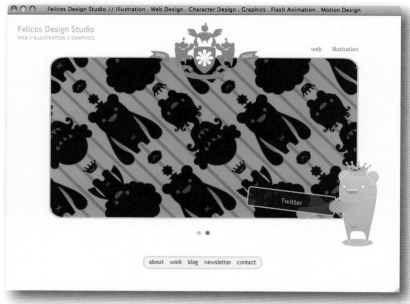

www.felicosdesign.com
D: felicos design studio C: felix wang
P: felicos design studio M: felix@felicosdesign.com

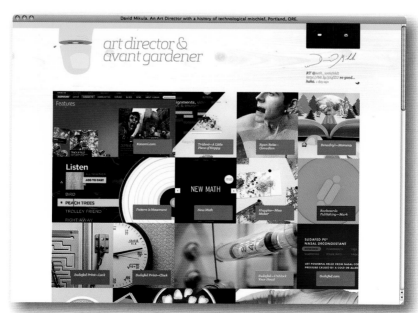

www.davidmikula.com
D: david mikula C: joshua tuscan
P: david mikula M: wtf@me.com

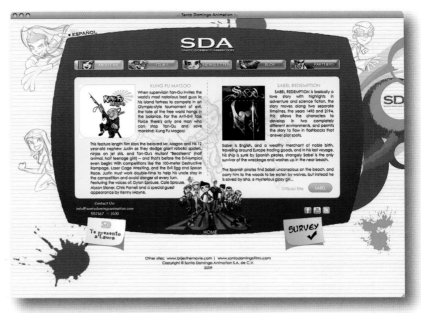

www.santodomingoanimation.com

D: alberto roser, arturo pardo C: arturo pardo, alberto roser
P: santo domingo animation M: web@santodomingoanimation.com

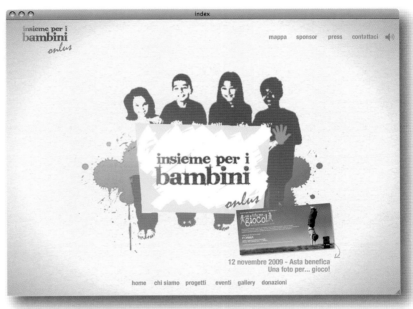

www.insiemeperibambini.it

D: mauela misani C: manuela misani
P: ulderico saverio M: info@icscomunicazione.it

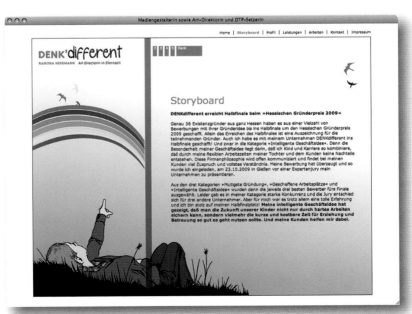

www.denkdifferent.de

D: ramona herrmann C: wacon internet gmbh
P: ramona herrmann M: info@denkdifferent.de

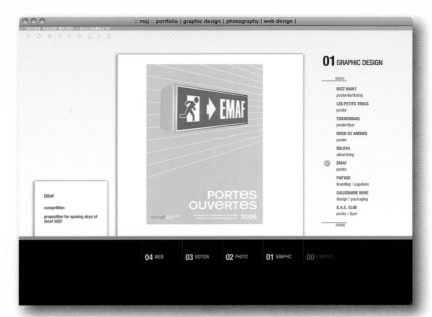

www.moj.ch

D: nadine mojado C: nadine mojado
P: nadine mojado M: hello@moj.ch

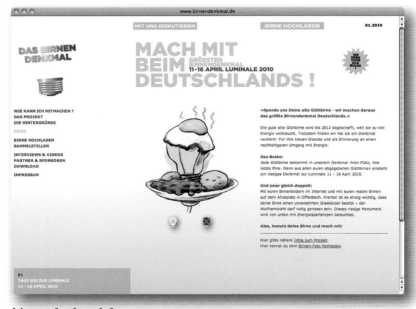

www.birnendenkmal.de

D: lutz jahnke, julia diehl, teresa habild C: lutz jahnke, michael schumann
P: luminale 2010, das birnendenkmal M: info@birnendenkmal.de

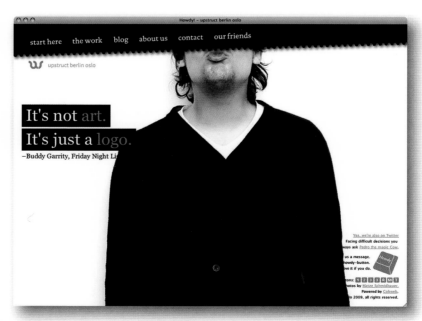

www.upstruct.com

D: upstruct berlin oslo as C: upstruct berlin oslo as
P: upstruct berlin oslo as M: anders@upstruct.com

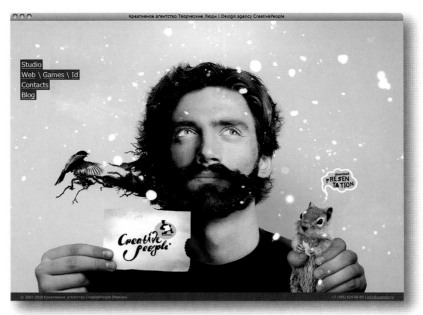

cpeople.ru

D: creativepeople C: creativepeople
P: creativepeople M: info@cpeople.ru

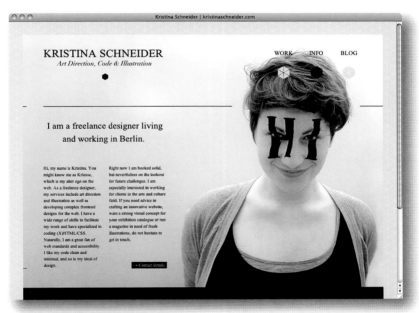

www.kristinaschneider.com

D: kristina schneider C: kristina schneider
P: kristina schneider M: mail@kristinaschneider.com

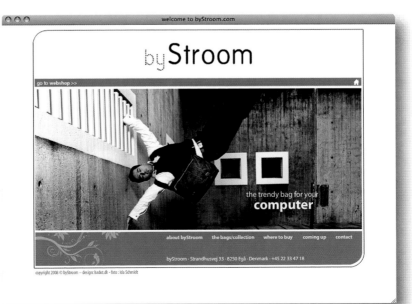

www.bystroom.com

D: dea sievertsen C: dea sievertsen
P: dea sievertsen M: info@bystroom.com

131

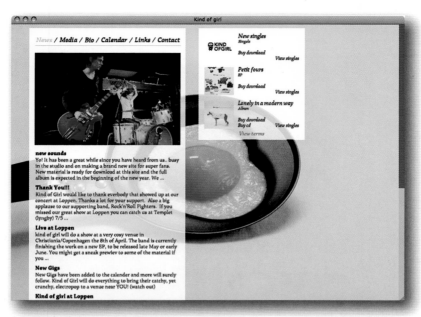

www.kind-of-girl.com

D: made in china, andrea noegaard, lars johansen C: stefan rasmussen, liquidize.dk
P: kind of girl, trak2r records M: jesper@trak2r.dk

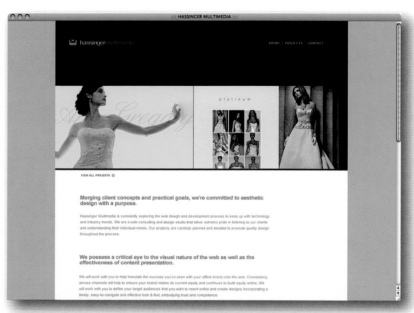

www.hassingermultimedia.com

D: alan hassinger C: alan hassinger
P: hassinger multimedia M: hassinger@roadlynx.net

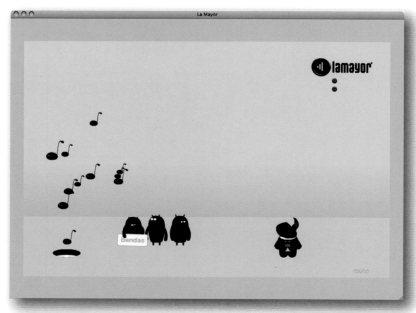

www.lamayor.com.uy

D: publicis impetu, joaquin guimaraens C: publicis impetu, cuartopunto
P: la mayor - audio production M: jguimaraens@publicisimpetu.com.uy

www.siturbandesign.com
D: velcrodesign C: velcrodesign
P: sit M: velcrodesign@velcrodesign.com

www.comediedesanges.com
D: bleuceladon, sylvie meunier C: aline romat
P: comédie des anges M: contact@bleuceladon.com

www.traverse-designedinfrance.fr
D: sylvie meunier, bleuceladon
P: traverse M: contact@bleuceladon.com

www.persiel.com

D: jan persiel C: jan persiel

P: persiel design M: studio@persiel.com

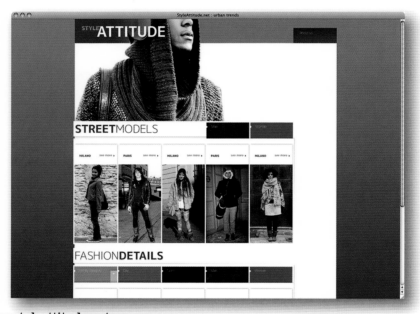

www.styleattitude.net

D: jan tonellato C: andrea paleni

P: ana ghisalberti M: anamaria.ghisalberti@styleattitude.net

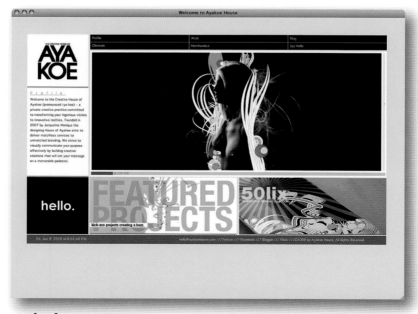

www.ayakoehouse.com

D: jacqueline monique C: jacqueline monique

P: creative house of ayakoe M: hello@ayakoehouse.com

essenza.bg

D: i-creativ studio C: i-creativ studio
P: essenza furniture & lighting M: office@i-creativ.net

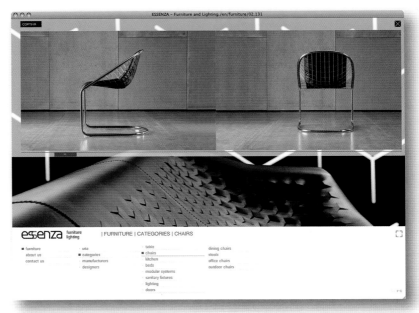

hauptschule.riegersburg.com

D: pamela kern C: framebox.at
P: hauptschule riegersburg M: pamela@framebox.at

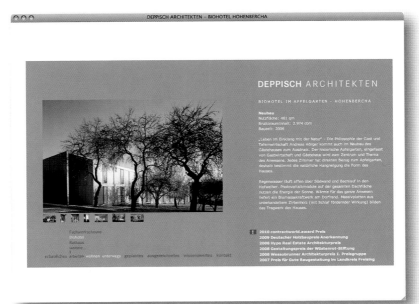

www.deppischarchitekten.de

D: petra suchard C: gestalterhuette.de
P: petra suchard M: info@suchard-design.de

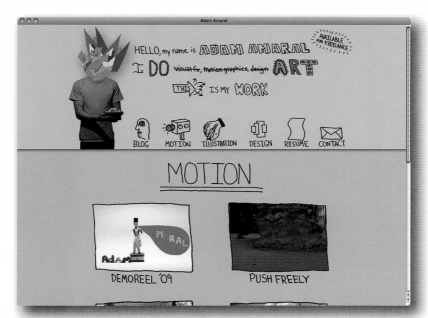

www.adamamaral.com

D: adam amaral C: adam amaral
M: adamsamaral@yahoo.com

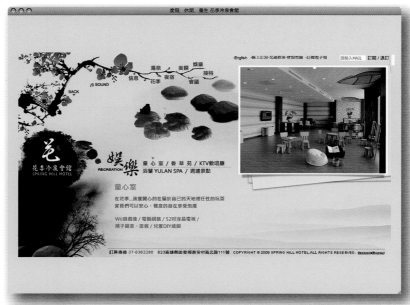

www.springhill.com.tw/home.htm

D: hao chuang C: nick liu
P: tonic huang M: tonic@lesson.com.tw

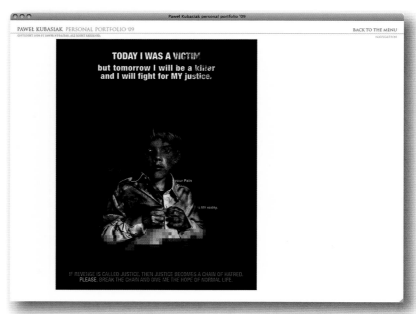

www.kubasiak.pl

D: pawel kubasiak
P: pawel kubasiak M: pawel@kubasiak.pl

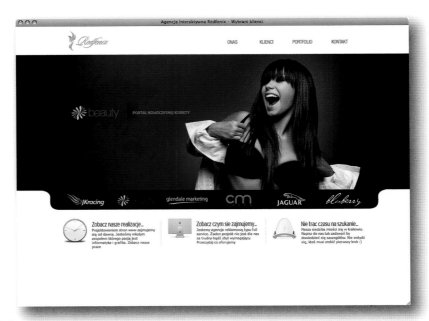

redfenix.pl
D: tom gebala C: tom gebala
P: redfenix M: info@redfenix.pl

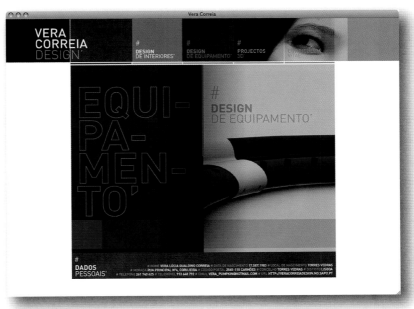

veracorreiadesign.no.sapo.pt
D: vanda correia C: vanda correia
P: vera correia M: vandacorreia2O@hotmail.com

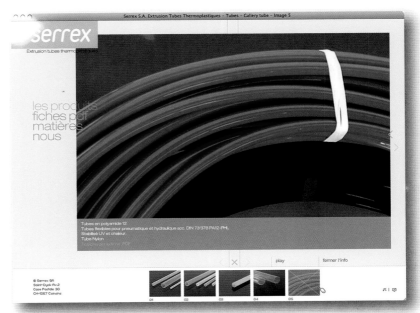

www.serrex.com
D: david lartigue, dldl webdesign lab C: david lartigue, dldl webdesign lab
P: serrex sa M: info@lartigue.ch

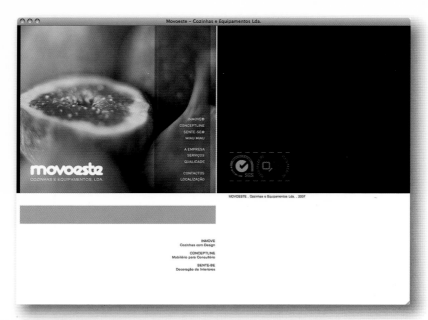

www.movoeste.pt

D: vanda correia C: slingshot, comunicação e multimédia, cláudio franco
P: movoeste M: vanda.correia@slingshot.pt

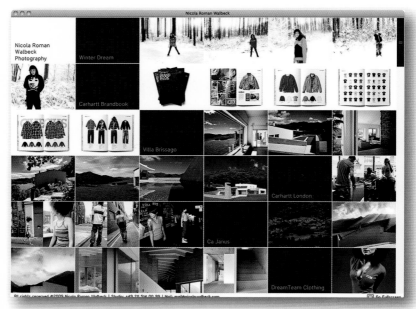

www.nicolawalbeck.com

D: hans yorck schaale C: christian potthast
P: nicola roman walbeck M: mail@nicolawalbeck.com

www.kornelius.info

D: ludmila lorenz C: ludmila lorenz
P: ulla kornelius | hair & make up M: hallo@fraulorenz.de

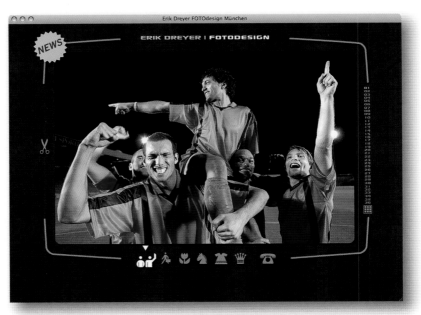

www.erikdreyer.de

D: pascal rohé C: michael sonnek
P: erik dreyer M: erik@erikdreyer.de

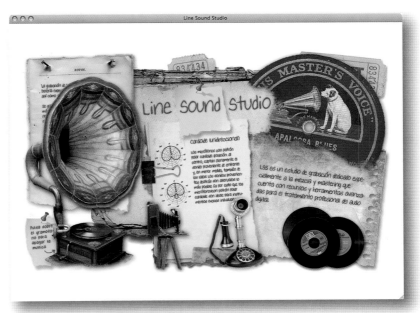

www.linesoundstudio.com

D: orlando nández C: orlando nández
P: orlando nández M: orlandonandez@hotmail.com

www.m1-design.de

D: christian petersen C: christian petersen
P: m1[design] M: mone@m1-design.de

www.kitchen.es

D: jimena catalina, kitchen C: jimena catalina
M: kitchen@kitchen.st

www.gekode.eu

D: andrea greco C: andrea greco
P: andrea greco M: scrivi@andreagreco.it

www.roywolfs.com

D: roy wolfs C: adam van reijswoud
M: contact@roywolfs.com

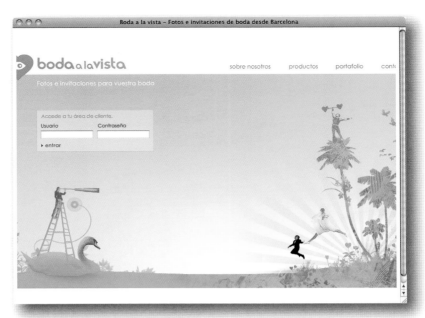

www.bodaalavista.com

D: marc alongina C: marc alongina
P: boda a la vista M: marcalongina@hotmail.com

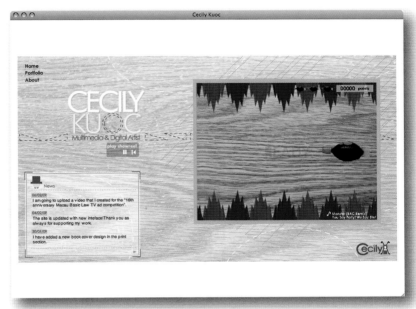

www.cecilykuoc.com

D: cecily kuoc
M: cecilykuoc@gmail.com

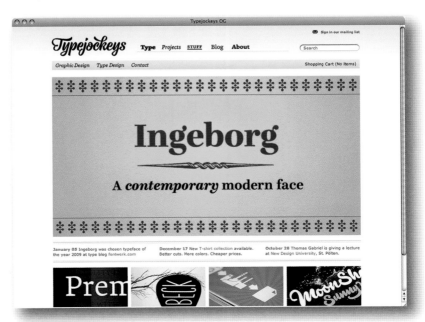

www.typejockeys.com

D: typejockeys C: bgcc
P: typejockeys M: hello@typejockeys.com

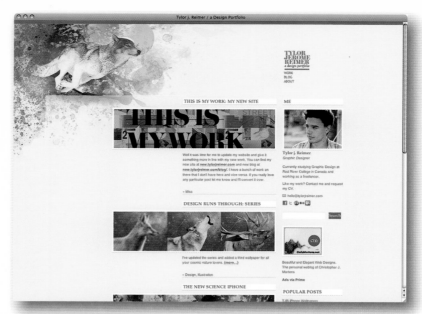

www.tylorjreimer.com

D: tylor reimer C: tylor reimer

P: tylor reimer M: hello@tylorjreimer.com

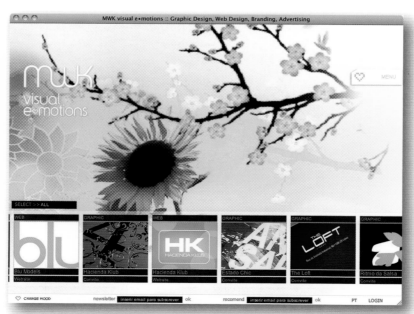

www.natfilippini.com.ar

D: nat filippini diseño & ilustración C: nat filippini diseño & ilustración

P: nat filippini M: info@natfilippini.com.ar

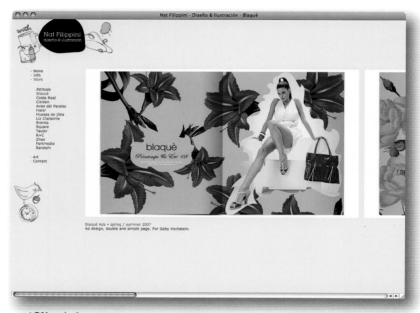

www.mwk.pt

D: mwk visual e • motions, miguel duarte, renato lopes C: mwk visual e • motions, miguel duarte

P: mwk visual e • motions M: design@mwk.pt

www.stefanobartolini.com

D: paso

M: info@mr-pong.com

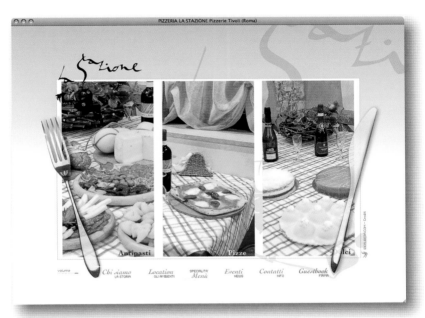

www.pizzerialastazione.it

D: aldo dominici C: gianluca di croce

P: la stazione M: info@idealibera.com

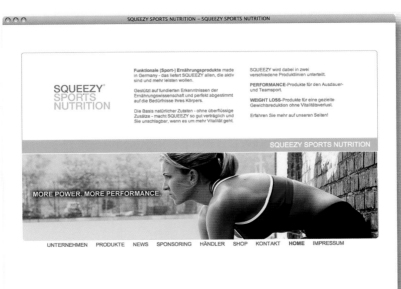

www.squeezy.de

D: frank gebhard, cpeach, saints, munich C: frank gebhard, cpeach

P: www.squeezy.de M: info@cpeach.de

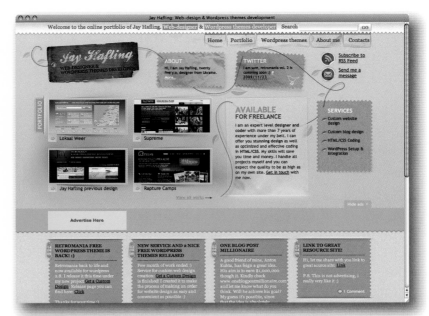

www.jayhafling.com
D: jay hafling C: jay hafling
P: jay hafling M: jayhafling@gmail.com

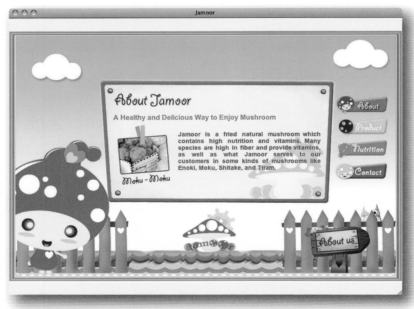

www.jamoor.com
D: vie studio C: willy sunarto
P: jamoor M: willy@viestudio.com

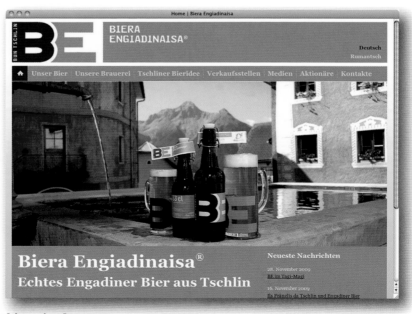

www.bieraria.ch
D: stephen england C: marc rinderknecht
P: bieraria tschlin sa M: mr@kobebeef.ch

sz.ffri.hr/vodic

D: stjepan stajduhar

P: szffri M: stjepan@stajduhar.org

www.mschroen.de

D: martin schrön C: martin schrön

P: everybody M: post@mschroen.de

www.agcontrol.gob.ar

D: manuel ressia, paula recalde, ricardo carra C: lucas ober leandro ochoa, leandro ochoa, lera

P: agc M: lucas@obermedia.com.ar

www.giambalvoenapolitano.com

D: federico mauro C: federico mauro
P: giambalvo e napolitano M: info@federicomauro.com

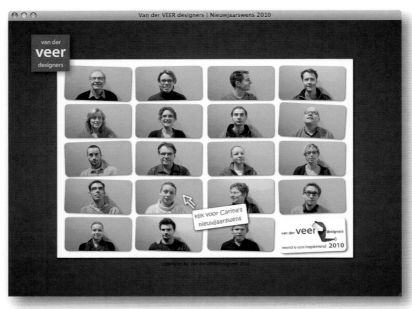

www.vanderveerdesigners.nl/nieuwjaarswens2010

D: jonghdesign C: patrick de jongh
P: van der veer designers M: info@jonghdesign.nl

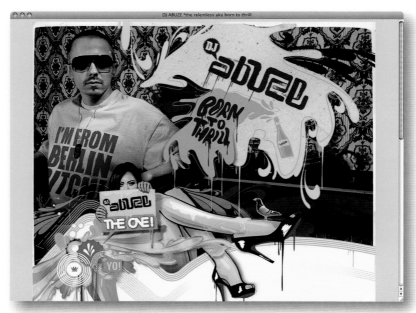

djabuze.de

D: jan.casu C: jan.casu
P: dj abuze M: jan@casu-design.de

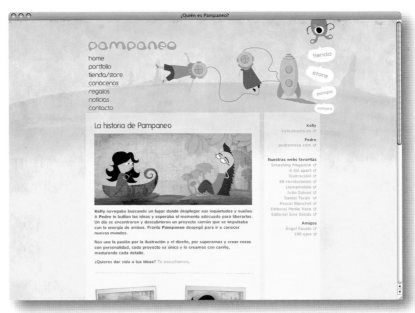

www.pampaneo.es

D: pampaneo, kelly abanto, pedro meca　　C: pampaneo

P: pampaneo　　M: info@pampaneo.es

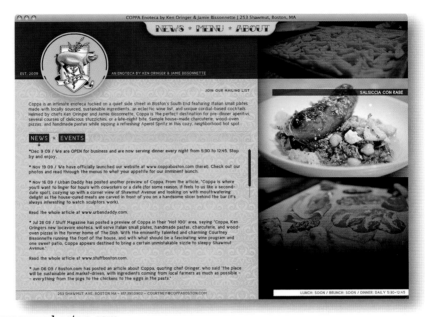

www.coppaboston.com

D: ben hantoot　　C: ben hantoot

P: coppa enoteca　　M: ben@slickmill.com

www.uvsq.fr

D: xavier drouaud　　C: kosmos

P: université de versailles st quentin　　M: communication@uvsq.fr

www.pointdevue.eu
D: christophe hello C: christophe hello
M: contact@pointdevue.eu

www.etu.uvsq.fr
D: xavier drouaud C: kosmos
P: université de versailles st quentin M: xavier.drouaud@kosmos.fr

www.watt-you-want.de
D: sebastian thoennes C: sebastian thoennes
P: simon schneider M: info@watt-you-want.de

www.quanto70.com
D: joana caprichoso C: joão dias
P: monas M: quanto70@gmail.com

www.tontorino.com
D: domagoj telisman C: dalibor sver
P: tomislav kozarcanin M: domagoj@studioimago.hr

www.rougetomate.be
D: sophie hollebecq C: valentin gregoire, cedric masson
P: rouge tomate M: info@glucone.com

www.isola-menti.it
D: cristian cirillo
M: cristian@isola-menti.it

hello-mynameis.com
D: adrian wee, vi ee lau C: flava design
P: hello-mynameis M: enquire@flava.sg

www.ezqualo.com
D: sandra natalia gómez alcántara, marciano studio C: fernando torres losa
P: antonio valle M: info@marciano.com.mx

www.woo-life.com
D: c y C: c y
P: woo-life M: canney@ms26.url.com.tw

www.classictita.com
D: tita niyomthai
M: classictita.com

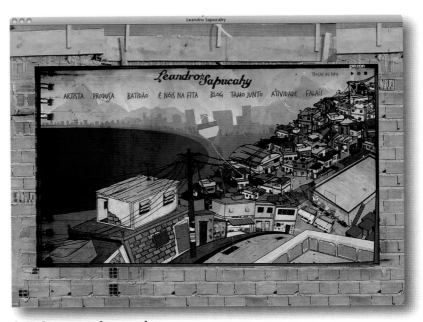

www.leandrosapucahy.com.br
D: marcello cavalcanti, pinzon17 disseny carioca C: marcello cavalcanti
P: leandro sapucahy M: estudio@pinzon17.com.br

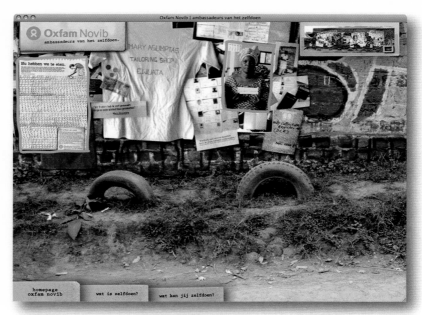

www.oxfamnovib.nl/zelfdoen/scrollwall.html

D: a. franssen, v. gayadin, y. vijn C: v. gayadin, y. vijn
P: w. reuven, j. lavalette M: info@kongamsterdam.com

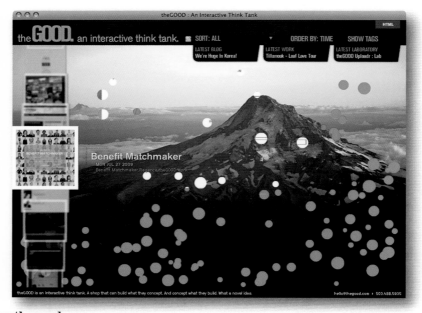

www.thegood.com

D: thegood C: thegood
P: chris teso M: hello@thegood.com

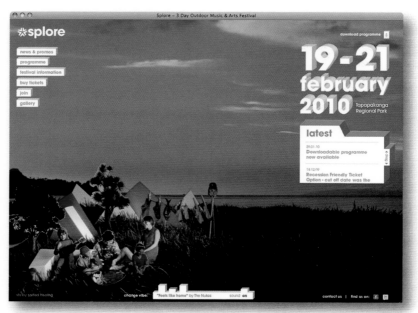

www.splore.net

D: pepijn zuijderwijk C: lauren schaer
P: splore M: kate@saltedherring.com

www.freikirchliche.com
D: andre weier, samuel trebbin C: andre weier, nalindesign
P: freikirchliche gemeinde M: info@nalindesign.com

www.informinds.com
D: informinds consulting C: informinds consulting
P: informinds consulting M: info@informinds.com

www.paje.biz
D: vincent pauly
P: paje - photographe M: contact@vincentpauly.com

www.mellowmushroom.com

D: markham unlimited, mode visual C: mode visual
P: mellow mushroom M: michael@mellowmushroom.com

www.candoti.com.ar

D: luciano candotti C: luciano candotti
P: candoti M: lcandotti@gmail.com

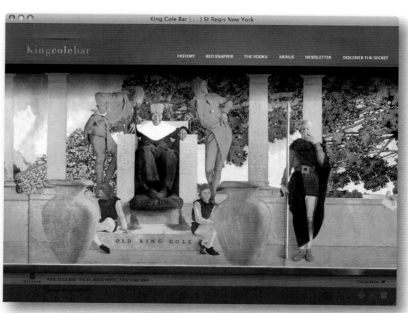

www.kingcolebar.com

D: felix espinoza ramirez C: felix espinoza ramirez, jar creative
P: the st regis hotel new york M: felix@jarcreative.com

154

www.underdog.tv

D: alex macleod
P: underdog M: matt.mazloomian@underdog.tv

www.aristocraticadomus.com

D: danilo marinaccio C: danilo marinaccio
P: aristocratica domus srl M: info@aristocraticadomus.com

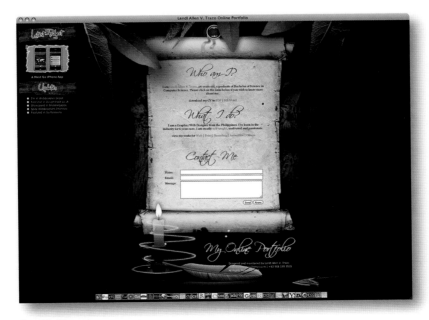

www.lendlallenvtrazo.com

D: lendl allen trazo C: lendl allen trazo
P: lendl allen v. trazo M: lendl.allen.v.trazo@gmail.com

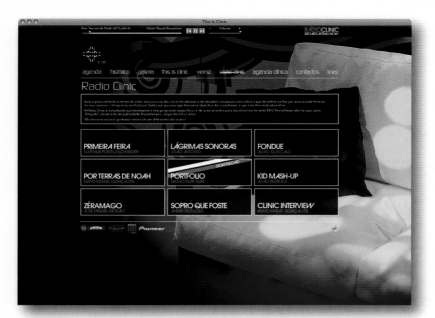

www.thisisclinic.com

D: velcrodesign C: velcrodesign
P: clinic M: velcrodesign@velcrodesign.com

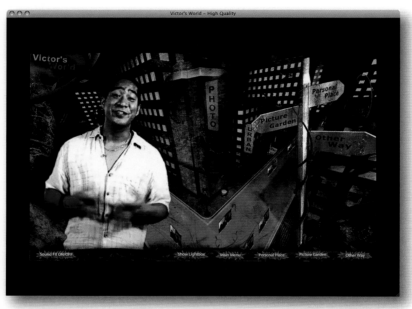

www.victorsworld.de

D: karsten seipp C: karsten seipp, victor gonzales
P: victor gonzales M: karsten@karstor.de

allanrosenow.com

D: allan rosenow C: allan rosenow
M: allan@allanrosenow.com

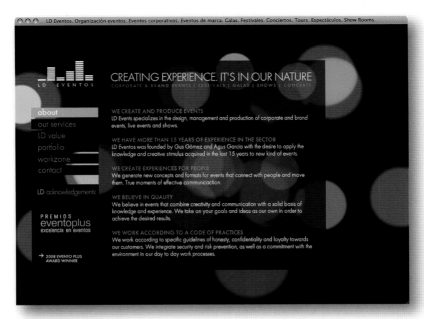

www.ldeventos.com

D: angeles moreno C: alejandro ramirez

P: laura clark M: naima@anaimation.com

www.tierraviva.net

D: alejandro baeza luco, www.devastudio.cl C: cecilia nuñez caballol

P: tierra viva a.g. M: janoopy@gmail.com

www.originalsource.co.uk

D: john lander C: stuart hamilton

P: deb clarke M: info@codecomputerlove.com

www.takeshape.it

D: daniele de batté, davide sossi C: daniele de batté, davide sossi
P: artiva design M: info@artiva.it

chapolito.com

D: jesse chapo C: greg trinidad
P: chapolito M: info@chapolito.com

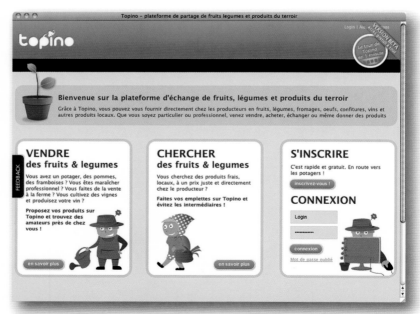

www.topino.be

D: benoît vrins C: 1md
P: topino M: info@topino.be

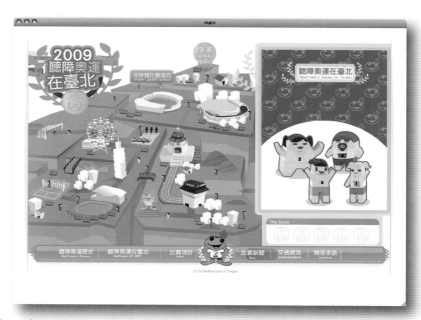

welearning.taipei.gov.tw/ecup/ecup5_top/DEMO/213/Index.html
D: more's 2kb
M: x770104x@yahoo.com.tw

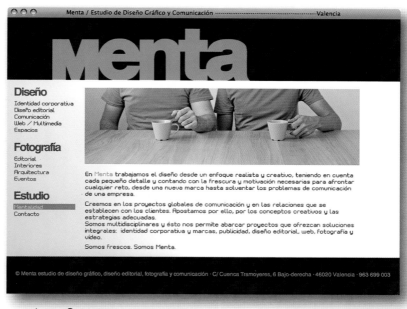

www.mentagrafica.com
D: raul climent, xavi calvo
M: menta@mentagrafica.com

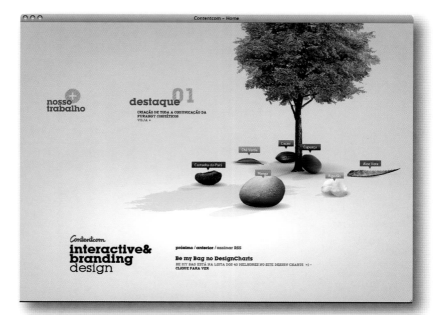

www.contentcom.com.br
D: contentcom interactive & branding design C: contentcom interactive & branding design
P: contentcom interactive & branding design M: fique@contentcom.com.br

shop.pettywood.co.uk

D: nathan kingstone, aspin interactive limited C: kevin elvin, adam gorse, parmar

P: petty wood & co ltd M: nathank@aspin.co.uk

impactideas.be

D: jessica maus de rolley C: benjamin de cock

P: impactideas M: jessica@impactideas.be

www.taniasilva.com

D: paul-christian thiele, didomeso

P: tania silva M: info@didomeso.de

www.fritz-quadrata.de

D: dominik friedrich C: dominik friedrich
P: dominik friedrich M: donni@fritz-quadrata.de

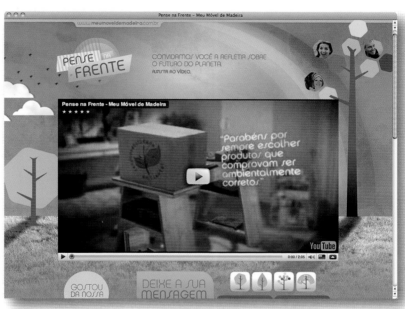

www.meumoveldemadeira.ind.br/pensenafrente

D: house cricket C: octavio augusto oliveira
M: bleite@housecricket.com.br

www.ecta.org

D: benoît vrins C: benoît vrins
P: ecta M: ecta@ecta.org

www.encian.hr

D: euroart93 d.o.o. C: euroart93 d.o.o.
P: encian d.o.o. M: encian@encian.hr

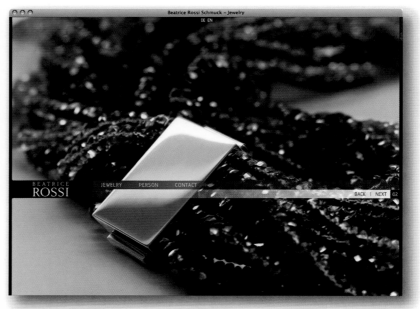

www.beatricerossi.com

D: david zangger, allink.creative C: mike walder, ron kirchheimer
P: beatrice rossi M: walder@allink.ch

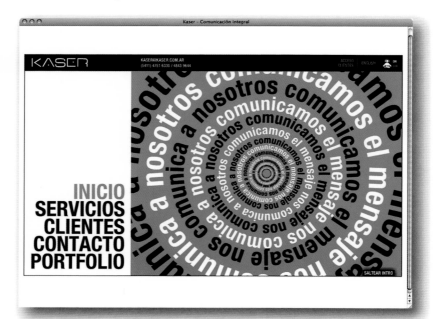

www.kaser.com.ar

D: juan pablo morello C: gustavo ariel garcia
P: romina morello M: kaser@kaser.com.ar

162

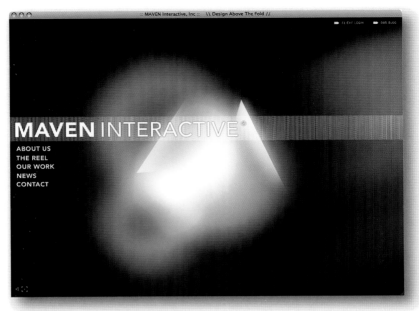

www.maven-interactive.com

D: maven interactive, inc. C: won you
P: maven interactive M: info@maven-interactive.com

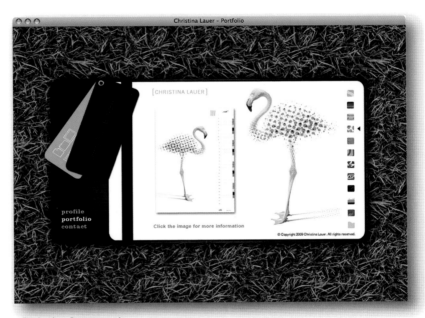

www.christinalauer.net

D: christina lauer C: christina lauer
M: info@christinalauer.net

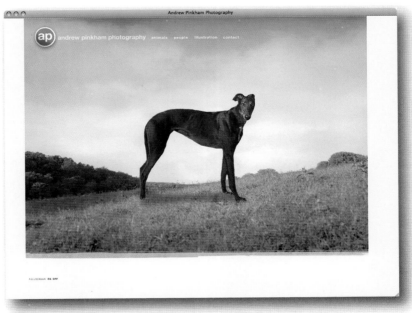

andrewpinkham.com

D: chris pinkham C: chris pinkham
P: andrew pinkham photography M: andrew@andrewpinkham.com

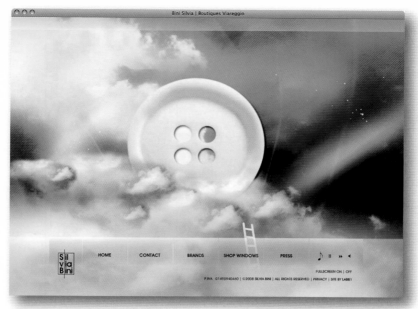

www.binisilvia.it

D: lab81 C: lab81

P: bini silvia boutique M: info@lab81.com

www.floklo.com

D: alessio gravinese C: alessio gravinese

P: alessio gravinese M: floklo@floklo.com

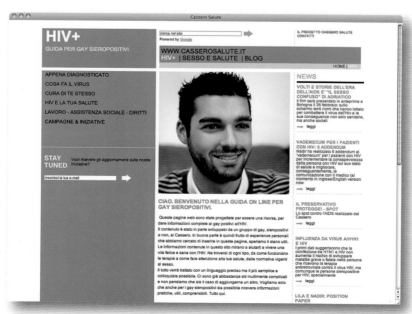

www.casserosalute.it

D: kitchen C: kitchen

P: cassero - gay lesbian center bologna M: info@kitchencoop.it

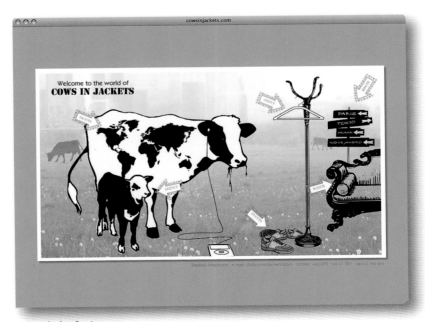

www.passievoorpuurcatering.nl

D: jorn van amerongen C: jorn van amerongen
P: passie voor puur M: jorn@wijmakenwebsites.nl

www.brunocaruso.com

D: javier frades C: francisco estradera, miguel soler
P: rafael castillo, ana poveda M: info@grupoenfoca.com

www.cowsinjackets.com

D: mario debout C: mario debout
P: daniela krautsack M: dk@cowsinjackets.com

165

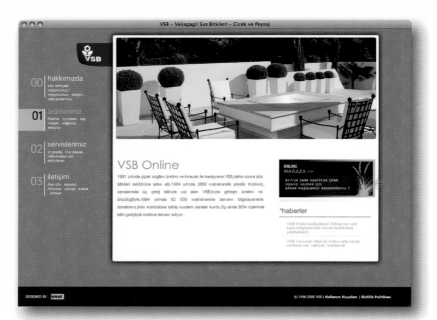

www.vsb.com.tr

D: orkun alabaz C: orkun alabaz
P: orkun alabaz M: oalabaz@wmas.us

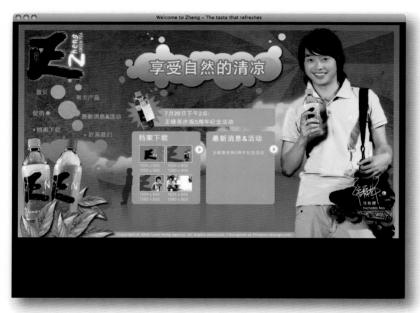

www.zheng.com.my

D: piradius design team
P: terence choong M: contact@piradius-design.com

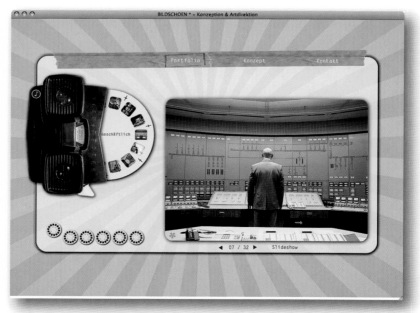

www.bildschoen-konzept.de

D: erik dreyer, martine praessl C: michael sonnek
P: bildschoen* martine praessl M: post@bildschoen-konzept.de

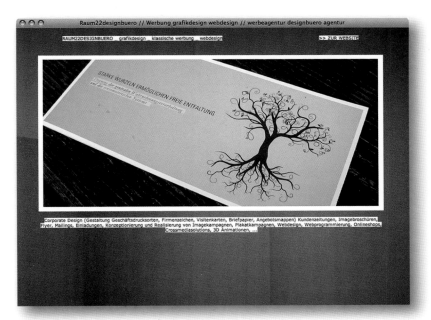

www.raum22.at

D: andreas königsmayr C: andreas königsmayr
P: andreas königsmayr M: buero@raum22.at

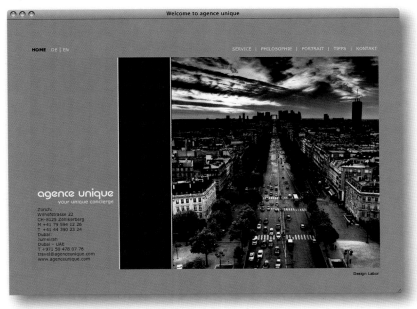

www.agenceunique.com

D: zoran bozanic, design labor C: ivan stokic, design labor
P: agence unique zurich M: travel@agenceunique.com

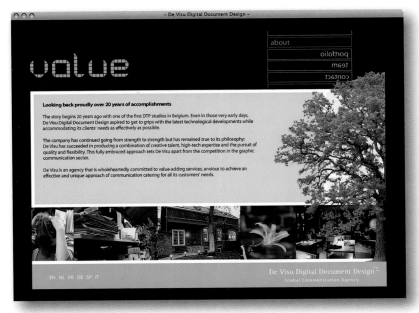

www.devisu.com

D: de visu C: de visu
P: de visu M: ht@devisu.com

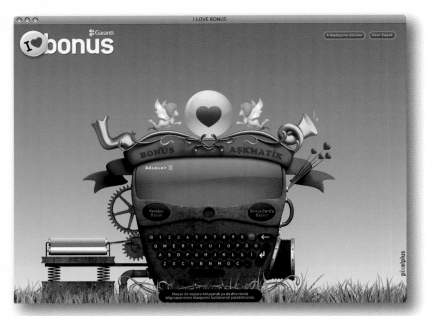

www.ilovebonus.com

D: talih caglayan guner C: kadir yazgan
P: garanti bank M: info@pixelplus.net

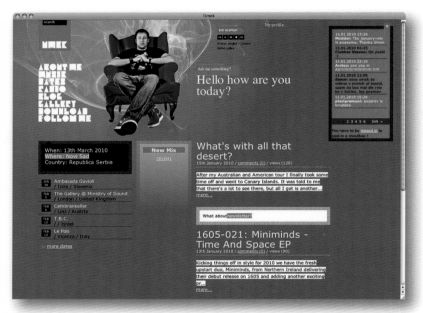

www.umek.si

D: vbg.si C: vbg.si
P: umek, futuristični marketing M: gregor.zakelj@vbg.si

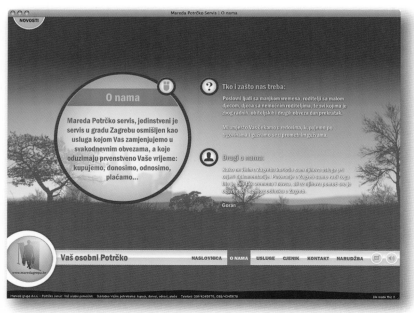

www.maredagrupa.hr

D: kreativa studio C: kreativa studio
P: mareda grupa M: potrcko@maredagrupa.hr

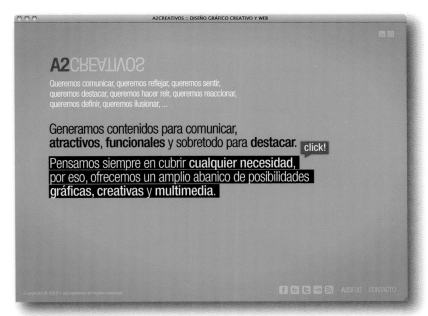

www.a2creativos.com

D: alberto escolano, andrés asencio
P: a2creativos M: info@a2creativos.com

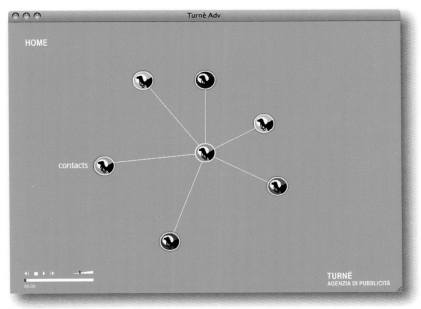

www.turneadv.it

D: francesco de concilio C: raffaele apuleo
M: deconcilio@turneadv.it

www.akmultimedia.fr

D: emeric kangueven C: jonathan auribault
P: ak multimedia M: contact@akmultimedia.fr

www.vassiliszoulias.com

D: alexandra merkouri C: i-design.gr
P: vassilis zoulias M: contact@vassiliszoulias.com

www.superemotion.com

D: seungwon lee
P: seungwon lee M: workstation@live.co.kr

www.laurasighinolfi.it

D: laura sighinolfi C: carlo compagno, fluidoadv.com
M: info@laurasighinolfi.com

www.masernicka.cz

D: studio9 C: studio9
P: miroslav malek M: info@studio9.cz

www.greenanysite.com

D: inhive, tal ater C: tal ater
P: green any site M: tal@talater.com

www.unowhy.com

D: sébastien laading, zee agency C: philippe blanc, aaz interactive
P: unowhy M: hbloch@unowhy.com

www.jynx.com.br

D: maurício nunes, eduardo padrão, felipe medeiros C: andré ponce, andré burgos

M: felipe@cappen.com

www.emotionslive.co.uk

D: mike muzhychkov

P: emotions live M: jaguarrish@gmail.com

www.mikael-lafontan.com

D: sylvie meunier, bleuceladon C: aline romat

P: mikaël lafontan M: contact@bleuceladon.com

www.uppercut.es
D: elsa tapia hurtado C: elsa tapia hurtado
P: elsa tapia hurtado M: info@uppercut.es

www.mamieboo.fr
D: magali michel C: dimitri gougeon
M: mamzhell.dogo@gmail.com

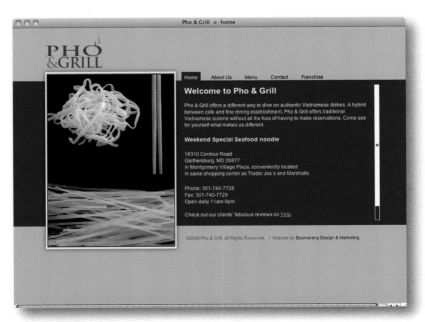

www.pho-grill.com
D: ohsome inc, jen ohs C: ethan kemp
P: pho & grill M: jen@ohsomeinc.com

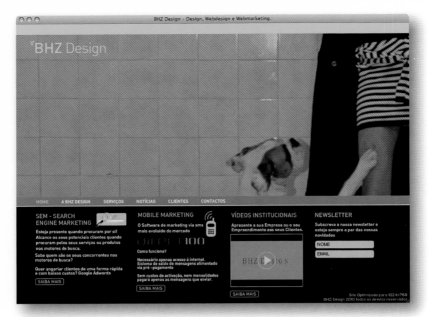

www.bhzdesign.pt

D: antonieta barros, alexandre pereira C: alexandre pereira

P: www.bhzdesign.pt M: geral@bhzdesign.pt

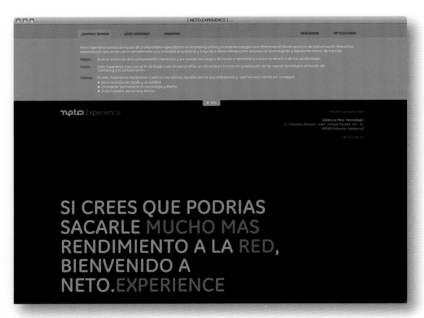

www.netoexperience.com

D: oscar ruiz

M: info@netoexperience.com

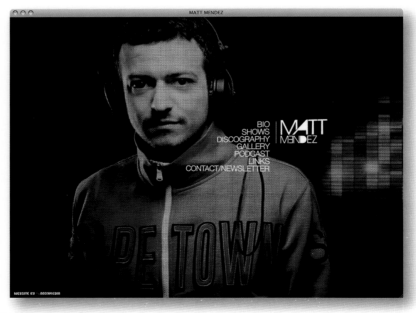

www.djmattmendez.com

D: nodymedia C: nodymedia

P: dj matt mendez M: contact@djmattmendez.com

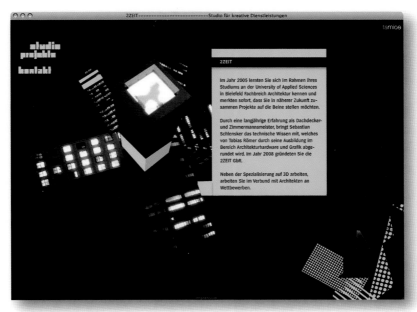

www.tamioe.de/zweiZeit

D: christoph kock, benjamin tieck C: christoph kock
P: 2zeit studio M: info@tamioe.de

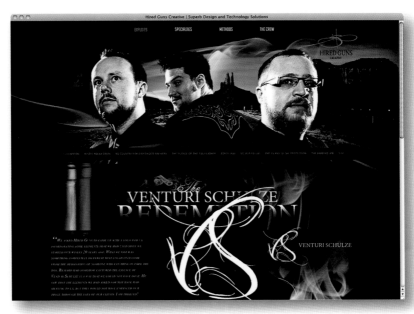

www.hiredgunscreative.com

D: richard hatter C: leif miltenberger, reed botwright
P: hired guns creative M: info@hiredgunscreative.com

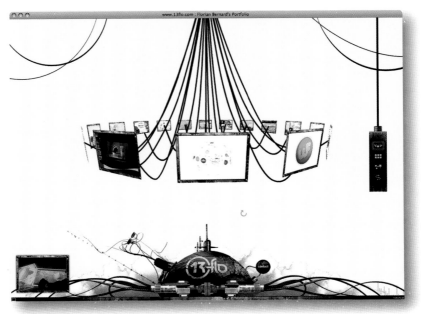

www.13flo.com

D: tony cianci C: florian bernard
P: 13flo M: contact@13flo.com

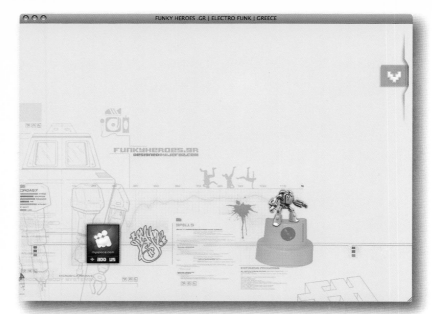

www.funkyheroes.gr

D: aloha studios C: theodoros n. darviris

P: funky heroes M: info@aloha.gr

www.acidik.net

D: paola romanos C: paola romanos

P: acidi.k M: acidi.k@hotmail.com

www.laufair.hu

D: studiosimple C: studiosimple

P: laufair M: jozsefkaraiz@simpleandyou.com

www.berber.com.pl
D: luks piekut C: rafal czuj
P: berber mateusz marczewski M: studio@berber.com.pl

www.artrivity.com
D: artrivity disseny
P: artrivity disseny M: info@artrivity.com

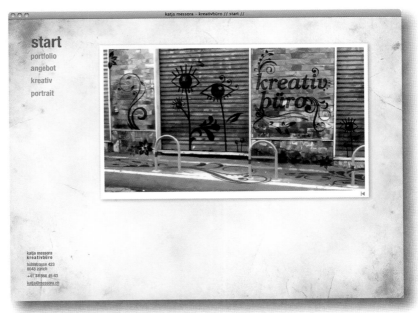

www.messora.ch
D: katja messora C: katja messora
P: katja messora - kreativbüro M: katja@messora.ch

www.wieczorekonline.com

D: wieczorek gbr C: wieczorek gbr

P: wieczorek gbr M: robert@wieczorekonline.com

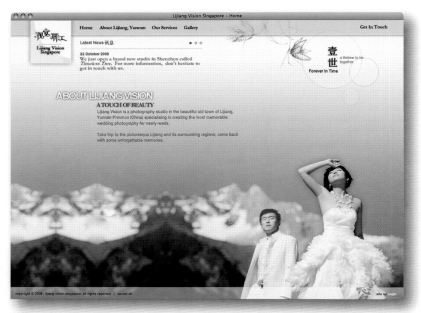

www.lijiangvisionsingapore.com

D: henry soon C: henry soon

P: lijiang vision M: mujiri@gmail.com

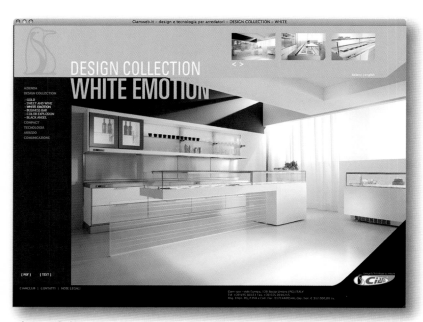

www.ciamweb.it

D: brokenice interactive, marini, fabiola brufani C: brokenice intercative

P: ciam s.p.a. M: info@brokenice.it

www.roland-holz.de

D: iconnewmedia C: iconnewmedia

P: roland holz M: spiros.tzanetatos@iconnewmedia.de

www.studioadinteractive.com

D: alexander bernal cortes C: diana m. serrano, fabian m. tamara

P: studio adinteractive M: gerencia@studioadinteractive.com

www.segelschein.de

D: michael wessel C: michael wessel

P: yachtschule dreyer M: mail@segelschein.de

www.muralsbyclara.com

D: lee shaari　C: lino suarez
P: murals by clara　M: mystiqq17@gmail.com

www.graphik3.com

D: alex alvarez　C: alex alvarez
P: alex alvarez　M: contact@graphik3.com

www.thegraphictree.com/design/index.html

D: alejandro alvarez　C: alejandro alvarez
P: the graphic tree　M: contact@thegraphictree.com

www.d10studio.com.mx
D: d10studio C: d10studio
P: d10studio M: pez@d10studio.com.mx

www.thepeachdesign.com
D: peachanan rojwongsuriya C: peachanan rojwongsuriya
M: peachananr@gmail.com

www.philippdoms.com
D: philipp doms C: philipp doms
M: hello@philippdoms.com

www.elkebroothaers.be

D: elke broothaers C: elke broothaers

M: elke.broothaers@gmail.com

www.letterbirdlane.com.au

D: delia marsono C: rendy marsono

M: design@bubblefish.com.au

www.gzh.hr

D: euroart93 d.o.o. C: euroart93 d.o.o.

P: gzh croatia M: euroart93@euroart93.hr

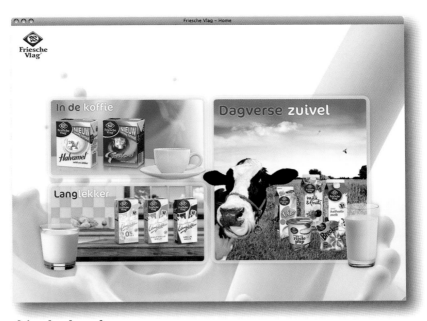

www.frieschevlag.nl

D: abraham gonzalez, achtung! C: usmedia
P: frieslandcampina M: agm@gridex.com

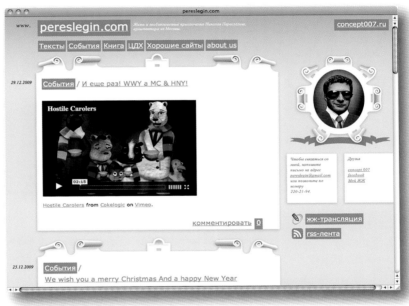

www.pereslegin.com

D: dising studio "shuka" C: dising studio "shuka"
P: nikolay pereslegin, concept007 M: pereslegin@gmail.com

www.mondongorecords.com

D: mr kofla C: mr mondongo
P: mr wilson prado M: wilsonprado@mondongorecords.com

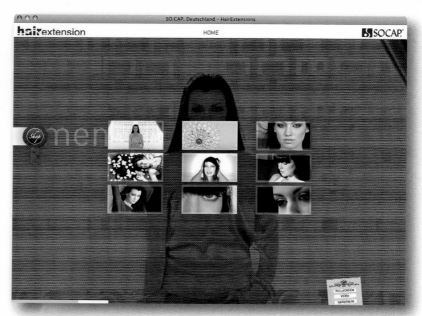

www.hairxtensions.info

D: domeniceau I intermediales design C: domeniceau I intermediales design
P: so.cap. M: info@domeniceau.de

www.ryszardgorecki.de

D: barbara sobańska C: barbara sobańska
P: ryszard górecki M: barbara.sobanska@onet.pl

www.maxiburtin.com.ar

D: maximiliano burtin C: maximiliano burtin
P: maxi burtin M: mburtin@maxiburtin.com.ar

www.gummisig.com

D: guðmundur bjarni sigurðsson C: saisuresh govindasami

P: gummisig M: gummisig@gmail.com

www.kopfstand.ch

D: gregory gasser, id-k.com C: manuel gentinetta

P: kopfstand M: g.gasser@id-k.com

www.postermedia.com.mx

D: d10studio C: d10studio

P: postermedia M: pstez@d10studio.com.mx

www.alexarts.ru

D: alexey abramov C: alexey abramov
P: alexey abramov M: idea@me.com

promo.kamaz.net

D: tim goubaidoullin C: roman slide
P: andri abramov M: abra@osterleys.com

www.rodhunt.com

D: rod hunt
P: rod hunt M: rod@rodhunt.com

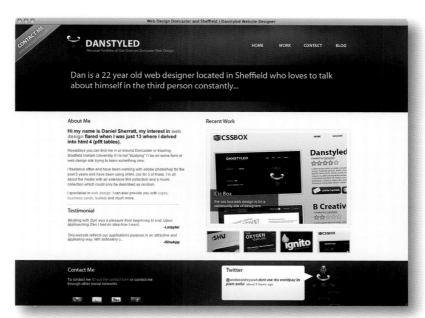

www.Danstyled.com

D: daniel sherratt C: daniel sherratt
P: danstyled M: danstyled@gmail.com

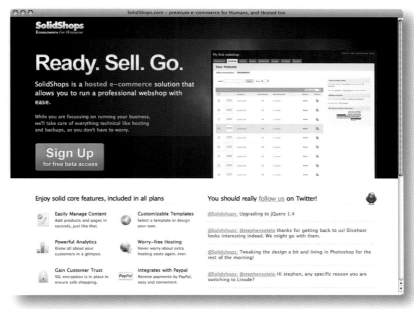

www.solidshops.com

D: joris hens C: joris hens
P: goodbytes.be M: jorrespam@gmail.com

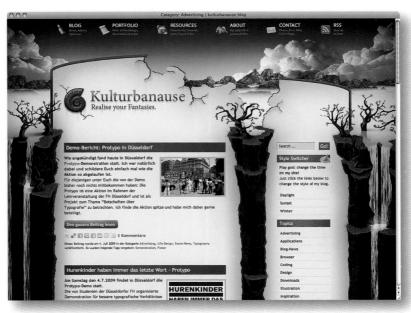

www.kulturbanause.de

D: jonas hellwig C: jonas hellwig
P: jonas hellwig M: jonas@kulturbanause.de

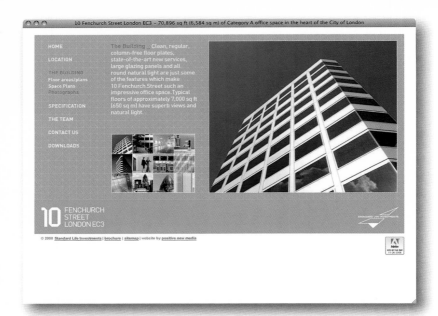

10fenchurchstreet.co.uk

D: andrew thomas, kate tanner C: hamish paterson

M: ask@positivenewmedia.co.uk

homemade.artefakt.be

D: sébastien monnoye C: sébastien monnoye

M: sebastien.monnoye@artefakt.be

www.go-on-web.com

D: jeremie bancilhon C: julien garand, jeremie bancilhon

P: go on web M: contact@go-on-web.com

www.gabrielebrombin.com
D: gabriele brombin C: gabriele brombin
M: hello@gabrielebrombin.com

www.designministeriet.se
D: designministeriet C: designministeriet
P: designministeriet M: hej@designministeriet.se

www.austrade.gov.au
D: ian j butler C: elcom
P: australian government M: ian@mc3.com.au

www.lesnuitsslaves.com

D: les influents, olivier devillers C: les influents
P: kusmi tea M: aline@lesinfluents.com

www.zhfcn.com

D: studio opensight C: studio opensight
P: zhf M: opensight@163.com

www.morphix.si

D: morphix design studio C: morphix design studio
P: gasper vidovic M: matrix@morphix.si

rickymontel.com
D: edgar leijs C: edgar leijs
P: edgar leijs M: ik@edgarleijs.nl

www.dersya.net
D: lizbeth hidalgo, erika kashiwagui, miguel palacios C: kenji tanamachi, mauro hidalgo
P: grupo dersya M: mauro@devorameotravez.com

www.e-hitman.jp/wthc
D: atsushi yamada C: satoshi aoki
P: hitman corporation M: yamada@e-hitman.jp

www.somoslaperalimonera.com

D: somos la pera limonera C: hector escriche pulido, juan carlos gea, antonio gonzalez

P: somos la pera limonera M: info@somoslaperalimonera.com

www.webtek.cz

D: webtek C: webtek

P: webtek M: info@webtek.cz

www.jungeenergie.com

D: ali rastagar C: pierre groth, michael märz

P: tobias flosdorf (projekt manager) M: contact@db-n.com

www.2minds1click.com

D: annemieke de groot
P: 2mc b.v. M: info@2mc.cc

www.esperantozorg.nl

D: kim swemmer, rick schuttinga C: rick schuttinga
P: esperanto zorg M: info@beandesigned.eu

www.djbattle.co.nz

D: michael trilford C: jeremy wells
P: nathan donaldson M: info@boost.co.nz

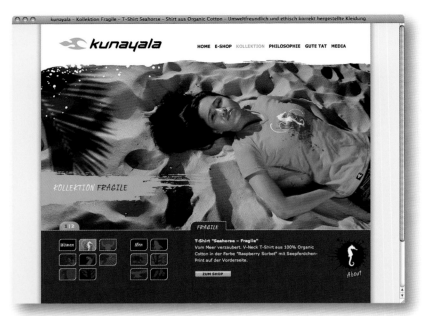

www.kunayala.de

D: katja rüppell C: christian milde
M: mail@kunayala.de

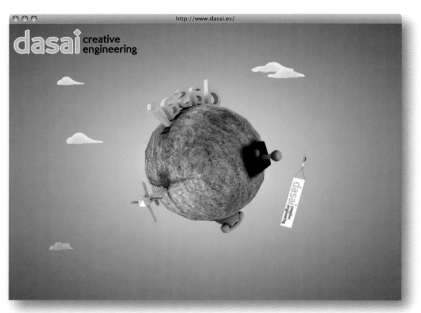

www.dasai.es

D: dasai C: dasai
P: dasai M: miguel.sanguino@dasai.es

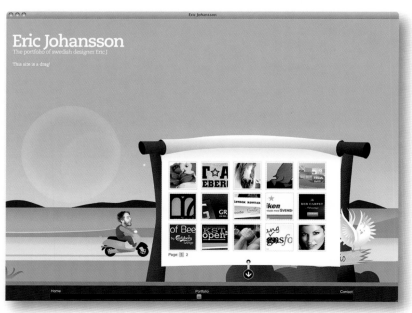

www.ericj.se

D: eric johansson C: eric johansson
M: ericj@ericj.se

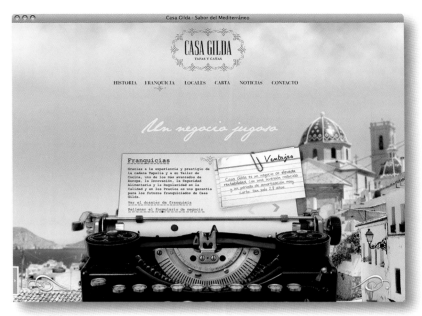

www.casagilda.com

D: javier frades C: david saiz, rafael castillo

P: francisco estradera, ana poveda M: info@grupoenfoca.com

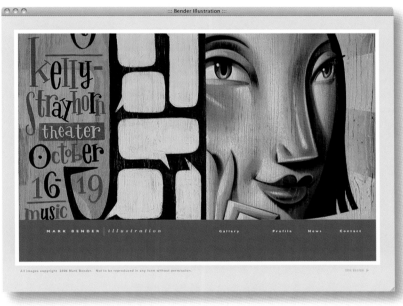

www.benderillustration.com

D: alan hassinger C: alan hassinger

P: mark bender M: mark@benderillustration.com

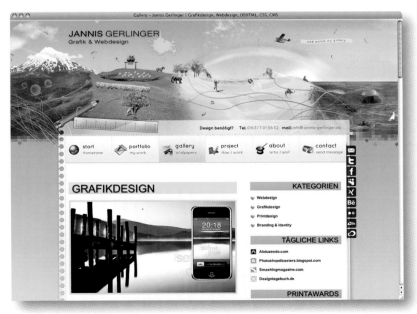

www.jannis-gerlinger.de

D: jannis gerlinger C: jannis gerlinger

P: jannis gerlinger M: info@jannis-gerlinger.de

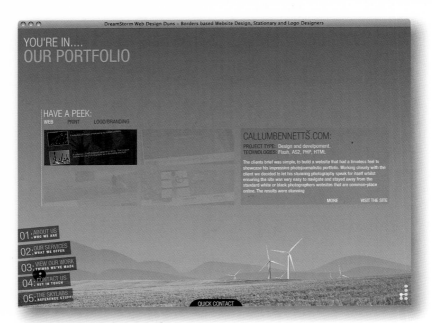

www.dreamstormdesign.co.uk

D: alan manning C: alan manning
P: alan manning M: info@dreamstormdesign.co.uk

www.lcgsa.com.ar

D: manuel ressia, obermedia C: obermedia
P: lcg M: lucas@obermedia.com.ar

www.arrepiadovelho.com

D: bruno alexandre conceição
M: b.alexandre@nameless.pt

www.vargoworld.com

D: cross one C: alexander karmosin
P: ansgar üffink M: office@crossone.de

www.baikal-web.ru

D: ivan eremko C: ivan eremko
P: baikal web M: mail@baikal-web.ru

www.resatlantico.pt

D: rui oliveira C: luís braga
P: resatlântico M: info@estudiorjdesign.com

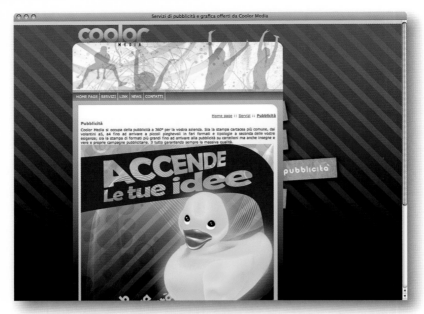

www.coolormedia.com

D: marco pedri C: marco pedri, alessandro angelotti, cartoni
P: coolor media, mantra multimedia s.r.l. M: info@coolormedia.com

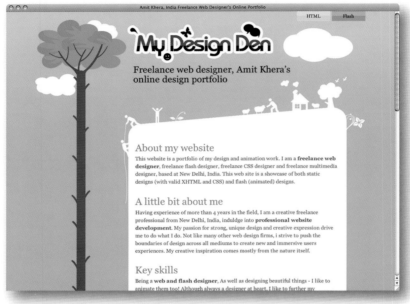

www.amitkhera.com

D: amit khera C: amit khera
P: my design den M: allchums@gmail.com

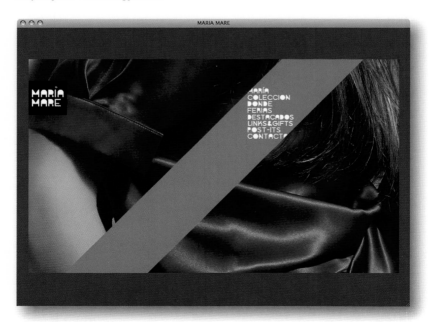

www.mariamare.com

D: dostintas, sandra martinez C: nitsnets
P: proyecto maria mare M: andres@dostintas.es

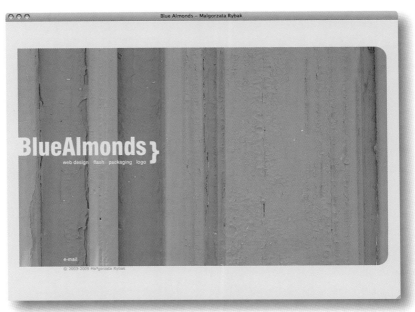

www.bluealmonds.com
D: malgorzata rybak
P: malgorzata rybak M: nospam@bluealmonds.com

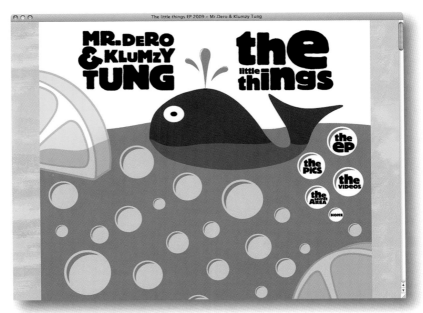

tiefparterre.net/thelittlethings
D: franz-xaver daublebsky, franzrocks.at C: raphael copony, gecoweb
P: tiefparterre.net M: office@geco-web.at

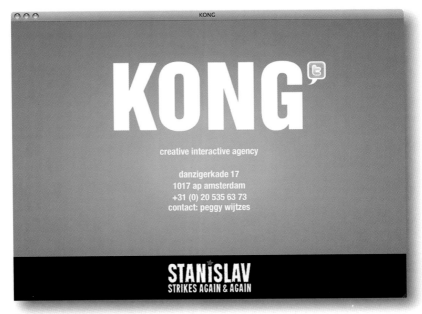

www.kongamsterdam.com
D: vinesh gayadin, yacco vijn C: kong amsterdam
P: kong amsterdam M: yacco@kongamsterdam.com

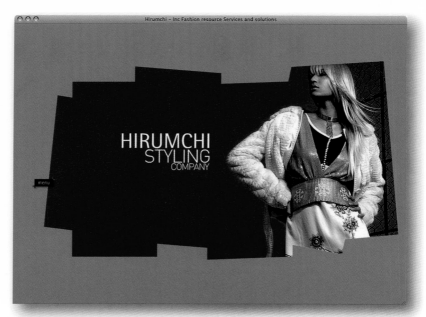

www.hirumchi.com

D: tushar garg

M: contact@reversethought.com

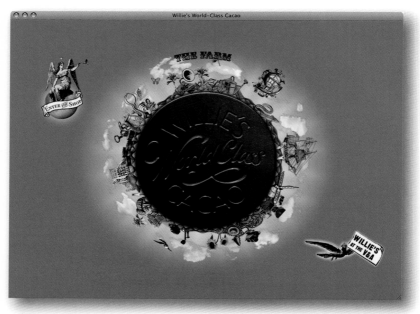

www.iamawesome.nl

D: jonghdesign C: patrick de jongh

P: iamawesome.nl M: info@jonghdesign.nl

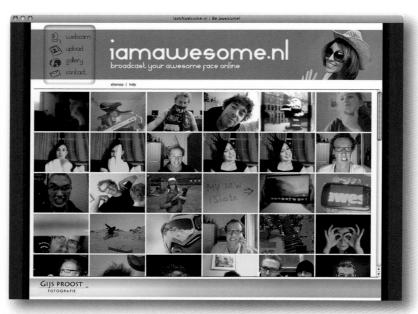

www.williescacao.com

D: spencer buck, ryan wills, gareth beeson C: link & co

M: sarah@taxistudio.co.uk

200

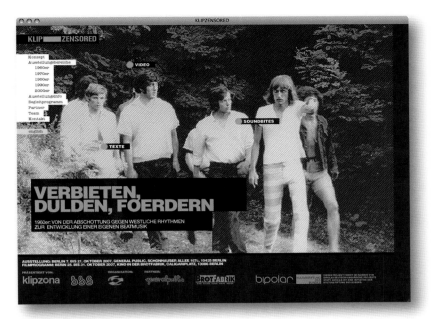

www.klipzensored.de

D: sven barletta C: sven barletta

P: sven barletta M: info@svenbarletta.com

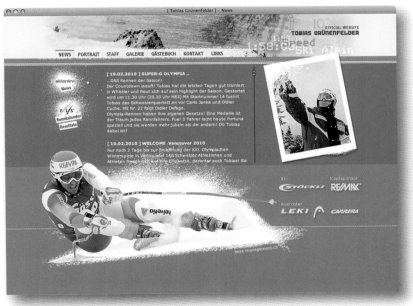

www.grueni.ch

D: hess-management.ch C: hess-management.ch

P: tobias grünenfelder M: info@hess-management.ch

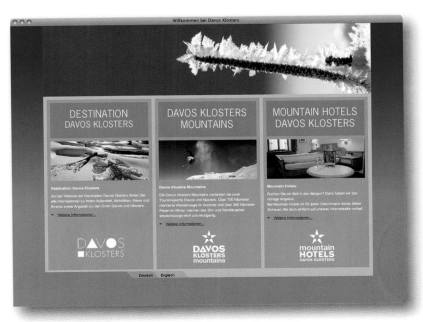

www.davosklosters.ch

D: südostschweiz newmedia ag

P: davos klosters mountains M: info@newmedia.ch

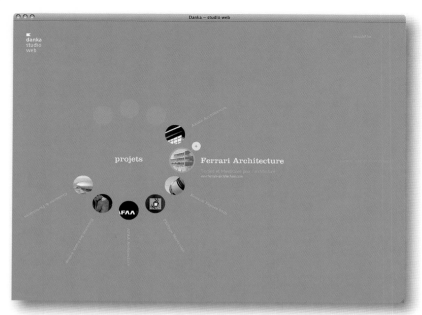

www.dankastudio.fr/#/projets
D: danka studio C: danka studio
P: danka studio M: danka@dankastudio.fr

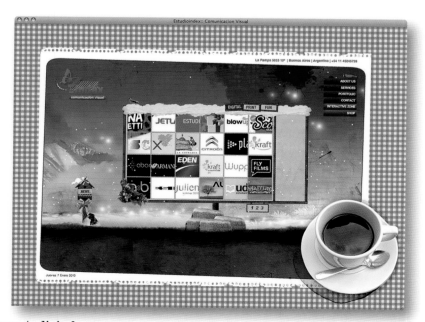

www.umbralfunk.com
D: eric moldero C: eric moldero
P: umbral funk M: eric@moldero.com

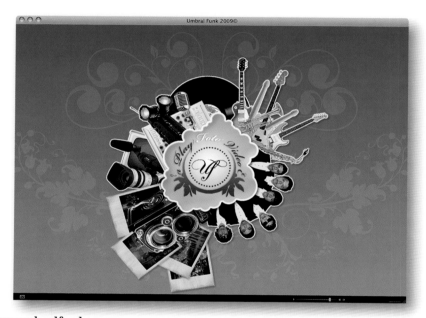

www.estudioindex.com.ar
D: estudioindex C: ezequiel cuirolo, estudioindex
P: romina prado - estudioindex M: info@estudioindex.com.ar

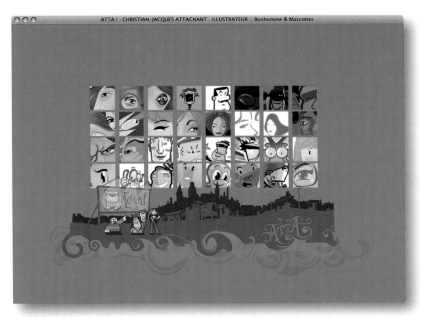

www.cj-atta.com

D: christian-jacques attagnant C: les produits de l'épicerie
M: christian-jacques.attagnant@wanadoo.fr

www.renaudgrand.com

D: renaud grand
P: renaud grand M: design@renaudgrand.com

www.wildflame.co.uk

D: scotty vernon
P: showcase M: scotty@wildflame.co.uk

www.s3design-studio.com

D: eliana sobrino, rodrigo mendoza C: rodrigo mendoza
P: the site's principal M: s3@s3design-studio.com

www.zonkzone.net

D: immo blaese C: immo blaese
M: immo@zonkzone.net

www.i2fly.com

D: kumar vivek C: kumar vivek
P: kumar vivek M: vivek@i2fly.com

www.disturbmedia.com

D: chris phillips C: greg danford, alex stanbury
P: disturb media M: contact@disturbmedia.com

www.secondfloor.be

D: olivier leemans, denis decroix C: thomas gimzer, olivier leemans
P: @graph.be M: info@agraph.be

www.yuna.nl

D: martijn heijnen C: martijn heijnen
P: martijn heijnen M: info@yuna.nl

www.trix.pt

D: foan82 C: foan82
P: foan82 M: mail@foan82.com

www.crossone.de

D: cross one C: alexander karmosin
P: cross one M: office@crossone.de

www.fabrikagency.com

D: chris petty, john damelio, ryan cuthriel C: caleb wright
P: fabrik agency M: chris@fabrikagency.com

patriciaferreira.com
D: patricia ferreira C: patricia ferreira
M: phelfferreira@gmail.com

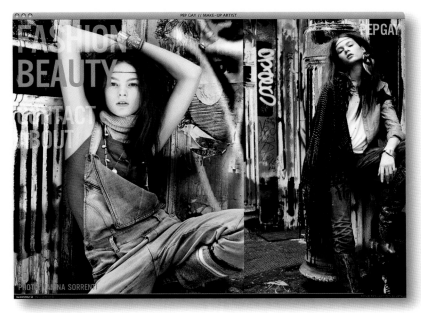

www.pepgay.com
D: oriol bèdia, 2otsu C: oriol bèdia, 2otsu
P: www.pepgay.com M: talk@2otsu.com

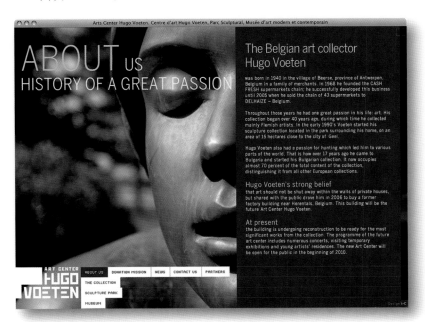

artcenter.hugovoeten.org
D: i-creativ studio C: i-creativ studio
P: hugo voeten art center M: office@i-creativ.net

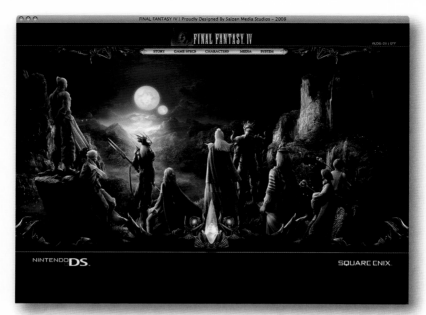

www.saizenmedia.com/FFIV
D: saizen media studios C: saizen media studios
P: square enix ltd M: davide@saizenmedia.com

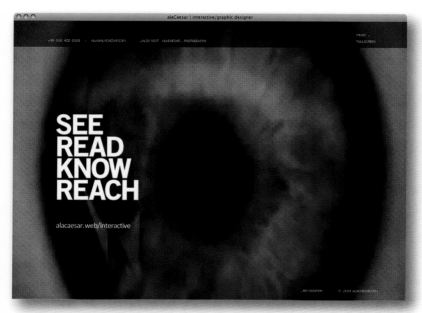

www.alacaesar.com
D: alacaesar C: alaa muhammad
P: alacaesar M: alacaesar@yahoo.com

www.digitmotion.com
D: shkumbin ferizi, drawingart C: drawingart
P: shkumbin ferizi digitmotion M: shkumbinf@hotmail.com

www.carloshermoso.com

D: carlos hermoso C: carlos hermoso
P: carlos hermoso M: carlos@carloshermoso.com

citymetria.ru

D: creativepeople C: creativepeople
P: citymetria M: info@cpeople.ru

www.andyabraham.com

D: ryan millard, web creation uk ltd C: web creation uk ltd
P: andy abraham M: info@andyabraham.com

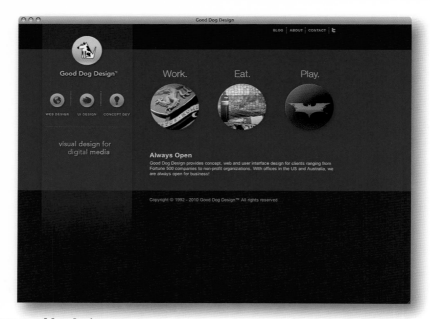

www.gooddogdesign.com

D: tom gooden C: good dog design

P: good dog design M: info_us@gooddogdesign.com

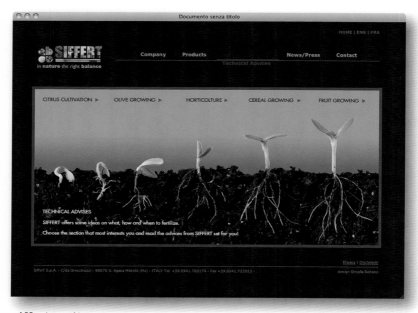

www.siffertspa.it

D: ornella reitano

P: siffert s.p.a. M: ornella.reitano@gmail.com

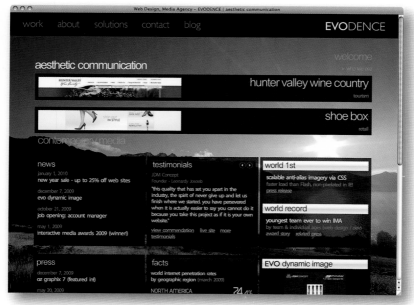

www.evodence.com

D: james hazelton C: suryadi lawira

P: james hazelton M: ingrid@evodence.com

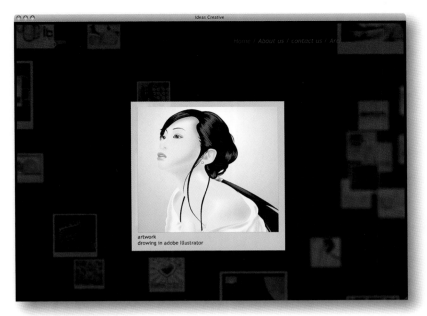

www.ideascreative.org

D: fadi ajjan C: fadi ajjan
P: fadi ajjan M: newideas2008@hotmail.com

www.crittercreative.com

D: norm soule C: norm soule
P: critter creative M: norm@crittercreative.com

www.allaboutjames.co.uk

D: james monaghan C: james monaghan
M: james@allaboutjames.co.uk

www.fanfreluches.it

D: tania conte C: tania conte
P: fanfreluches M: me@purple2pink.com

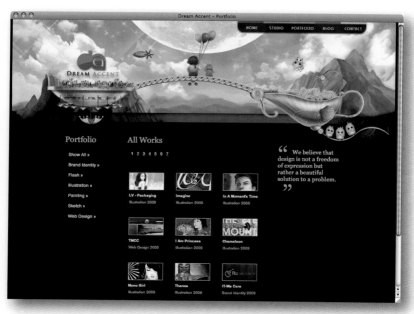

www.dickiebirds.com

D: tomasz grabowiecki C: piotr wesołowski
P: the dickiebirds web studio M: studio@dickiebirds.com

www.dreamaccent.com

D: edric yoeliawan C: kelly li
P: jourdan kamal M: info@dreamaccent.com

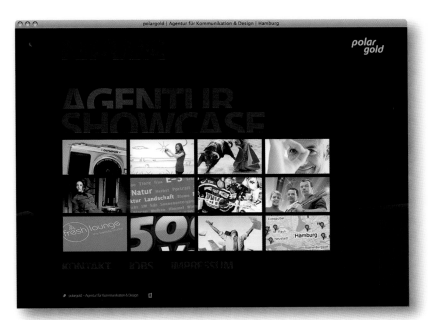

www.polargold.de
D: polargold C: polargold
P: polargold M: info@polargold.de

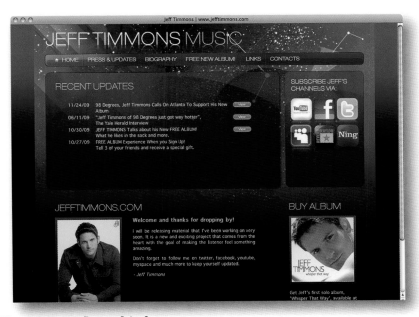

jefftimmons.com/home.html
D: muid latif, jenn hoffman C: muid latif, cameron adams
P: jeff timmons M: muidlatif@gmail.com

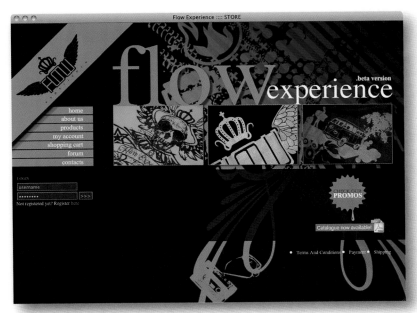

www.flowexperience.pt
D: miguel duarte C: shezad anavarali, miguel duarte
P: flow experience M: info@flowexperience.pt

www.infinitcolours.com

D: infinit colours C: infinit colours
P: infinit colours M: web@infinitcolours.com

www.theonlinedoc.com

D: the online doc
M: info@theonlinedoc.com

www.scottsigurdson.com

D: scott sigurdson C: scott sigurdson
P: scott sigurdson M: scott@scottsigurdson.com

www.platfuse.com

D: platfuse interactive, llc C: platfuse interactive, llc
P: interactive media designs M: info@platfuse.com

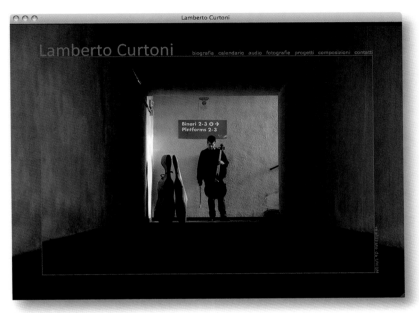

www.lambertocurtoni.com

D: ubyweb&multimedia C: ubyweb&multimedia
P: lamberto curtoni M: ubaldoponzio@ubyweb.com

www.point39.com

D: tushar garg
M: contact@reversethought.com

www.ozarkhenry.com

D: pieter michels C: pieter michels
P: golazo media M: pieter@wellconsidered.be

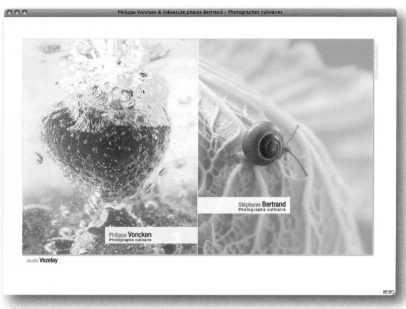

www.philippe-voncken.com

D: alexandre tougne, monsieur alex C: tougne alexandre, monsieur alex
P: philippe voncken M: contact@monsieur-alex.com

www.menuiseriebeaudry.be

D: françois-xavier marciat
P: olivier beaudry M: xy@xyarea.com

www.digidecal.com
D: nathan kingstone C: nathan kingstone
P: digidecal M: nathan@digidecal.com

www.robson.art.br
D: robson rodrigues C: robson rodrigues
P: robson M: robson@robson.art.br

www.pigeonandpigeonette.com
D: sarah verroken C: dirk derom
P: enchanted lion books, n.y. M: sarahverroken@gmail.com

www.laroshel.cz

D: david grus C: david grus
P: laroshel M: grus@grapharts.cz

www.grapharts.cz

D: david grus C: david grus
P: grapharts M: grus@grapharts.cz

www.fachwerkstatt-coenen.de

D: susanne coenen, nicole slink C: sven kauffmann
M: info@lockstoff-design.de

www.mediamedics.nl

D: richard straver C: victor van rijn
P: valentin khechinashvili M: info@mediamedics.nl

www.jjmaes.be

D: misa petrovic, ana van aerden C: misa petrovic
P: albertcan M: info@albertcan.com

www.sesey.com

D: hector gomis C: hector gomis
P: hector gomis M: info@hectorgomis.com

www.ladyflower.org

D: sara mazzotti C: sara mazzotti

P: ladyflower design, sara mazzotti M: saramazzotti@gmail.com

www.malak.be

D: malak C: malak

P: malak M: contact@malak.be

www.pizublic.com

D: raquel agrella galván C: raquel agrella galván

P: raquel agrella galván M: info@pizublic.com

www.4060.com.ar
D: 4060 C: 4060
P: 4060 M: info@4060.com.ar

www.kadix.com.br
D: carolina kadix C: carolina kadix
M: contato@kadix.com.br

www.mc3.com.au
D: ian j butler C: jack flash
P: mc3 M: ian@mc3.com.au

www.devoler.com

D: devoler design C: devoler design

P: devoler design studio M: info@devoler.com

www.pranzodiferragosto.it

D: federico mauro C: federico mauro

P: fandango srl M: info@federicomauro.com

www.ecosfalsos.com.br

D: daniel akashi C: daniel akashi

P: daniel akashi M: akashidan@gmail.com

www.brunoreal.com/grooveit
D: bruno real
P: groove it! M: brunoreal@solidalab.com

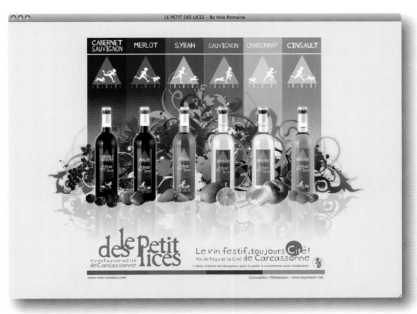

www.lepetitdeslices.com
D: bertrand petit C: enguer messin, bertrand pigois
P: vignerons de la voie-romaine M: bertrand.petit@expressiv.net

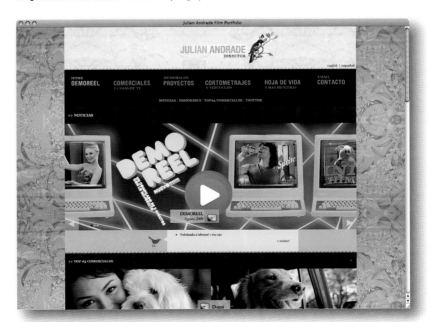

www.julianandrade.com
D: julian andrade C: julian andrade
P: julian andrade M: info@julianandrade.com

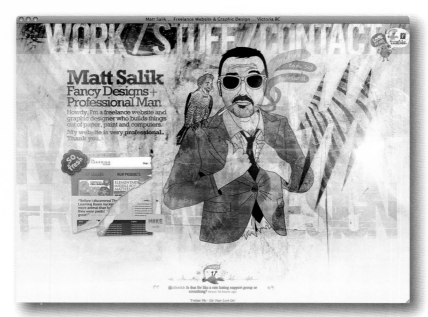

www.mattsalik.com
D: matt salik C: matt salik
P: matt salik M: matt@mattsalik.com

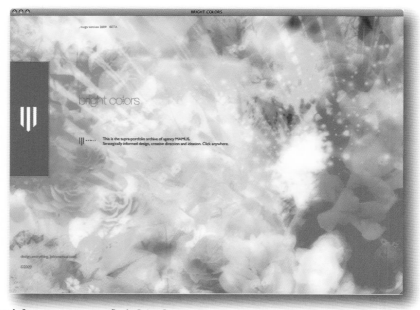

www.johnmamus.com/brightcolors
D: john mamus C: laszlo tandi
M: john@mamuscreative.com

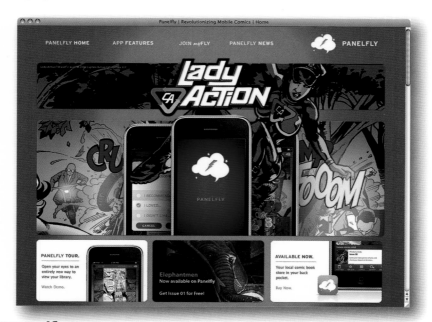

www.panelfly.com
D: stephen lynch C: stephen lynch, jules janssen
P: panelfly M: stephen@panelfly.com

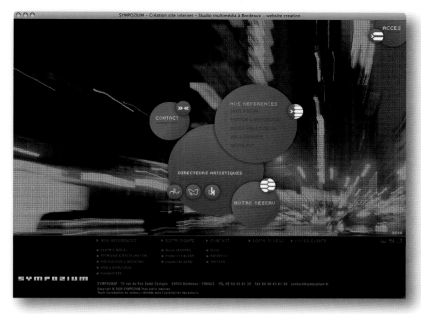

www.sympozium.fr

D: david janssen, frederick lackmy, laurent elgard C: frederick lackmy
P: sympozium M: contact@sympozium.fr

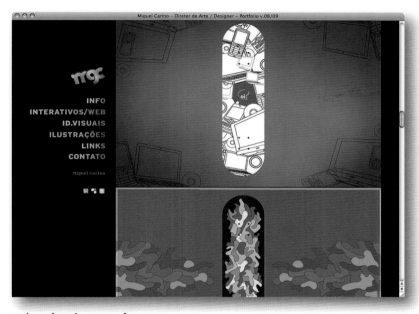

www.miguelcarino.com.br

D: miguel carino C: miguel carino
P: miguel carino M: contato@miguelcarino.com.br

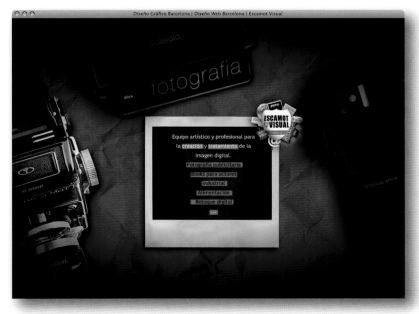

www.escamotvisual.com

D: escamot visual, raül roch C: escamot visual, joan manel moran
P: escamot visual M: info@escamotvisual.com

www.lecaid.com

D: katja pilz C: robert schwieger
M: katja@lecaid.com

liondance.lungkong.org

D: travis lum C: travis lum
P: lung kong physical culture club M: travis@travislum.com

www.designbysenso.com

D: senso studios
P: senso studios M: hello@designbysenso.com

www.alewivesfabrics.com
D: big room studios, samuel mateosian, rhea daiute C: big room studios
P: barbara neeson M: alewives@alewivesfabrics.com

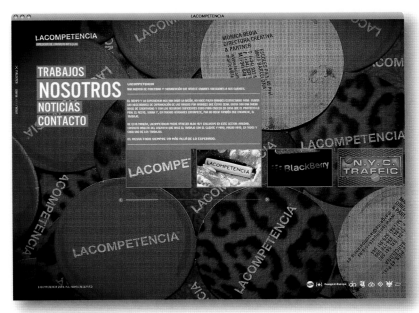

www.lacompetencia.es
D: oriol bèdia, 2otsu C: oriol bèdia, 2otsu
M: talk@2otsu.com

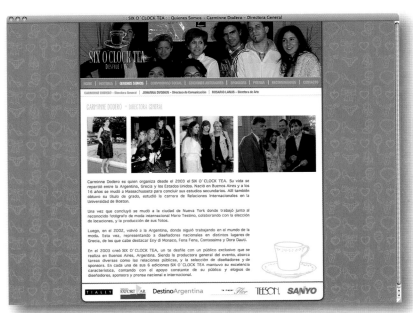

www.sixoclocktea.com.ar
D: florencia sadous C: santiago sadous
P: 6elementos_cs M: info@6elementos.com.ar

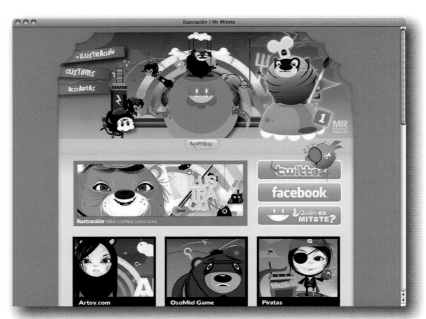

www.mrmitote.com.mx

D: mr. mitote C: roger, rick, mr. mitote
P: mr. mitote M: mr.mitote@hotmail.com

www.schema.gr

D: dimitra chrona C: optimedia
P: schema design M: dchrona@schema.gr

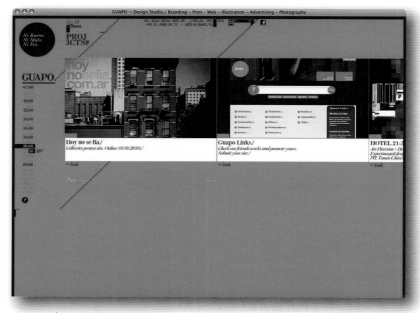

www.guapo.tv

D: esteban ibarra C: esteban ibarra
P: guapo design studio M: info@guapo.tv

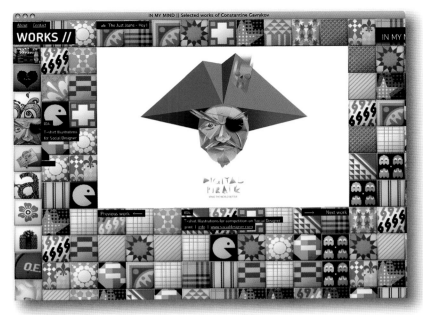

www.inmmnd.com

D: constantine gavrykov C: andrew guryanov, sergiy kosharuk
P: constantine gavrykov M: inmmnd@gmail.com

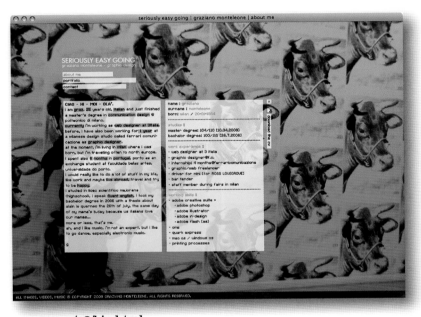

www.g-raz.com/v2/bio.html

D: graziano monteleone C: graziano monteleone
P: graziano monteleone M: gra.monteleone@gmail.com

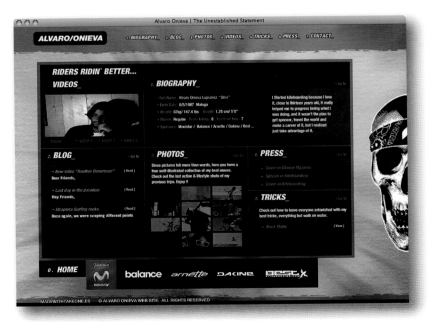

www.alvaronieva.com

D: takeone.es C: q-interactiva
P: takeone.es M: tk1@takeone.es

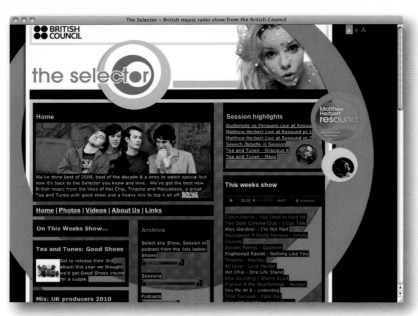

www.selector-radio.com

D: steven oakes, sean mort C: steven oakes
P: hotpot digital M: steven@hotpotdigital.com

www.cristinavaz.com

D: cristina vaz
P: cristina vaz M: info@cristinavaz.com

kreativer-kopf.de

D: käthe schomburg C: jost hannemann
P: kreativer kopf M: ks@kreativer-kopf.de

www.aziendavitivinicolacasa.it

D: francesca autiello, massimiliano autiello C: massimiliano autiello, francesca autiello
P: azienda vitivinicola casà M: info@autandaut.it

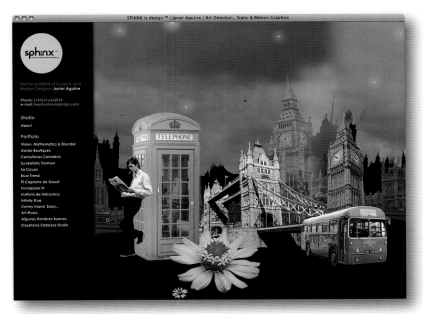

www.sphinxisdesign.com

D: javier aguirre C: javier aguirre
P: javier aguirre M: hey@sphinxisdesign.com

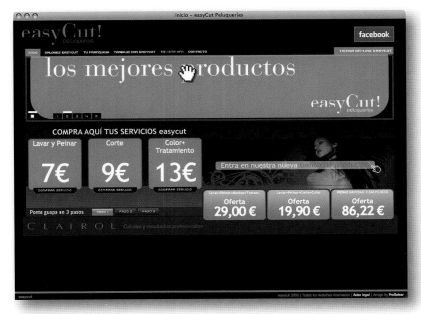

www.easycut.es

D: probalear C: probalear
P: easycut M: creativos@probalear.info

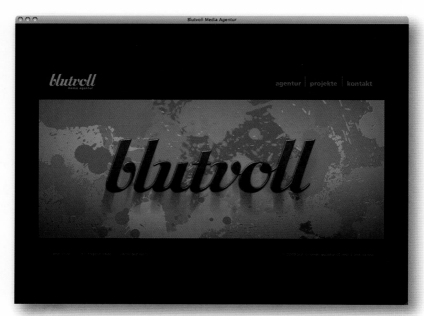

www.blutvoll.de

D: blutvoll media agentur, markus huber C: blutvoll media agentur, markus huber
P: blutvoll media agentur M: info@blutvoll.de

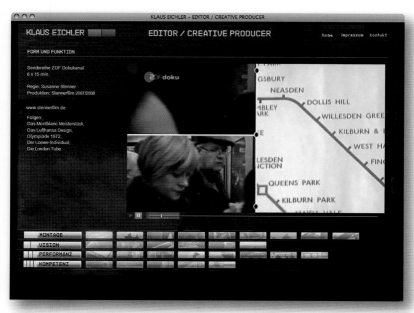

www.klauseichler.de

D: corina giller, markus egerter C: markus egerter
P: corina giller M: hello@mingmekka.com

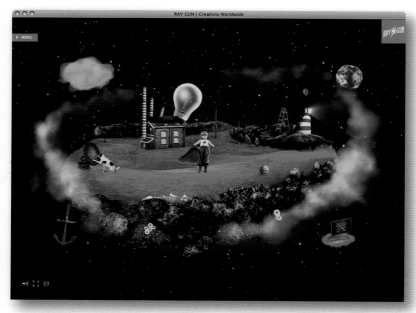

www.ray-gun.pt

D: ray gun, hugo filipe pinto, tiago rio C: tiago rio
P: ray gun M: contacto@ray-gun.pt

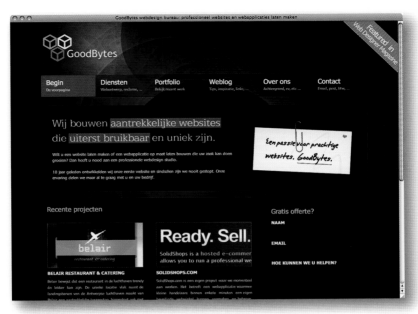

www.goodbytes.be
D: joris hens C: joris hens
P: goodbytes.be M: jorrespam@gmail.com

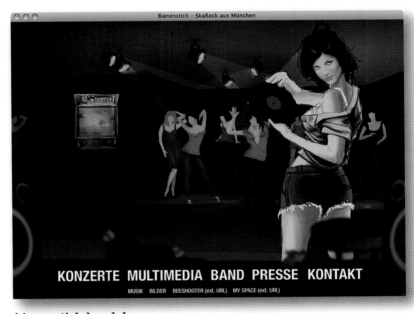

www.bienenstich-band.de
D: blutvoll media agentur, felix temmler, laura klohn C: blutvoll media agentur, markus huber
P: bienenstich M: info@blutvoll.de

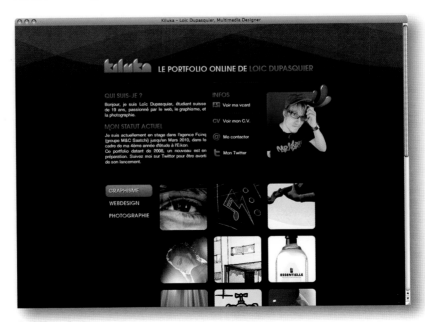

www.kiluka.ch
D: loic dupasquier C: loïc dupasquier
M: loicdupasquier@kiluka.ch

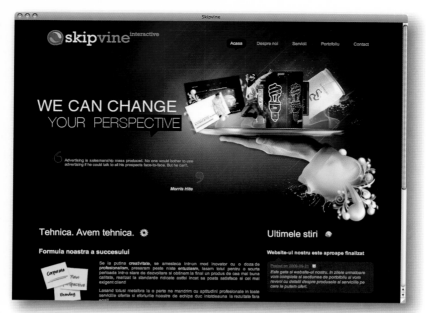

skipvine.ro

D: ionut zamfir C: victor zamfir
P: skipvine interactive M: ionut.zamfir@skipvine.ro

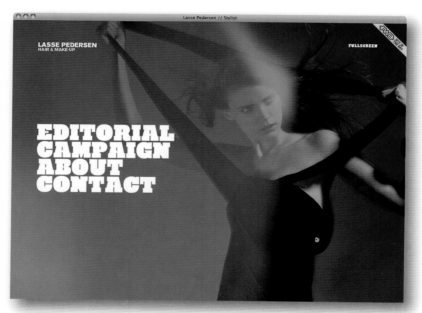

lassepedersen.biz

D: pelle martin C: felix nielsen
P: lasse pedersen M: me@iampelle.com

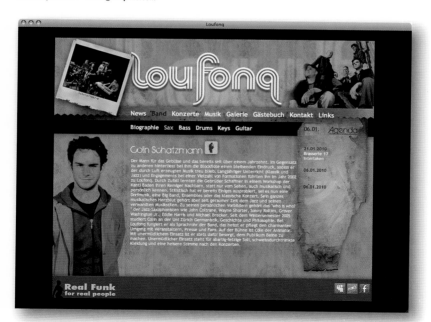

www.loufonq.ch

D: yves lüthi, claude lüthi C: yves lüthi
P: loufonq M: yves@welovekicks.ch

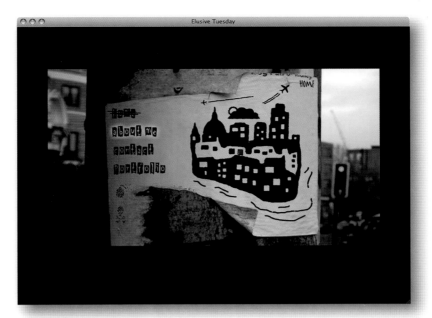

www.elusivetuesday.com

D: alix poscharsky C: alix poscharsky
P: alix poscharsky M: youssou@linuxmail.org

www.bozhinovskidesign.com

D: valentin petroff C: valentin petroff
P: bozhinovski design M: info@bozhinovskidesign.com

www.tiagoc.com

D: tiagoc C: tiagoc
P: tiagoc M: creative@tiagoc.com

www.lastnightadjsavedmylife.com

D: mathieu zylberait C: mathieu zylberait
P: norman scherer M: mathieu@adenek.com

www.flipinmental.info

D: maría jesús escosura C: maría jesús escosura muñoz
M: mjescosura@gmail.com

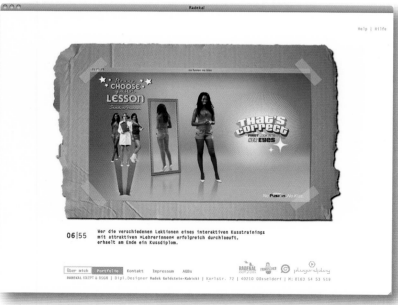

www.radekal.de

D: radek goldstein-kubicki C: christoph landers
P: radek goldstein-kubicki M: radek@radekal.de

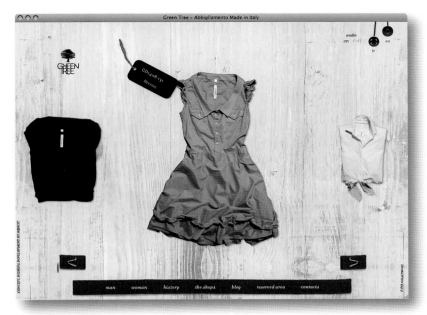

www.greentree.it
D: aquest.it C: aquest.it
P: greentree M: fmerlin@aquest.it

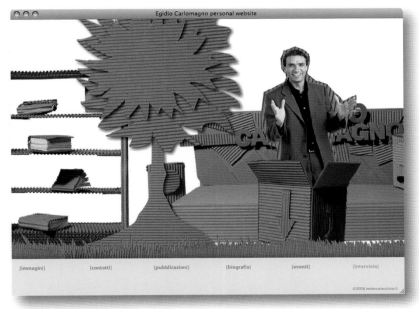

www.egidiocarlomagno.it
D: marco mattio, motoreacreazione.it C: marco mattio
P: egidio carlomagno M: marco@motoreacreazione.it

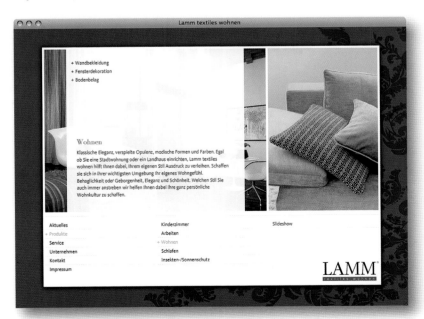

www.textiles-wohnen.de
D: franka futterlieb C: franka futterlieb
P: frank lamm M: reception@urbn.de

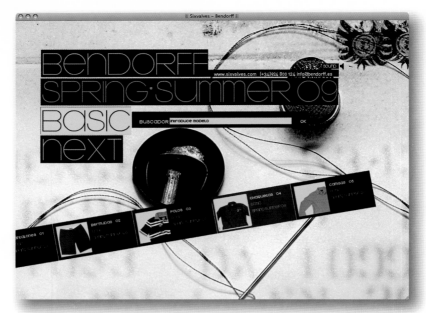

www.bendorff.es

D: alejandro baquero C: antonio garcia

P: aunamedia M: alebaquero@lamadruga.com

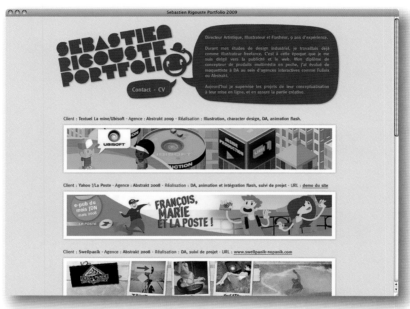

www.sebastienrigouste.com

D: sebastien rigouste C: sebastien rigouste

P: sebastien rigouste M: srigouste@gmail.com

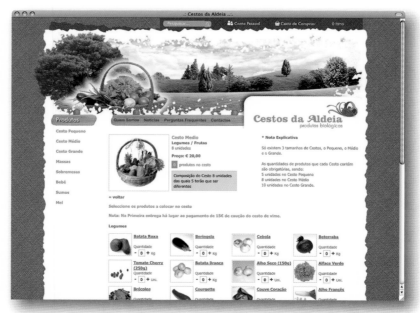

www.cestosdaaldeia.pt

D: ana abreu C: ana abreu

P: ana abreu M: info@coresaocubo.pt

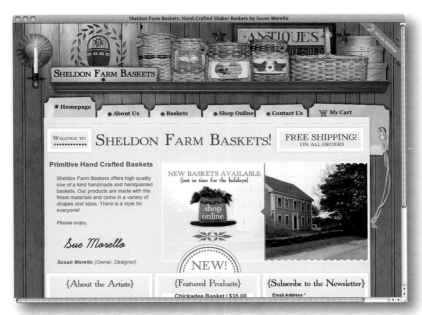

www.sheldonfarmbaskets.com
D: mikal morello, micagrafica C: mikal morello
P: sheldon farm baskets M: mikal@micagrafica.com

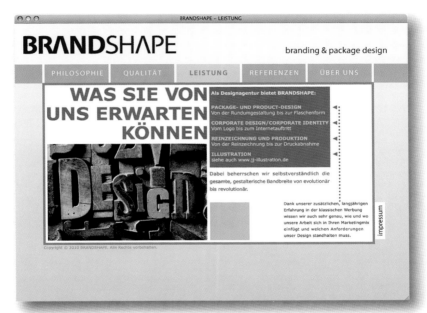

www.brandshape.de
D: brandshape, jan o. jentsch C: brandshape
P: brandshape M: mail@brandshape.de

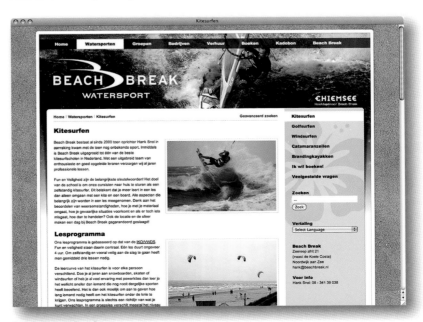

www.beachbreak.nl
D: bas boerman C: bas boerman
P: bas boerman M: info@basboerman.nl

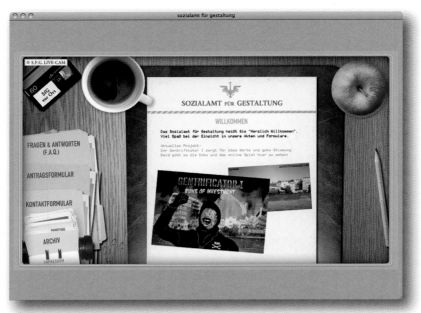

www.sozialamt-fuer-gestaltung.de

D: giraffentoast C: giraffentoast

P: giraffentoast design gmbh M: antrag@sozialamt-fuer-gestaltung.de

www.wonowmedia.com

D: emily haggar C: yellowseed web development

P: vince hempsall M: info@wonowmedia.com

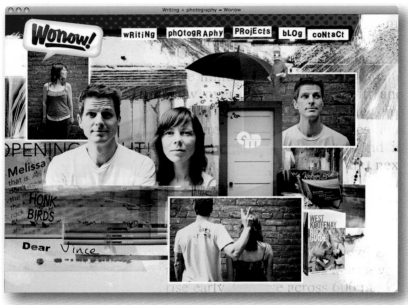

www.notecomaslamanzana.com

D: berth99 C: berth99

P: javier ossorio - sintesis producciones M: contacto@berth99.com

240

www.hibriden.com

D: felix espinoza C: felix espinoza

P: hibriden studio M: felix@hibriden.com

www.bgs-architekten.com

D: fantonnet gmbh, marisa hangartner C: marisa hangartner

P: bgs architekten rapperswil-jona M: paul.rickli@bgs-architekten.ch

www.dspcreativity.com

D: césar g. pérez C: césar g. pérez

P: césar g. pérez M: info@dspcreativity.com

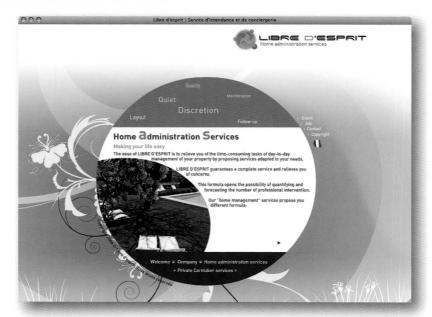

www.libredesprit.com

D: michael van-houten C: pixilog
P: pixilog M: contact@pixilog.com

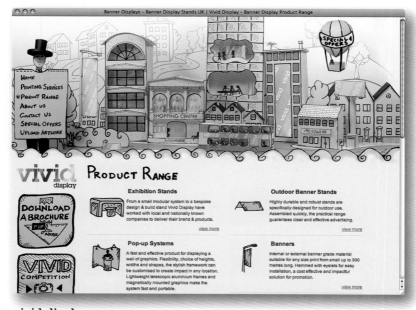

www.vivid-display.com

D: martin pownall, grzegorz kozakiewicz C: grzegorz kozakiewicz
P: martin pownall M: msp@allendesigngroup.com

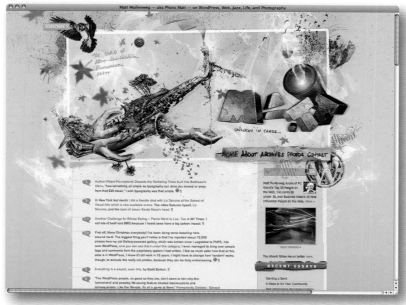

ma.tt

D: joolz, julien morel C: brian collinger
P: matt mullenweg M: hello@joolz.fr

www.deineschoenewelt.de

D: stefie furtner C: stefie furtner
P: stefie furtner M: stefie.furtner@deineschoenewelt.de

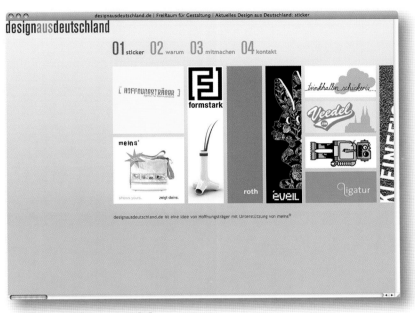

www.designausdeutschland.de

D: dierk roeder, hoffnungsträger C: dierk roeder, hoffnungsträger
P: hoffnungsträger - agentur für kommunikation M: d.roeder@die-hoffnungstraeger.de

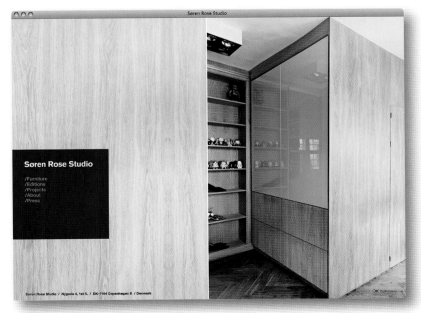

sorenrose.com

D: pelle martin C: felix nielsen
P: søren rose kjær M: me@iampelle.com

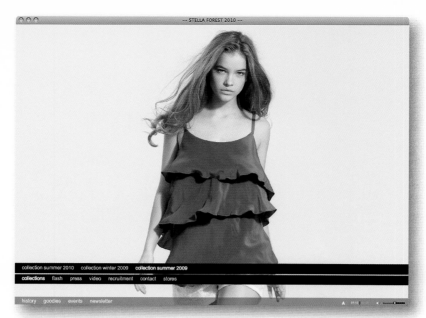

www.stellaforest.fr

D: eedesign C: www.eedesign.fr
P: stella forest M: contact@eedesign.fr

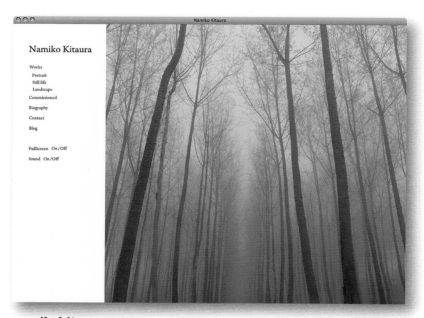

www.namikokitaura.com

D: angela lidderdale
M: namiko@namikokitaura.com

www.colewelty.com

D: cole welty C: cole welty
P: cole welty M: cole.welty@gmail.com

www.pejola.com
D: jana pejoska C: jana pejoska
P: jana pejoska M: pejola@gmail.com

www.atolmag.com
D: ideoma C: ideoma
P: ideoma M: geral@atolmag.com

www.inteko.it
D: matteo ziviani C: matteo ziviani
P: trevisan finishing systems M: m.ziviani@sanzeno.org

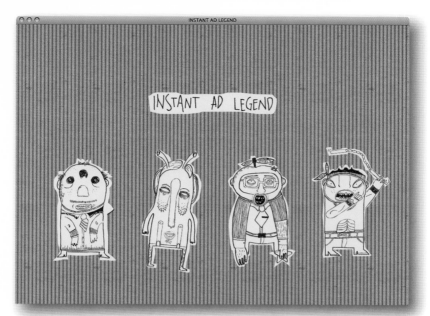

www.instantadlegend.com

D: sara kujundzic C: laureano solis

P: sara kujundzic, ruchir sachdev M: saraqujundzic@gmail.com

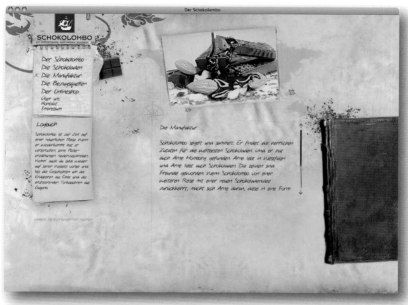

www.schokolombo.at

D: rubikon werbeagentur gmbh, richard hudeczek C: rubikon werbeagentur gmbh

P: rubikon werbeagentur gmbh M: office@rubikon.at

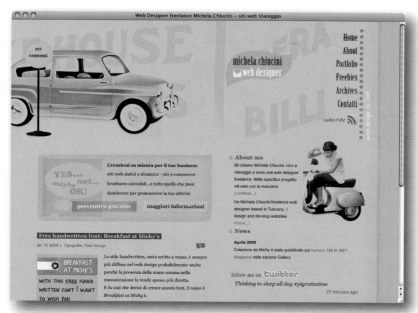

www.colazionedamichy.it

D: michela chiucini C: michela chiucini

P: michela chiucini M: info@colazionedamichy.it

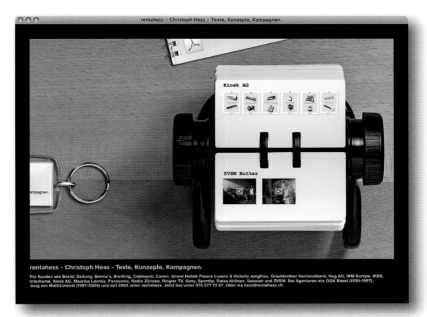

www.rentahess.ch
D: christoph dubach, marc rinderknecht C: christoph dubach, marc rinderknecht
M: info@codama.ch

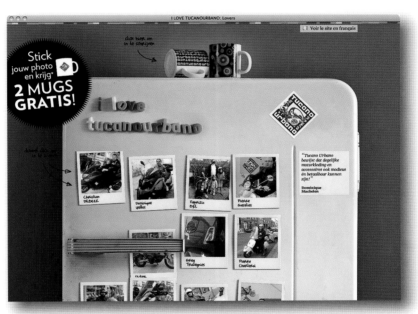

www.ilovetucanourbano.be
D: thibault klijkens C: thibault klijkens
P: dlv import sa/nv M: thibault@klijkens.be

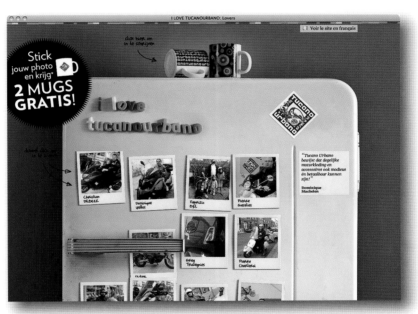

www.c-jardin.fr
D: studio graphique becom C: nathalie erb
P: cote jardin M: contact@c-jardin.fr

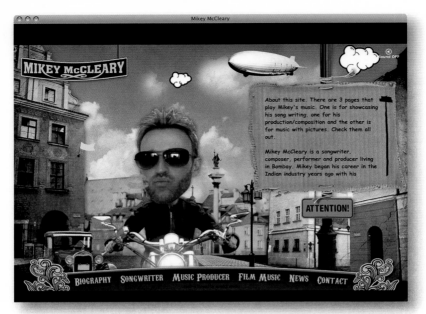

mikeymccleary.com
D: amol dalvi, mikey mccleary
P: mikey mccleary M: mikeymccleary@btinternet.com

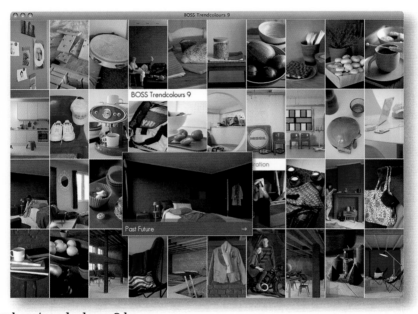

www.bosstrendcolours9.be
D: ram broekaert, mediamind.be C: neuroproductions.be
P: boss paints M: ram@mediamind.be

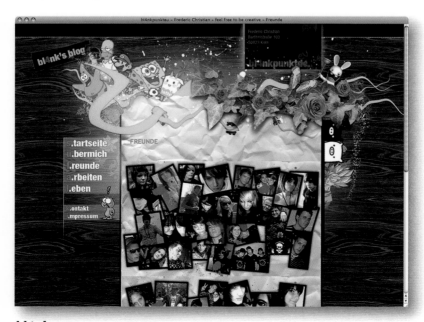

www.bl4nk.eu
D: frederic christian C: frederic christian
P: frederic christian M: frederic.christian@web.de

www.organicadg.com
D: maria bravo montarelo C: maria bravo montarelo
M: organicadg@gmail.com

www.mountain-factory.com
D: adrien heury C: noe interactive
P: mountain-factory M: info@noe-interactive.com

www.pixelplanet.it
D: alfdesign C: raffaele turci, simon lövgren
P: pixelplanet, matteo bosi M: info@alfdesign.com

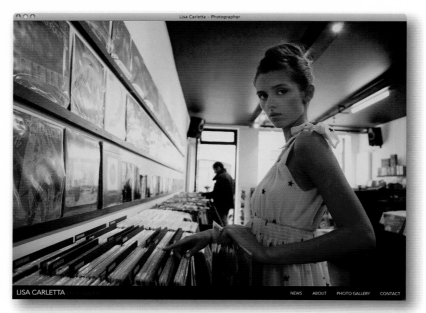

www.lisacarletta.be

D: nicolas lair C: nicolas lair

P: lisa carletta M: info@lisacarletta.be

www.ericsteuten.nl

D: eric steuten C: eric steuten

P: eric steuten M: webmaster@ericsteuten.nl

camille.boidron.me

D: camille boidron C: anthor

P: camille boidron M: c.boidron@yahoo.fr

www.rachelreveley.co.uk

D: rachel reveley C: rachel reveley
P: rachel reveley M: rachelreveley@hotmail.com

www.mademoisellelychee.com

D: amelie bracq, mademoiselle lychee C: pierre moati
M: mademoiselle.lychee@gmail.com

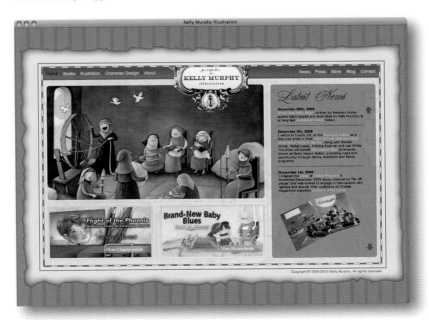

www.kelmurphy.com

D: antoine revoy
M: kelly@kelmurphy.com

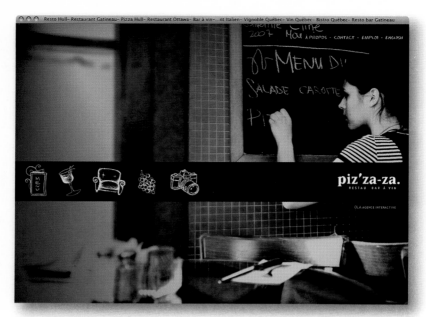

www.pizzaza.ca

D: ola interactive agency C: ola interactive agency
P: piz'za-za M: info@olainteractive.ca

www.identidad.tv

D: fede puopolo, leandro lazzeretti, identidad C: javier españa, identidad
P: identidad M: info@identidad.tv

www.burnedbrain.com

D: simone simola C: simone simola
P: simone simola M: simone@burnedbrain.com

www.plazaarte.com.ar

D: luciano candotti C: luciano candotti
P: plaza arte M: lcandotti@gmail.com

www.outofmedia.com

D: matteo rostagno C: riccardo campioni
P: out of media s.n.c. M: teoross@gmail.com

www.ilovecolors.com.ar

D: elio rivero C: elio rivero
P: elio rivero M: eliorivero@gmail.com

www.leonardospina.com

D: leonardo spina C: leonardo spina
P: leonardo spina M: info@leonardospina.com

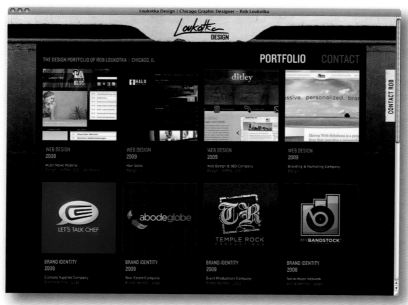

www.loukotka.com

D: rob loukotka C: rob loukotka
P: loukotka design M: rob@loukotka.com

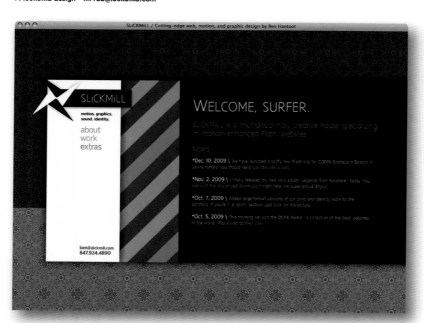

www.slickmill.com

D: ben hantoot C: ben hantoot
P: slickmill M: ben@slickmill.com

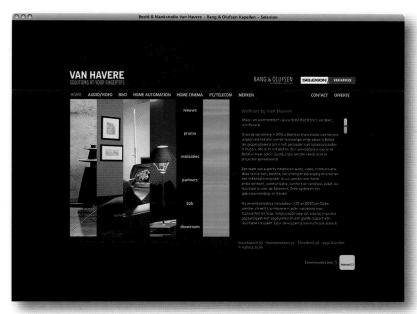

www.vanhavere.be

D: weblounge C: weblounge

P: vanhavere kapellen M: info@weblounge.be

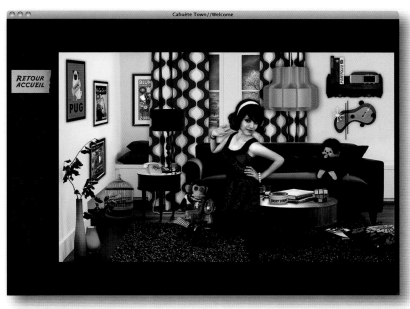

www.lamiecahuete.com

D: caroline loehr becker C: caroline loehr becker

P: www.lamiecahuete.com M: contact@lamiecahuete.com

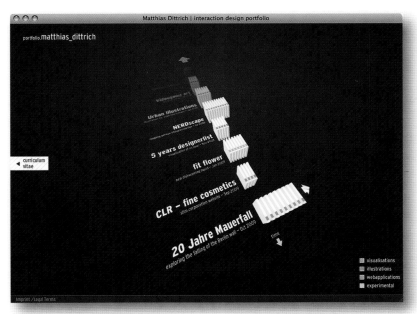

www.matthiasdittrich.com

D: matthias dittrich C: matthias dittrich

P: matthias dittrich M: info@matthiasdittrich.com

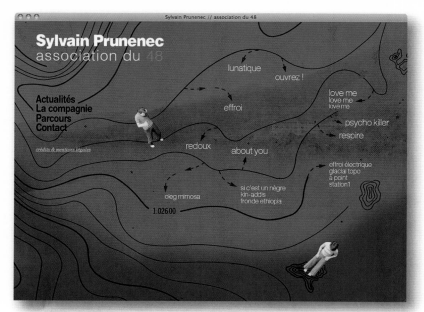

www.sylvainprunenec.fr
D: bleuceladon, sylvie meunier C: bleuceladon, sylvie meunier
P: association du 48 M: contact@bleuceladon.com

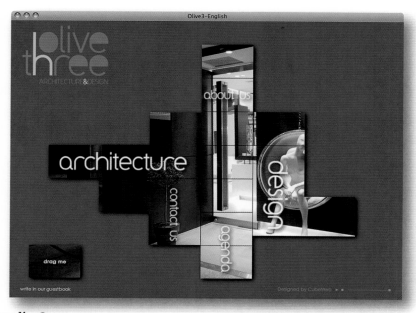

www.olive3.gr
D: nontas ravazoulas C: nontas ravazoulas
P: nontas ravazoulas M: info@cubeweb.gr

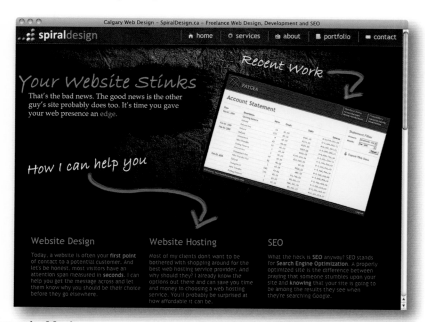

www.spiraldesign.ca
D: mike barnlund C: mike barnlund
P: mike barnlund M: mike@spiraldesign.ca

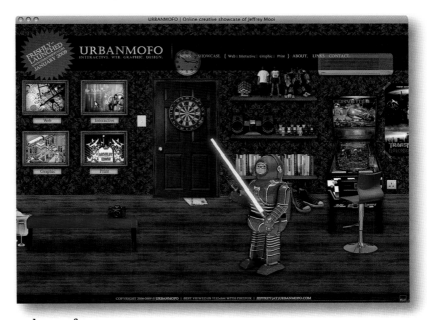

www.urbanmofo.com

D: jeffrey mooi C: jeffrey mooi
M: jeffrey@urbanmofo.com

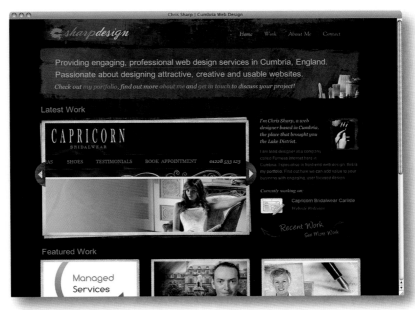

www.csharpdesign.co.uk

D: chris sharp C: chris sharp
P: chris sharp M: enquiries@csharpdesign.co.uk

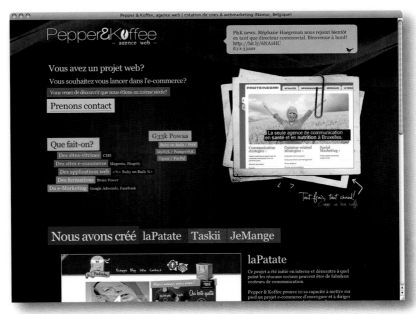

www.pepperkoffee.com

D: pepper & koffee C: pepper & koffee
P: pepper & koffee M: hello@pepperkoffee.com

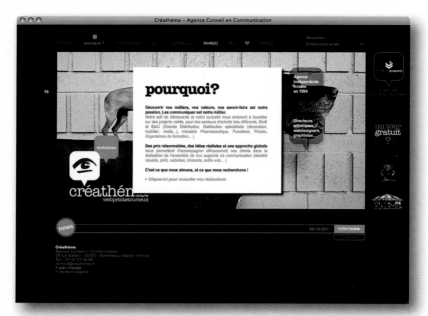

www.creathema.fr

D: nicolas valla creathema C: bertrand delanissays, amandia kuoch
P: creathema M: nicolas.valla@creathema.fr

www.thereverse.net

D: elvis d'sgn C: elvis d'sgn
P: the reverse M: contact@elvisdesign.it

www.nicolasdimeo.ch

D: nicolas di meo C: nicolas di meo
P: nicolas di meo M: dimeo.nicolas@gmail.com

www.mijnpassieineenkassie.nl

D: tom aizenberg

P: mijn passie in een kassie M: tom@tomaizenberg.nl

mousewillplay.co.uk

D: mouse will play, helen olney, rachelle meyer C: mouse will play

P: mouse will play M: info@mousewillplay.co.uk

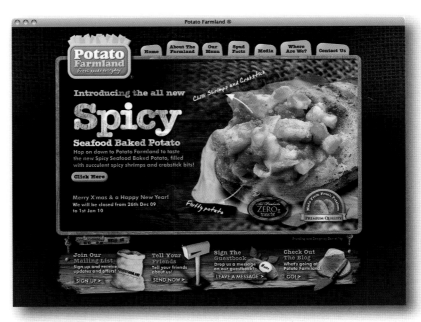

www.potatofarmland.com

D: daniel ng wei ta C: daniel ng wei ta

P: potato farmland M: contact@daniel-ng.net

www.spijkersite.com

D: ines van belle C: ines van belle
M: info@pinker.be

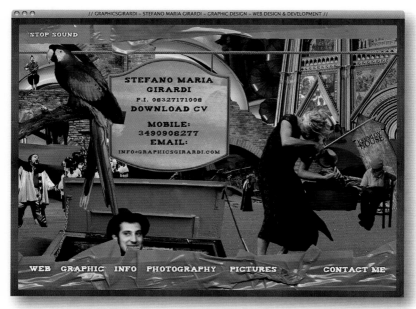

www.graphicsgirardi.com

D: stefano maria girardi C: stefano maria girardi
P: stefano maria girardi M: info@graphicsgirardi.com

www.ombulifestyle.com

D: nicolas mattioli, sin fin, ombu lifestyle C: nicolas mattioli
P: maria laura alemann M: marie@ombulifestyle.com

vinners.pl/dookolaswiata

D: emilia obrzut, maciek kozłowski, studio fru C: paweł gajewski, krzysztof opałka, paweł gajewski
P: vinners M: fru@studiofru.pl

www.denisolenik.com

D: denis olenik C: alexey loginov
P: denis olenik M: info@denisolenik.com

www.graphicdesign.bg

D: valentin petroff C: valentin petroff
P: valentin petroff M: info@graphicdesign.bg

261

www.zafferano.pt

D: softway.net C: softway.net
P: zafferano italian restaurant M: info@softway.pt

www.theseen.biz

D: the seen C: adrian morley
P: the seen M: amorley@theseen.biz

www.tisophoto.com

D: oleg slepcoff C: honza mensik
P: martin tiso M: tisophoto@gmail.com

www.guysfromthecaravan.com
D: daniel barradas C: rui simões
P: rui simões M: rui@pixelstudio.pt

www.minsic.com
D: simone carozzi C: simone carozzi
P: minsic studio M: info@minsic.com

www.petokata.com
D: kilfish C: kilfish
P: kilfish M: kilfish@kilfish.com

www.yarkamiller.com

D: jesús fernández C: isaac león
P: yarka miller M: info@tropart.com

www.kuhboom.com

D: neil wills C: neil wills
P: neil wills M: design@kuhboom.com

www.loshijosdejackson.com

D: devorame otra vez C: mauro hidalgo, kenji tanamachi
P: los hijos de jackson M: mauro@devorameotravez.com

www.g2webdesign.com.br
D: g2 web design **C:** g2 web design
P: g2 **M:** ggamaster@hotmail.com

www.cath-immod.com
D: arôme
M: besoin-de@arome.fr

www.thechocolatebullet.com
D: 51north **C:** 51north
P: visser chocolates **M:** info@thechocolatebullet.com

www.suna.com.co

D: rwm studios C: evans daza
P: suna colombia M: camilos13@hotmail.com

www.prolographie.com

D: vincent pucheux, karine prolo C: vincent pucheux, jason prolo
P: vincent pucheux M: vncntprolo@gmail.com

www.daniel-ng.com

D: daniel ng wei ta C: daniel ng wei ta
P: daniel ng wei ta M: contact@daniel-ng.net

www.antonintesar.com
D: pavel valek C: david rychly
M: info@studio9.cz

www.ideen-im-blut.de
D: pia hölzinger C: michael rinn
P: michael rinn M: info@imedia-design.de

www.rentstudiocologne.com
D: nowakstudios C: justin windle
P: nowakstudios rent M: hello@nowakstudios-rent.com

www.licornpublishing.com

D: aurélien guillaume C: aurélien guillaume
P: aurélien guillaume M: contact@licornpublishing.com

www.julesb.fr

D: jules battais C: jules battais
P: jules battais M: contact@jules.fr

www.simpleart.com.ua

D: simpleart C: simpleart
P: simpleart M: manager@simpleart.com.ua

www.nandoesteva.com

D: xavi royo C: octavio imazio

P: xavi royo M: xavi@grupovisualiza.com

nouincolor.com

D: oskar krawczyk C: oskar krawczyk

P: nouincolor M: thereis@nouincolor.com

www.greenfreshweek.com

D: nuno serrão C: urb

P: fresh citrus M: info@greenfreshweek.com

www.diegutgestalten.de

D: jan wischermann, goran poznanovic, andreas ennemoser C: alexander valentin

P: creative studio diegutgestalten M: jan@diegutgestalten.de

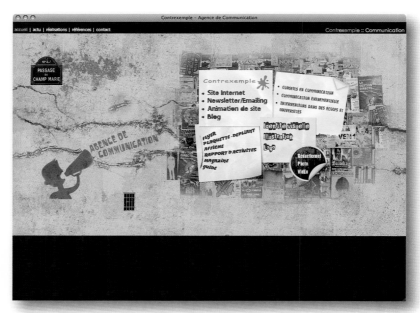

www.contrexemple.com

D: matthias sorge, audrey sorge C: matthias sorge

P: contrexemple M: contact@contrexemple.com

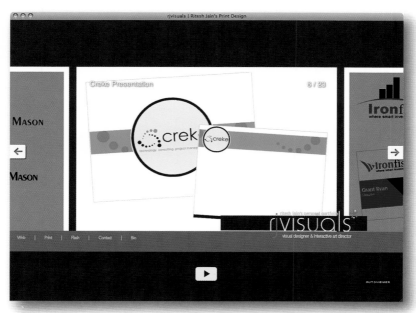

www.rjvisuals.com

D: ritesh jain

M: ritesh_urdera2003@yahoo.com

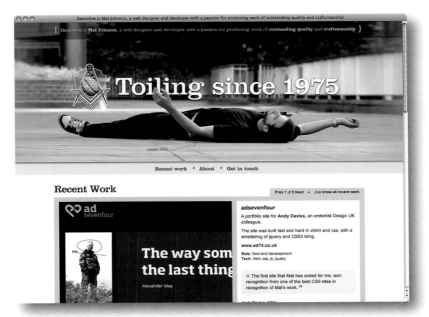

www.demotive.com

D: mat johnson C: mat johnson
M: mat@demotive.com

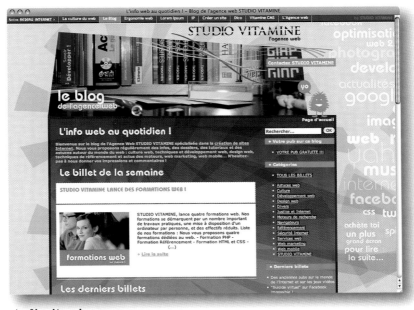

blog.studiovitamine.com

D: stéphane nicolas C: fabien branchut
M: contact@studiovitamine.com

theartistvisa.com

D: jpd studio C: jpd studio
P: alejandro filippa, esq. M: design@jpdstudio.com

www.colmo.cz

D: colmo C: duclair

P: colmo M: info@colmo.cz

www.mitosurbanos.org

D: nuno serrão C: urb

P: urb M: nunoserrao@madeirabynight.com

www.momu.com

D: sensis studio I london webdesign agency C: sensis studio I london webdesign agency

P: momu M: hello@sensis-studio.com

www.ateliergmp.cz

D: pavel micek, gabriela markova C: pavel micek
P: atelier gmp M: micek@ateliergmp.cz

www.bcandullo.com

D: brad candullo C: brad candullo
P: brad candullo M: brad@bcandullo.com

www.le198bis.com

D: intartaglia marine, woo theme
P: intartaglia marine M: intartagliamarine@gmail.com

www.atomoconsultores.com

D: luis miguel martínez bonilla C: luis miguel martínez bonilla
P: corporativo atomo M: luismiguel@atomoconsultores.com

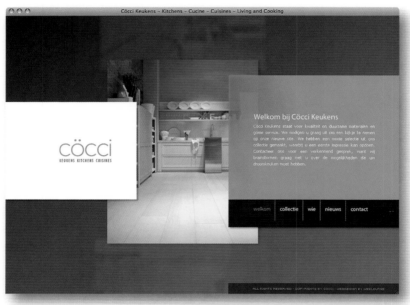

www.cocci.be

D: weblounge C: weblounge
P: cöcci M: info@weblounge.be

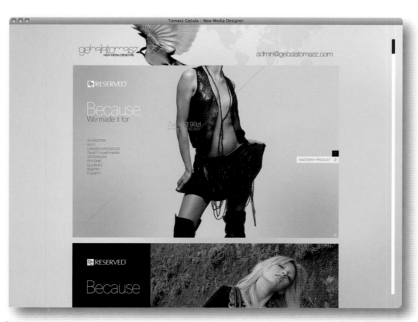

gebalatomasz.com

D: tom gebala C: tom gebala
M: admin@gebalatomasz.com

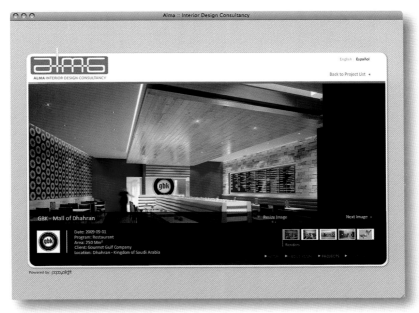

www.almadesignconsultancy.com

D: santiago vergara C: alexander aguilar
P: alma design consultancy M: svergara@papayalight.com

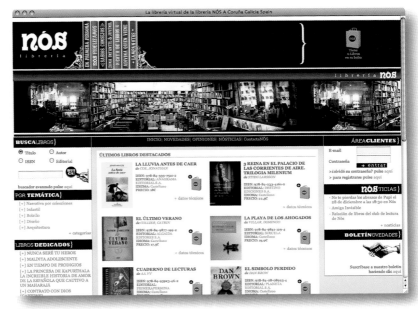

www.librerianos.com

D: anna maria lopez lopez C: anna maria lopez lopez
P: libreria nos M: hello@anna-om-line.com

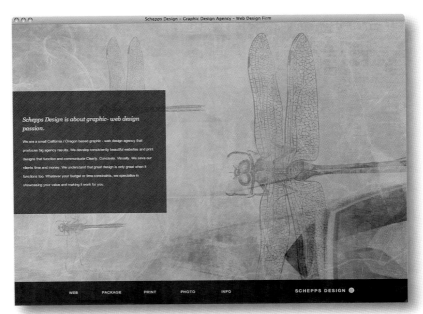

www.scheppsdesign.com

D: bryan schepps C: schepps design
P: schepps design M: bryan@scheppsdesign.com

www.maitevega.com

D: carmen trivino C: carmen trivino
P: puntobarros M: contact@puntobarros.com

www.enet.it

D: laura easynet C: monica easynet
P: easynet M: info@enet.it

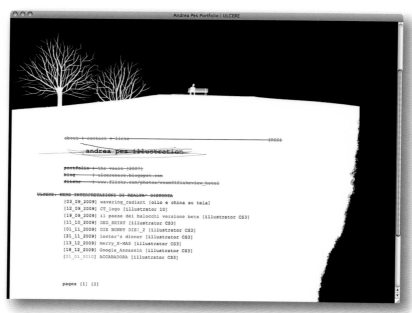

www.andreapes.com

D: andrea pes C: andrea pes
M: info@andreapes.com

www.ladupla.net

D: ernesto ramirez C: ernesto ramirez

P: ernesto ramirez, carlos rivas, davian martinez M: ernesto@ladupla.net

www.rotumatica.com

D: alejandro gallardo C: juan cuenca

P: www.rotumatica.com M: info@articoestudio.com

www.vahrammuradyan.com

D: vahram muradyan C: www.helix.am

P: vahram muradyan M: mail@vahrammuradyan.com

www.articoestudio.com

D: alejandro gallardo C: juan cuenca
P: www.articoestudio.com M: info@articoestudio.com

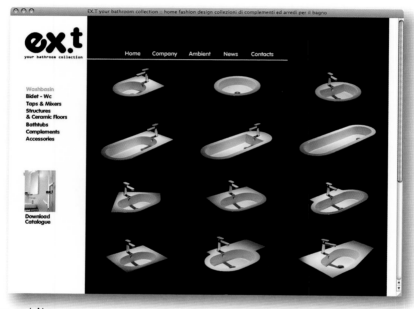

www.ex-t.it

D: alessio papi C: nextopen multimedia company
P: alessio papi M: info@nextopen.it

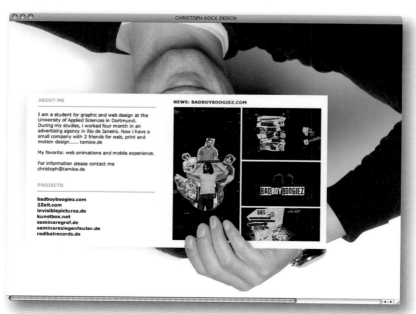

www.christophkock.com

D: christoph kock C: christoph kock
P: christoph kock M: christoph@tamioe.de

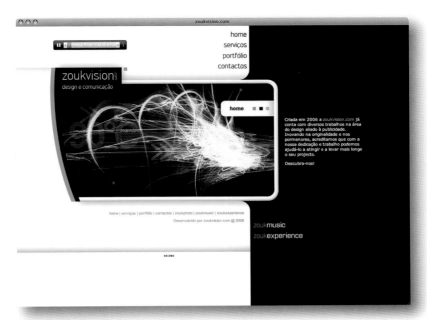

www.zoukvision.com
D: pedro ribeiro
M: geral@zoukvision.com

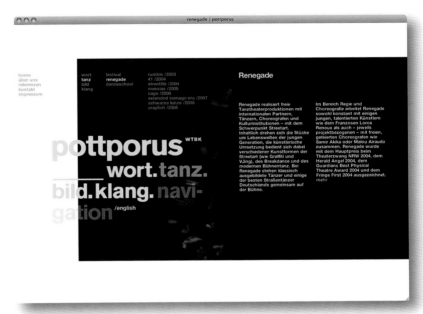

www.pottporus.com
D: büro für grafik design, raffael stüken C: raffael stüken
P: pottporus. zekai fenerci M: post@raffaelstueken.de

www.valencestudio.com
D: markus raffelsberger, michael zagorski C: klaus prochart, helmut prochart, sitedefinition
P: valence M: sitedefined@sitedefinition.at

www.djchrislegrand.com

D: janus networks C: manuel mair
P: chris legrand M: office@jnetworks.at

www.niksone.com

D: niksone rusin C: niksone rusin
P: niksone M: contact@niksone.com

www.radicallow.com

D: reg herygers, alex verswijvel C: reg herygers
M: info@undercast.com

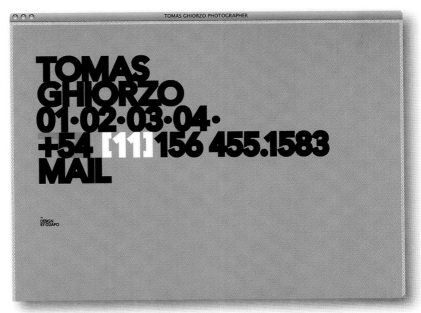

www.tomasghiorzo.com.ar

D: guapo C: esteban ibarra
P: tomas ghiorzo photographer M: info@guapo.tv

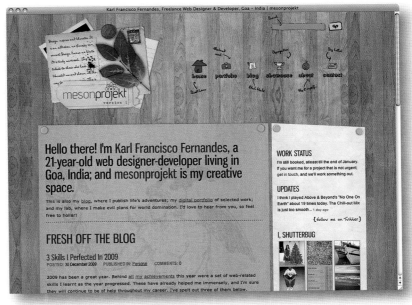

mesonprojekt.com

D: karl francisco fernandes C: karl francisco fernandes
P: karl francisco fernandes M: karl@mesonprojekt.com

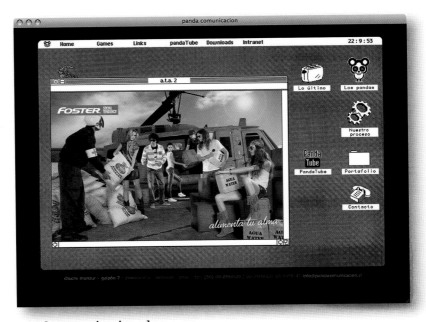

www.pandacomunicacion.cl

D: bernardita cossio, sebastian massoud, panda C: agustin arteaga
P: panda M: carlos@pandacomunicacion.cl

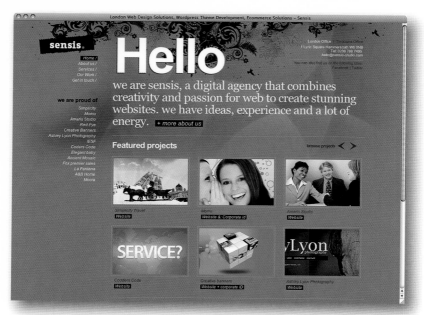

www.sensis-studio.com

D: sensis studio C: sensis studio
P: sensis studio M: hello@sensis-studio.com

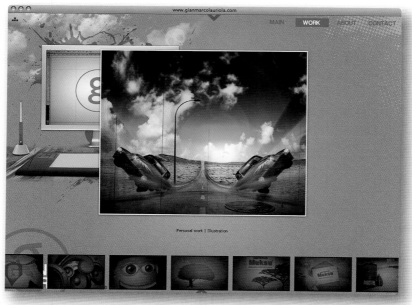

www.gianmarcolauriola.com

D: gianmarco lauriola C: gianmarco lauriola
P: gianmarco lauriola M: hello@gianmarcolauriola.com

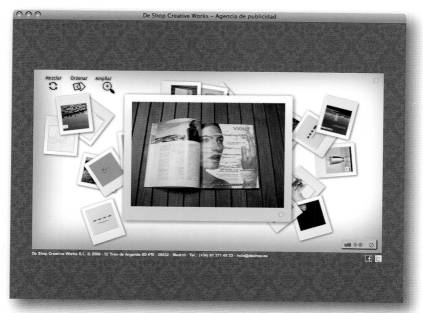

www.deshop.es

D: alex canora C: jaime padín
P: alex canora, jaime padín M: acanora@deshop.es

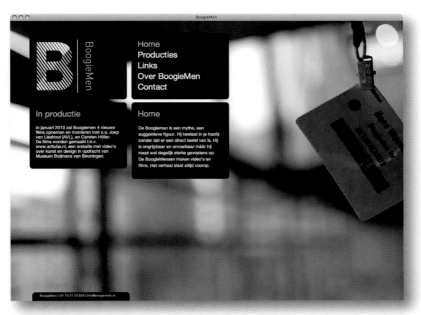

www.boogie-men.nl

D: tot en met ontwerpen C: blender, www.blender-online.nl
P: boogiemen M: info@blender-online.nl

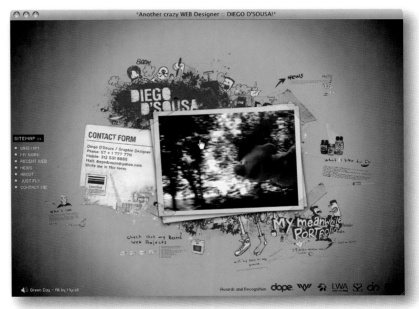

www.diegodsousa.com

D: diego d'sousa C: diego d'sousa
M: diegodsousa@yahoo.com

www.giovannitresso.com

D: giovanni b. tresso C: daniele gibertoni
M: info@giovannitresso.com

www.wohlklang.com

D: bernhard hümmer C: bernhard hümmer
P: bernhard hümmer M: icamefrommars@gmx.de

www.drukkerij-vaes.be

D: lawless & lotski C: lawless & lotski
P: drukkerij vaes M: info@lawlesslotski.nl

www.dcdecorators.com

D: root studio C: root studio
P: root studio M: design@rootstudio.co.uk

www.domgartenhof.de
D: daniel jansen, jansen-design C: daniel jansen
P: domgartenhof winningen M: info@domgartenhof.de

www.bayco.com
D: brian moghadam C: oneclickidea
P: bayco M: brian@bmoghadam.com

www.evacollini.com
D: @work milano, elisa terruzzi C: dejana pupovac, elisa teruzzi
P: eva collini M: web@macatwork.net

www.faithfashion.eu

D: effective studio di luca fadigati C: effective studio di luca fadigati

P: faith di federica sassella M: info@effectivestudio.com

screenagers.com

D: screenagers gmbh C: screenagers gmbh

P: screenagers gmbh M: office@screenagers.com

www.moritz.com.au

D: peter howie C: rare identity

P: rare identity M: info@rareid.com.au

www.carolinagomez.net

D: santiago vergara C: alexander aguilar
P: carolina gomez M: svergara@papayalight.com

www.souldeepdesigns.com

D: ilona filipenkova C: ilona filipenkova
P: ilona M: ilona@souldeepdesigns.com

www.laicreativa.com

D: isabel sola alfonso la icreativa, alberto fayos belda la icreativa C: isabel sola alfonso la icreativa
P: la icreativa M: info@laicreativa.com

www.saru110.com

D: saru_110
M: mail@saru110.com

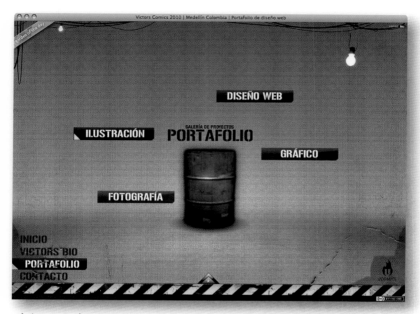

www.victorscomics.com

D: victor vergara C: victor vergara
P: victors comics M: design@victorscomics.com

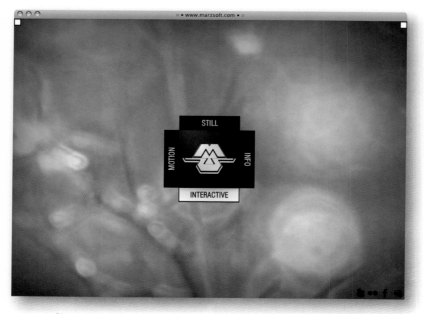

www.marzsolt.com

D: már zsolt C: már zsolt
M: info@marzsolt.com

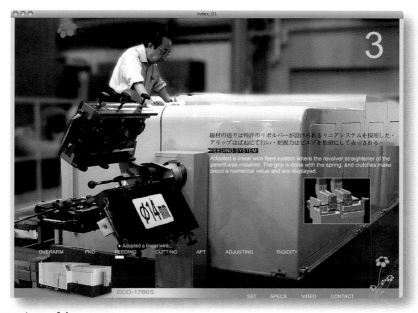

www.sst-machine.com

D: lee chejung
P: sst M: cjlee63@gmail.com

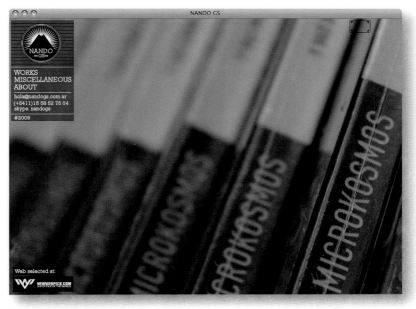

www.nandogs.com.ar

D: fernando gonzález sawicki C: gabriel da silva valer
P: nando gs M: hola@nandogs.com.ar

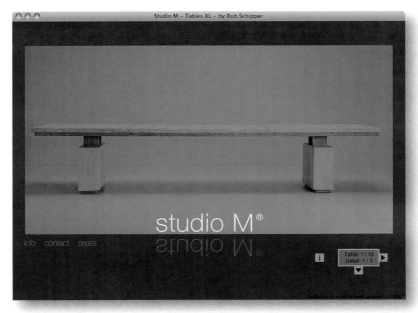

www.tablesxl.com

D: joppe lieverse, merlijn lieverse, lieverse design vof C: joppe lieverse, merlijn lieverse, lieverse design vof
P: studio m - tables xl - rob schipper M: info@lieverse-design.com

www.abandonedclothing.com
D: andre weier nalindesign C: andre weier nalindesign
P: abandoned clothing M: info@nalindesign.com

www.fatalimpact.no
D: raquel ferreira C: raquel ferreira
P: fatal impact M: raquel.ccmultimedia@gmail.com

www.edgarleijs.nl
D: edgar leijs C: edgar leijs
P: edgar leijs M: ik@edgarleijs.nl

www.fperreault.ca

D: françois perreault C: françois perreault
P: françois perreault M: perreault.francois@gmail.com

www.siggi-mertens.de

D: christoph wirth, josef bromenne, m4 media C: christoph wirth
P: siggi mertens M: info@christophwirth.de

www.muabologna.it

D: giacomo giancarlo C: andrea frattaruolo
P: paolo boni M: info@kynetos.com

www.zartherb.es

D: anja reimann C: anja reimann
P: anja reimann M: anjareimann@zartherb.es

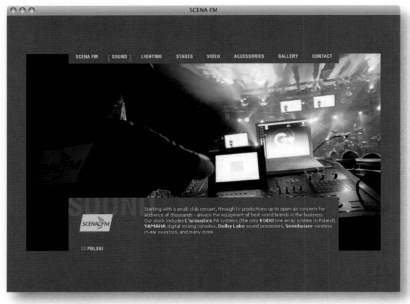

www.scena.fm.pl/index2.php

D: malgorzata rybak
P: malgorzata rybak M: nospam@bluealmonds.com

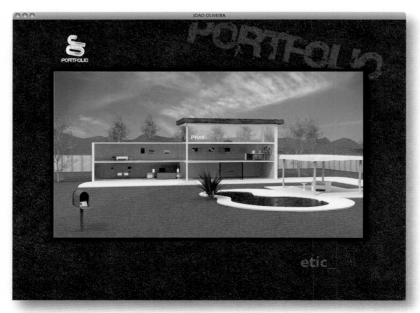

www.vazoliveira.com

D: joão oliveira C: joão oliveira
P: joão oliveira M: joao@vazoliveira.com

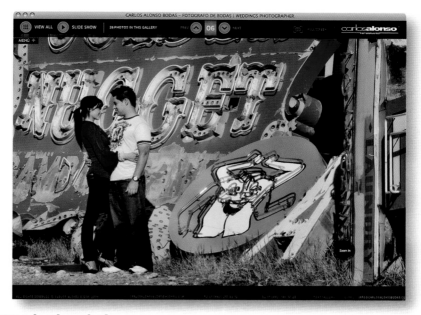

www.carlosalonsobodas.com

D: sandra natalia gómez alcántara, marciano studio C: fernando torres losa
P: carlos alonso fotógrafos M: info@marciano.com.mx

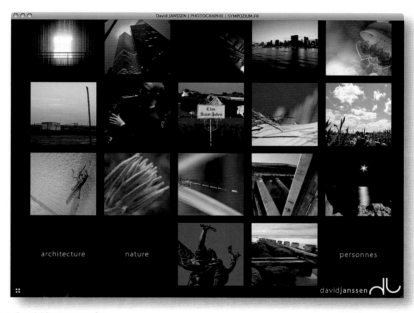

www.davidjanssen.fr

D: david janssen C: sympozium
P: david janssen M: d.janssen@sympozium.fr

www.bilderzoo.com

D: claudia mai C: claudia mai
P: claudia mai M: claudia2.mai@googlemail.com

www.moody-cat.com
D: bosko martinovic C: bosko martinovic, jaysoto
P: bosko martinovic M: bosko.martinovic@gmail.com

www.julienpons.fr/clio
D: julien pons
P: clio pajczer M: contact@julienpons.fr

www.moscatrailer.com
D: diagonal, diagonalmedia.com, marco reddavid, emanuele brussino C: diagonal, marco reddavid
P: mosca trailer s.r.l. M: info@diagonalmedia.com

www.ambientsiluminacion.com
D: xavi royo, grupo visualiza C: grupo visualiza
P: ambients iluminacion M: info@grupovisualiza.com

www.shysport.com
D: samuel gentile
P: liquid diamond M: reinvent@liquiddiamond.it

www.southlakewebdesign.net
D: christopher nelson C: christopher nelson
P: arora designs M: info@aroradesigns.com

www.stoked.cl

D: alvaro parrague ayala C: alvaro parrague ayala
P: alvaro parrague ayala M: info@ddw.cl

www.cafenoir.it

D: lorenzo fanti, marco misuri, silvia orso, lara galassini C: simone sassolini, gabriele grassi
P: cafènoir s.r.l. M: info@wayin.net

www.agence-kariboo.fr

D: pourin thomas, domenici edouard C: domenici edouard, pourin thomas
M: contact@agence-kariboo.fr

www.rodinalper.com

D: rodin alper bingöl C: rodin alper bingöl
P: rodin alper bingöl M: me@rodinalper.com

www.ianic.fr

D: ianic, yannick gatellier
M: yan_gatellier@yahoo.fr

www.dotcom.lu

D: claudia carpiaux C: christophe lutz
P: dotcom luxembourg M: info@dotcom.lu

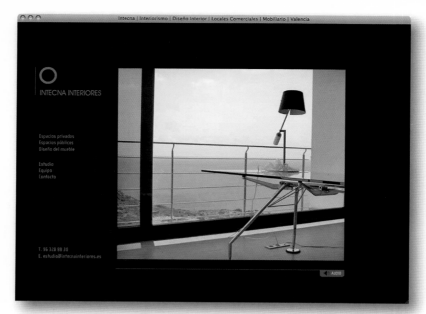

www.intecnainteriores.es

D: blai juárez

M: info@netoexperience.com

www.erlchi.com

D: erlchi design company C: erlchi design company

P: armand M: armand@erlchi.com

www.bassplayerman.com

D: pablo muñoz gatica C: pablo muñoz gatica

P: pablo muñoz gatica M: info@bassplayerman.com

jamarchitecten.nl

D: jorislandman.com C: jorislandman.com
P: jam* architects M: information@jorislandman.com

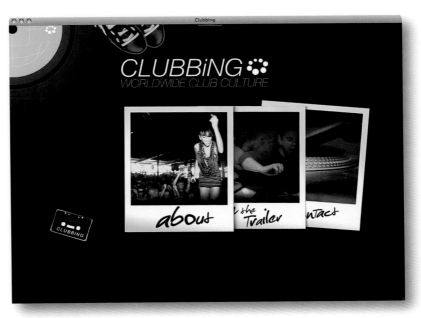

www.clubbing.dj

D: abaniko media, pierre del tour, ivan lajarin C: abaniko media
P: cristobal fernandez de salamanca M: csalamanca@abaniko.net

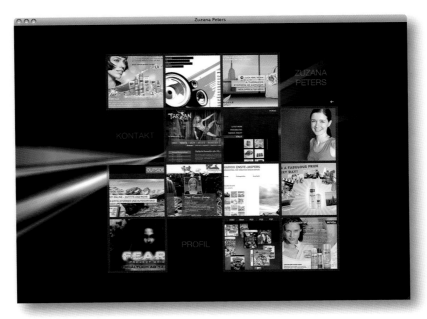

www.zuzanapeters.de

D: zuzana peters C: tim spitzer
P: zuzana peters M: mail@zuzanapeters.de

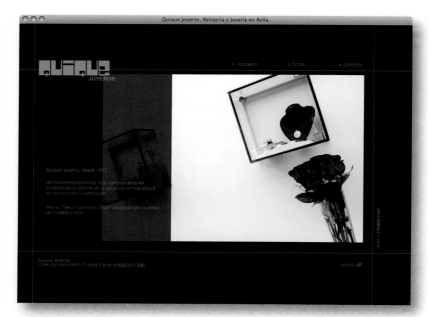

www.quiquejoyeros.es

D: ziddea solutions, david serrano
P: quique joyeros M: ziddea@ziddea.com

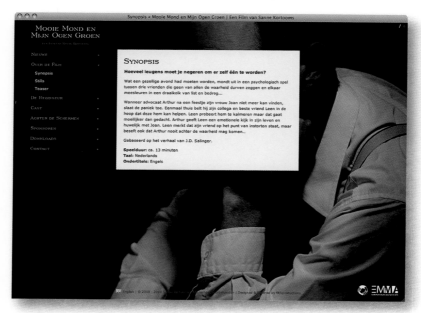

www.mooiemondenmijnogengroen.nl

D: berry timmermans, thijs sijlaar C: berry timmermans
M: info@filthproductions.com

www.portaldamaquiagem.com.br

D: veni cury C: agency basics
P: avon M: venicury@gmail.com

www.cuttingmat.co.nz

D: owen johnston C: owen johnston
P: owen johnston M: owen@cuttingmat.co.nz

www.vanax.nl

D: vanax C: vanax
P: vanax M: vanax@info.nl

www.kardoayoub.co.uk

D: kardo ayoub C: kardo ayoub
P: kardo ayoub M: kardob@hotmail.com

www.rootstudio.co.uk
D: root studio C: root studio
P: root studio M: design@rootstudio.co.uk

www.antiestatico.com
D: matias dumont
M: info@antiestatico.com

www.sociodesign.co.uk
D: nigel bates, socio design C: tom vodehnal
P: nigel bates M: nb@sociodesign.co.uk

www.danielhills.co.uk
D: daniel hills
P: daniel hills design M: daniel@danielhills.co.uk

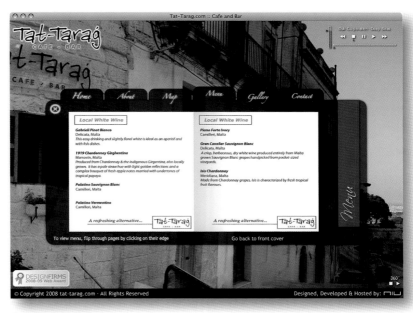

www.tat-tarag.com
D: matthew sammut C: liam farrugia
P: niu M: info@niu.com.mt

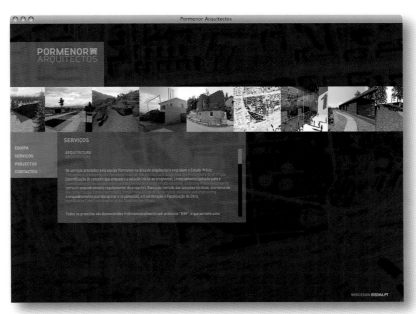

www.pormenor.net
D: ideoma design studio C: ideoma design studio
P: ideoma design studio M: estudio@ideoma.pt

303

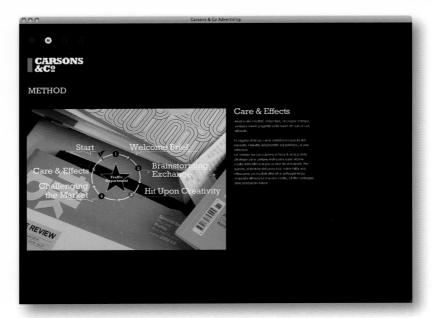

www.carsons.it

D: alessandro demicheli, laura barbera, paola damilano
P: g. garavaglia, l. barabaro M: a.demicheli@carsons.it

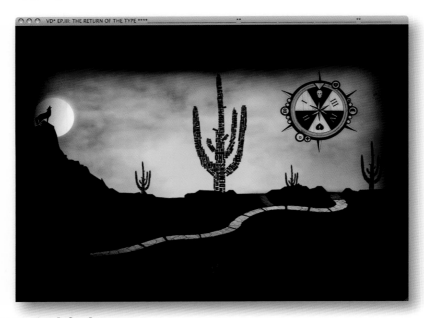

www.vectordefenders.com

D: on click creative studio C: on click creative studio
P: on click M: info@onclick.es

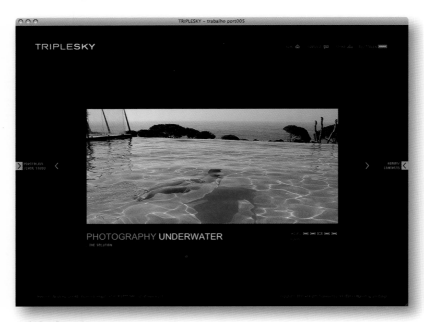

www.triplesky.pt

D: miguel gomes C: miguel gomes
P: triplesky M: miguel_gomes@sapo.pt

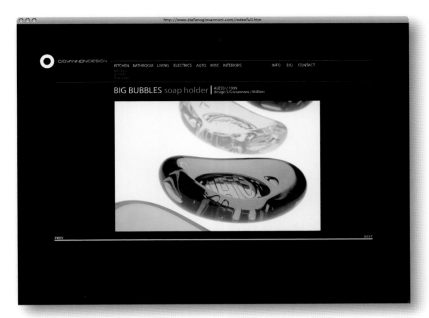

www.stefanogiovannoni.com
D: ivan pedri, alan de cecco C: ivan pedri
P: giovannoni design M: info@ivanpedri.com

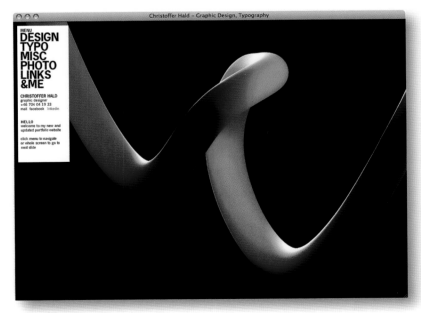

www.dmportfolio.com.ar
D: daniel maier
P: dany maier M: dany@dmportfolio.com.ar

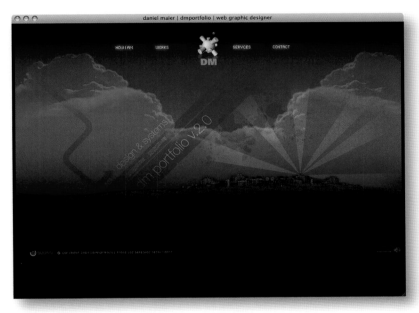

www.klon2.dk
D: christoffer hald C: christoffer hald
P: klon2 M: christofferhald@gmail.com

www.flash-web-stranice.com

D: saluto web presence provider C: saluto web presence provider
P: flash web studio M: info@flash-web-stranice.com

www.fwhotel.tw

D: jason cheng, chris kuan
P: free people M: info@expup.com

www.cucinaorientale.com

D: gaia zuccaro C: daniele padroni
P: cucina orientale M: info@gaiazzz.com

www.naplestreetstyle.com
D: naplestreetstyle creative lab., simon laudati, vincenzo schioppa C: simon laudati, vincenzo schioppa, d'aprile
P: naplestreetstyle.com M: info@naplestreetstyle.it

www.ottokasper.de
D: carl bartel C: marc h. widmer
P: tibor borbély M: web@gbvsa.com

www.gruny.net
D: christophe grunenwald C: grunystudio
P: christophe grunenwald M: christophe@grunystudio.com

www.webidea.pl

D: micha? banach C: adam klimas
M: webidea@webidea.pl

www.tower42.com

D: andreas fux C: andreas fux, frédéric benoit
P: saentys M: info@saentys.com

www.badboyboogiez.com

D: christoph kock C: christoph kock
P: badboyboogiez M: christoph@tamioe.de

www.matscordt.com

D: siteseeing interactive media, katharina moelle C: alexander feyerke
P: studio mats cordt M: info@siteseeing.de

www.osobo.co.uk

D: meetya astafyev C: serguey migalin
P: serguey migalin, meetya astafyev M: info@osobo.co.uk

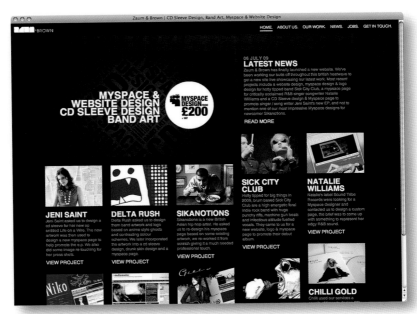

www.zaum.co.uk

D: rich brown C: brown & white
P: zaum & brown M: rich@rdbrown.me.uk

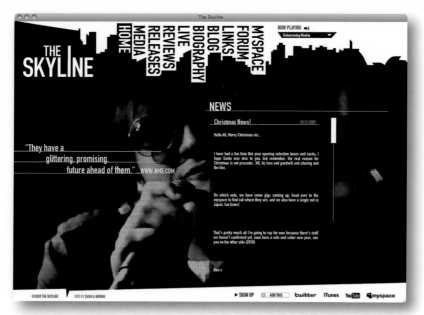

www.theskylinemusic.com

D: rich brown C: brown & white
P: the skyline M: rich@rdbrown.me.uk

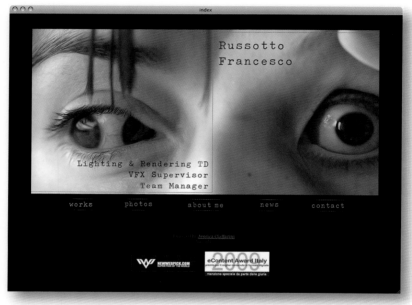

www.francescorussotto.it

D: jessica ciaffarini C: jessica ciaffarini
P: francesco russotto M: russotto.francesco@gmail.com

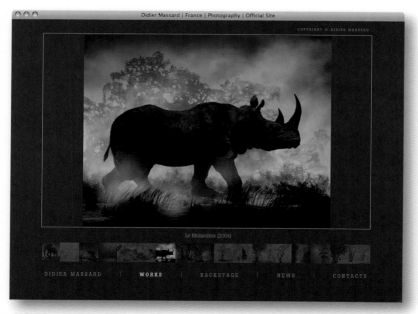

www.didiermassard.net

D: luca dotti C: monica costa
P: monica costa, luca dotti M: m.costa@lightafterdark.com

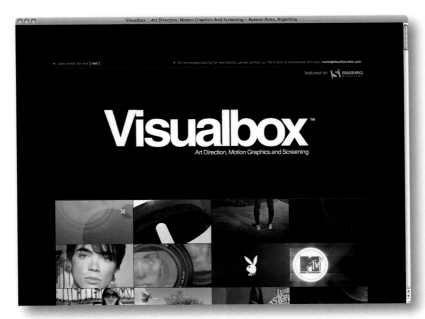

www.visualboxsite.com

D: carlos alemañy C: visualbox, 1en1 studio
P: visualbox M: works@visualboxsite.com

www.keal.com.br/v1

D: keal agência interativa, guilherme alberti C: keal agência interativa, guilherme alberti
P: keal agência interativa M: contato@keal.com.br

www.artsir.net

D: nalinda bandara, himaya jayathilake C: nalinda bandara
P: n.l.m.arunashanta M: info@artsir.net

www.accentodesign.it

D: leonardo guadagnin, alessandro susin C: leonardo guadagnin
P: accento design group M: info@leonardoguadagnin.it

www.nowinowskidesign.com

D: nate nowinowski C: nate nowinowski
P: nate nowinowski M: n.nowinowski@gmail.com

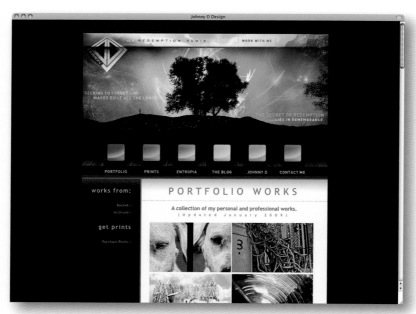

www.johnnyddesign.net/myworks.php

D: jack ciallella C: riza movahedi
P: jack ciallella M: jciallella@gmail.com

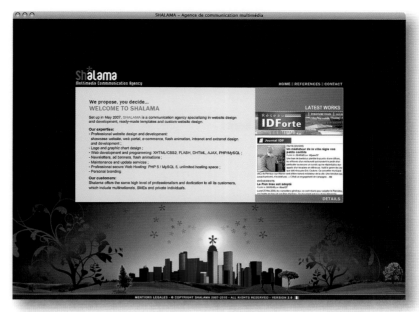

www.shalama.com

D: julien gagnerault C: isidora vidal

P: shalama M: contact@shalama.com

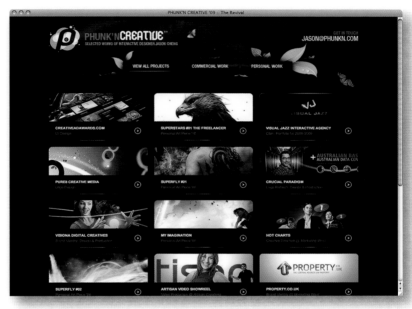

www.phunkn.com

D: jason chieng C: jason chieng

P: phunkn creative M: jason@phunkn.com

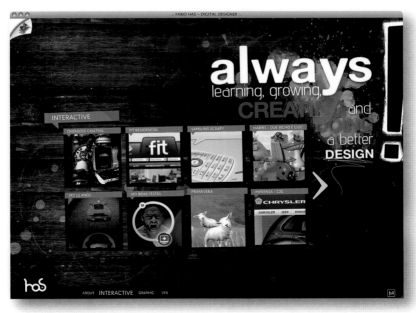

www.fabiohas.com.br

D: fabio has C: fabio has

M: fabiohas@gmail.com

www.clementina.net

D: renana kishon, izaack menshenfroind C: shay dayan

P: www.clementina.net M: shay@clementina.net

www.philleep.com/interactive

D: philleep florence C: jolomi onosode

M: email@philleep.com

www.jonnekjonneksson.com

D: tasos protopapas C: ffyeah

P: jonnek jonneksson M: tasos@ffyeah.gr

www.elysiumburns.com
D: sean baker C: sean baker
P: elysium burns M: baker@elysiumburns.com

www.beautiful2.com
D: christopher nelson C: christopher nelson
P: beautiful 2.0 M: info@beautiful2.com

www.skinnywrists.co.uk
D: josh smith
P: skinnywrists M: josh@skinnywrists.co.uk

www.sanimani.com

D: sani mani C: sani mani
M: sanimani@gmail.com

rbigwood.com

D: rob bigwood C: jason tordsen
P: rob bigwood M: rb@rbigwood.com

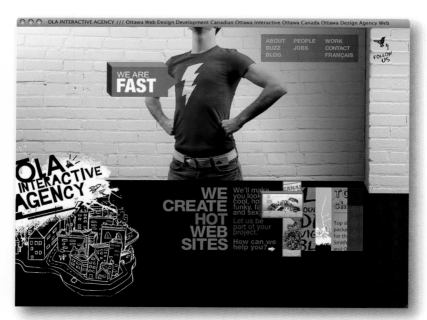

www.olainteractiveagency.com

D: ola interactive agency C: ola interactive agency
P: josée charbonneau M: info@olainteractive.ca

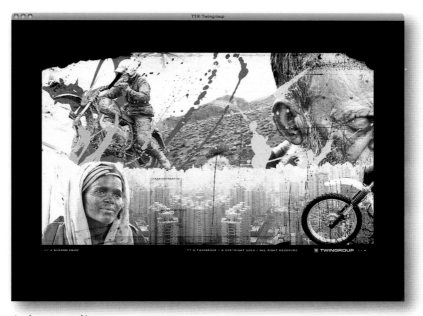

www.twingroup.it
D: gian pietro farinelli, aspirine C: gian pietro farinelli, daniele tumidei, aspirine
P: twin group M: info@twalcom.com

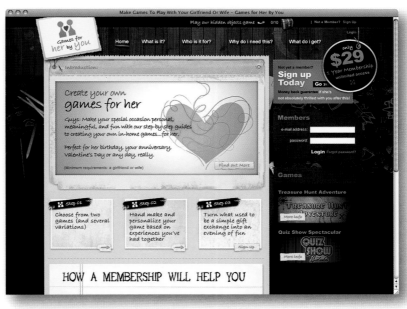

www.gamesforherbyyou.com
D: leigh taylor C: josh winter
P: games for her by you M: contact@leightaylor.co.uk

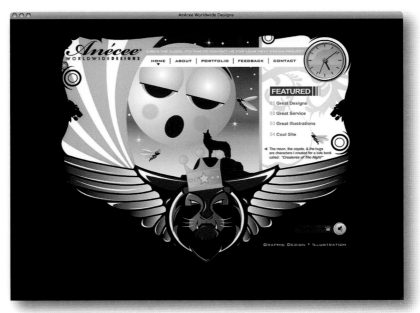

www.anecee.com
D: kwesi williams C: kwesi williams
P: anécee worldwide designs M: kwesianecee@gmail.com

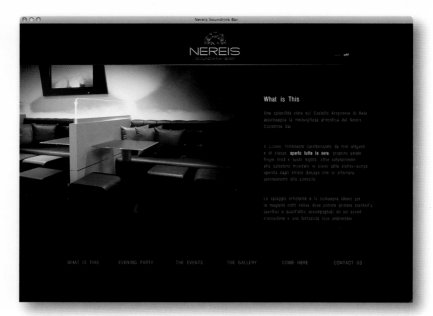

www.nereis.it

D: gabri gargiulo, gruppo chorus

P: nereis soundrink bar M: gargiulo@gruppochorus.com

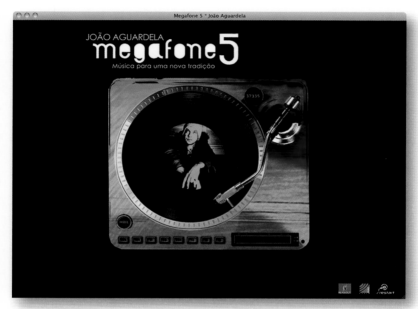

www.aguardela.com

D: lepix, tó trips, alexandre nobre C: lepix

P: megafone5 - cultural association M: lmf.rodrigues@gmail.com

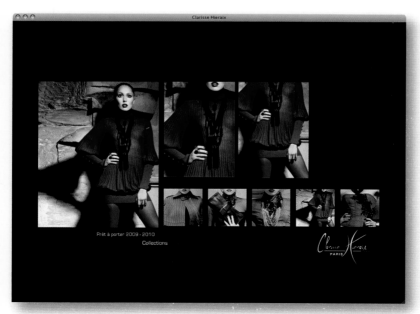

www.clarisse-hieraix.com

D: spirit of ecstasy, samuel bailhache, arthur chantrenne C: spirit of ecstasy, guillaume maggi

P: clarisse hieraix M: arthur@spiritofecstasy.cc

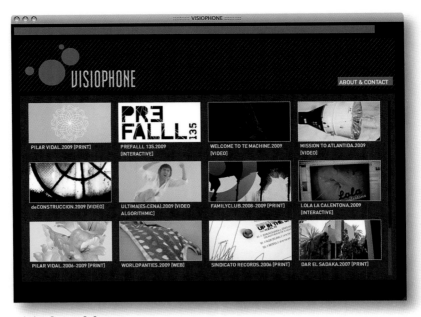

www.visiophone-lab.com
D: rodrigo carvalho C: rodrigo carvalho
P: visiophone M: info@visiophone-lab.com

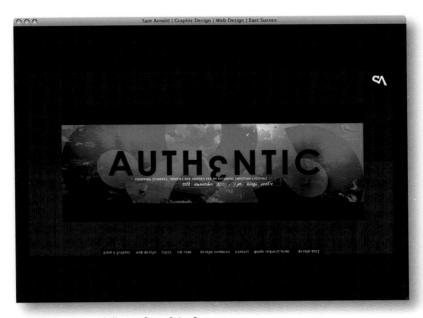

www.sa-design.co.uk/interface.html
D: samuel arnold
M: sam@sa-design.co.uk

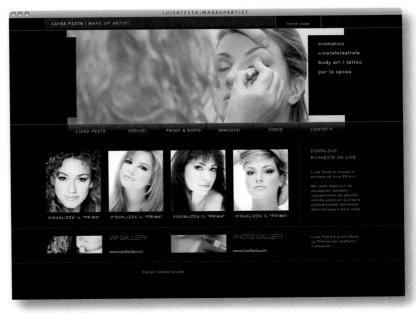

www.luisafesta.com
D: gabri gargiulo, andrea ricca C: ondaline adv
P: luisa festa M: gabri@ondaline-adv.com

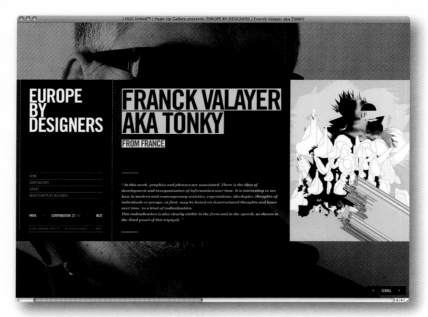

www.europebydesigners.com

D: julien grandclement, astrid rousseau, hug united™ C: hug united™
P: hug united™ M: hello@hug-united.com

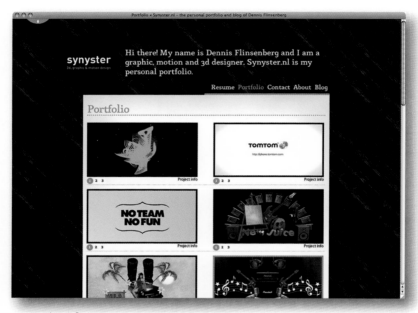

www.synyster.nl

D: dennis flinsenberg C: dennis flinsenberg
M: info@synyster.nl

www.kinso.fr

D: nicolas mériot C: nicolas mériot
M: nico@kinso.fr

320

www.studioaiko.com
D: sikan techakaruha
M: sikan.aiko@gmail.com

www.mamparasdoccia.es
D: maría naranjo
M: info@comunica-web.com

www.only2designers.com
D: only2designers C: zenn cheok
P: only2designers M: zenn@only2designers.com

www.joeldelane.com

D: joel delane C: joel delane
P: joel delane M: info@joeldelane.com

www.fakestudio.tv

D: ibon landa, ivan jurado, ignasi font C: roger pau
P: fake studio M: ibon@fakestudio.tv

www.aslan-malik.com

D: aslan malik C: claus ernst
P: aslan malik M: aslan@mr-malik.de

322

www.quetengoenlanevera.com
D: ernesto ramírez, _kofla C: ernesto ramírez, _kofla
P: ernesto ramírez _kofla M: kofla@quetengoenlanevera.com

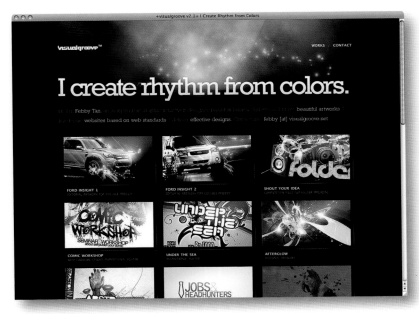

www.visualgroove.net
D: febby tan C: febby tan
M: febby@visualgroove.net

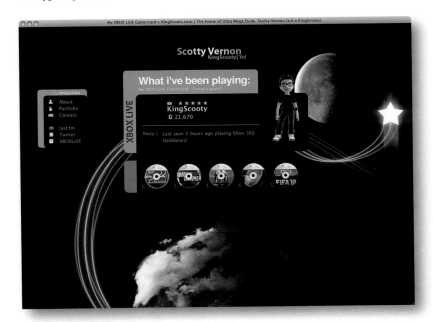

www.kingscooty.com
D: scotty vernon C: scotty vernon
M: scotty@wildflame.co.uk

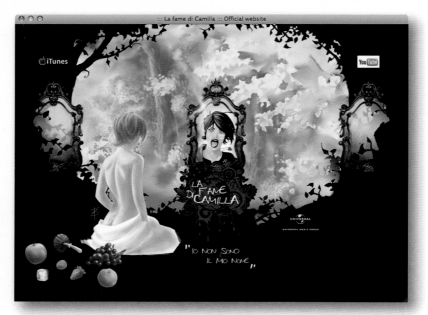

www.lafamedicamilla.com

D: tommaso bianchi C: alessandro faso lo
P: universal music italia M: info@e-blankpage.com

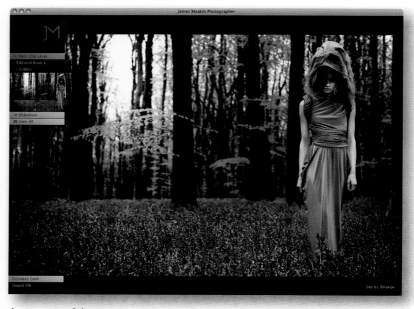

www.james-meakin.com

D: strange corp C: ricardo sanchez
P: james meakin M: jamie@strangecorp.com

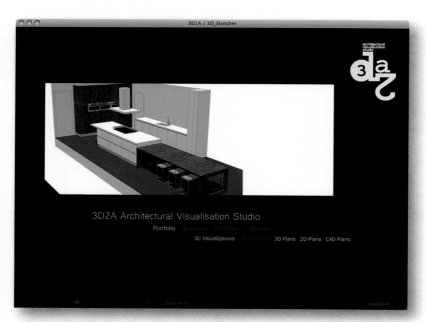

www.3d2a.be

D: alaa muhammed C: alaa muhammed
P: niels van der straeten M: info@3d2a.be

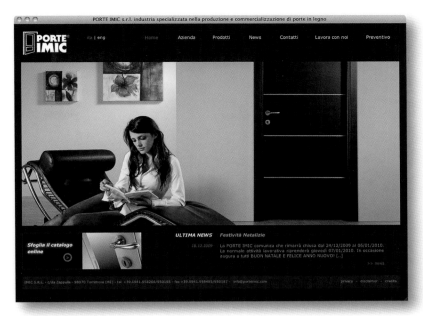

www.porteimic.com
D: ornella reitano
P: imic s.r.l. M: ornella.reitano@gmail.com

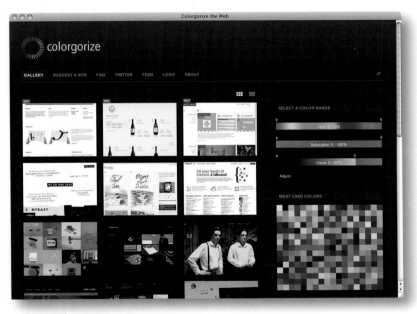

www.colorgorize.com
D: michael wessel C: michael wessel
P: colorgorize M: info@colorgorize.com

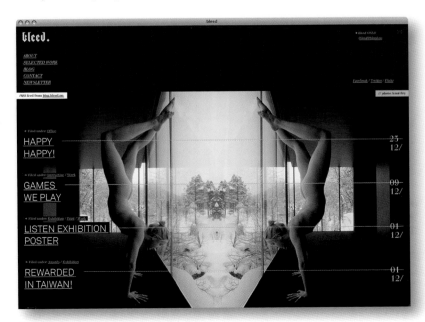

www.bleed.no
D: svein haakon lia C: andre elvan
P: bleed M: svein@bleed.no

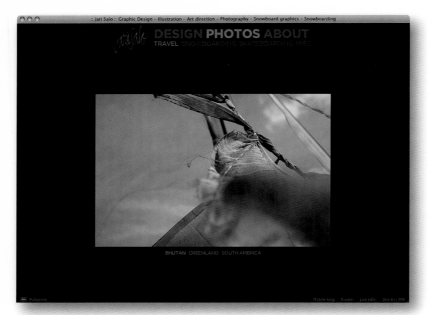

www.jarisalo.com

D: mika mäkinen, jari salo **C:** mika mäkinen
P: jari salo **M:** info@jarisalo.com

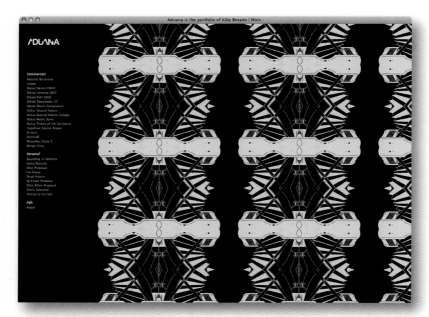

www.aduana.nom.es

D: kike besada **C:** kike besada, kike besada
M: kike@aduana.nom.es

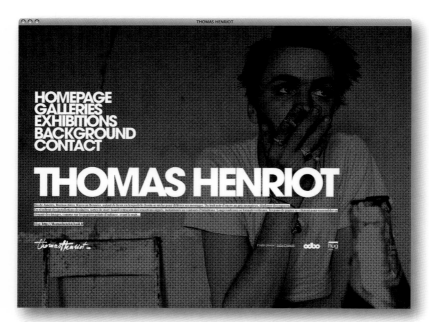

www.thomashenriot.com

D: julien grandclement, astrid rousseau, hug united™ **C:** hug united™
P: thomas henriot **M:** hello@hug-united.com

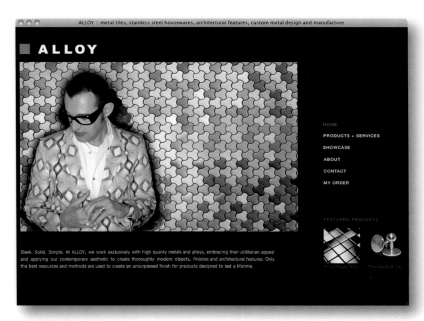

www.alloydesign.com.au
D: ful-vue C: sitesuite
P: alloy design M: sol@ful-vue.com

www.paradisodellanotte.it
D: kreatyveminds, antonella sinigaglia C: shift 2
P: paradiso della notte M: info@kreatyveminds.com

www.tomvining.co.uk
D: tom vining C: tom vining
P: tom vining M: tom@withmoreair.com

www.svenbarletta.com

D: sven barletta C: sven barletta
P: sven barletta M: info@svenbarletta.com

www.twigital.co.uk

D: chris phillips C: george profenza, greg danford
P: disturb media M: contact@disturbmedia.com

www.kokhostalets.com

D: bitworks, xevi vilardell bascompte C: bitworks, xevi vilardell bascompte
P: k.o.k. M: xevi@xelu.net

www.djnr.net

D: jenaro diaz C: jenaro diaz
P: djnr interactive M: djnr@djnr.net

www.momentumstudios.co.nz

D: momentum studios C: momentum studios
M: antony@momentumstudios.co.nz

www.derpixelist.de

D: daniel klatsidis C: daniel klatsidis
P: daniel klatsidis M: mail@derpixelist.de

camaraclara.rtp.pt

D: outbox^ativism C: outbox^ativism

P: rtp - camara clara M: luis.cardoso@outbox.ativism.pt

www.cadabra.pl

D: hubert swolkien

P: interactive agency M: info@cadabra.pl

www.entropiads.com/html

D: jack ciallella C: riza movahedi

P: entropia design studio M: jciallella@gmail.com

www.crswebstudios.com
D: santiago riera C: santiago riera
M: info@crswebstudios.com

www.barbonidilusso.it
D: studiopineapple C: studiopineapple
P: barboni di lusso, bdl studio s.r.l. M: info@barbonidilusso.it

www.ds3.citroen.com/fr
D: dagobert C: dagobert
P: citroën M: guillaume.gartioux@dagobert.fr

www.ativism.pt

D: outbox^ativism C: outbox^ativism
P: ativism M: luis.cardoso@outbox.ativism.pt

www.bikeworld.com.pt

D: kuattro design, luis santos C: kuattro design, luis santos
P: bikeworld M: geral@kuattrodesign.com

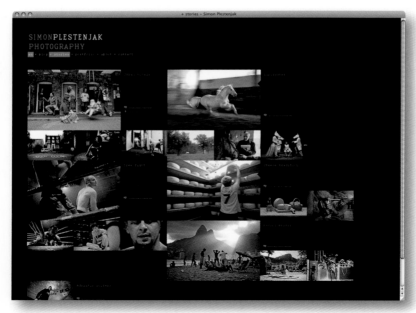

www.simonplestenjak.com

D: vbg.si C: vbg.si
P: simon plestenjak M: gregor.zakelj@vbg.si

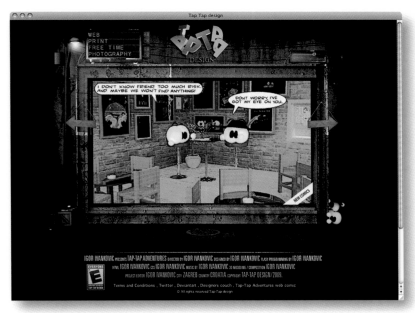

www.taptapdesign.com
D: igor ivankovic C: igor ivankovic
P: igor ivankovic M: taptap@taptapdesign.com

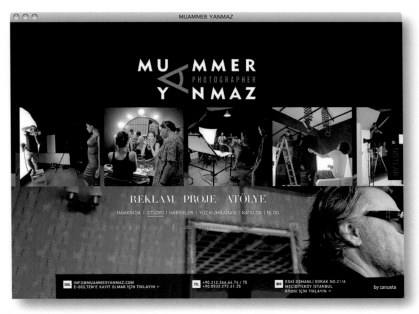

www.muammeryanmaz.com
D: can usta C: can usta
P: muammer yanmaz M: talkto@canusta.com

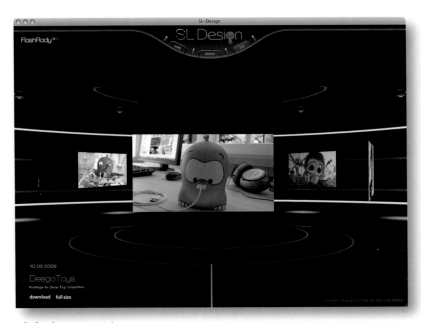

www.sl-design.com.pt
D: sebastião lopes C: sebastião lopes
P: sl-design M: info@sl-design.com.pt

www.jasonkrenson.com

D: jason krenson
M: jekarts@yahoo.com

creativean.com

D: yu. chang-jae C: hu. jong-su
P: yu. chang-jae M: gta18@naver.com

www.thefalconhaslanded.com

D: chris reihe C: chris reihe
M: creihe@gmail.com

www.51north.nl

D: 51north C: 51north
P: 51north M: contact@51north.nl

www.senseidj.com

D: jaime alberto romo san martin C: jaime alberto romo san martin
P: sensei dj M: romojaime21@gmail.com

www.4or.sk

D: jozef vereš C: jozef vereš
P: 4ór creative studio M: jveres@4or.sk

www.baccarne.com

D: ines van belle C: ines van belle
M: info@pinker.be

www.rsapps.de

D: robert sass C: robert sass
P: robert sass M: info@rsapps.de

www.k-netica.be

D: manu piton C: manu piton
P: manu piton M: info@k-netica.be

mars.fortis-watches.com

D: steffen blandzinski, marius alexander C: spreadlab gbr, christoph majewski, arne borchard

P: fortis uhren ag M: contact@spreadlab.com

www.frigeriosalotti.it

D: neotokio! comunicazione visiva

P: neotokio! comunicazione visiva M: info@neotokio.it

www.cantori.it

D: daniele frontini C: daniele frontini

P: daniele frontini M: www.greenbubble.it

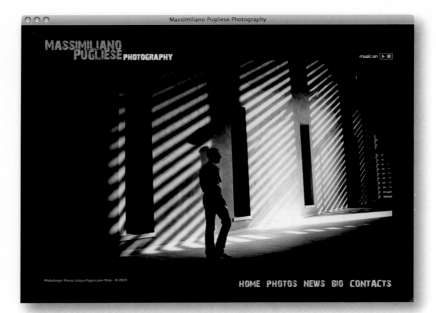

www.massimilianopugliese.com

D: marco letizia C: marco letizia

P: marco letizia M: marcoletizia@iol.it

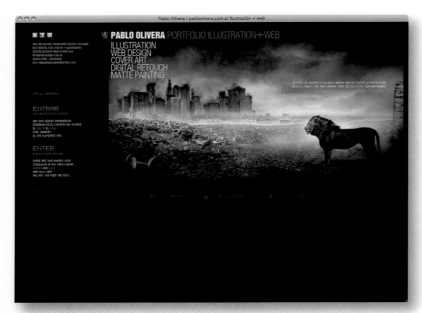

www.pabloolivera.com.ar

D: pablo olivera C: pablo olivera

M: info@pabloolivera.com.ar

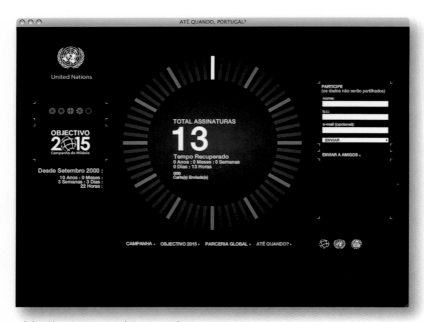

www.objectivo2015.org/atequando

D: ninjatranqui C: joão espadinha

P: digital@brandiacentral.com M: contacto@brandiacentral.com

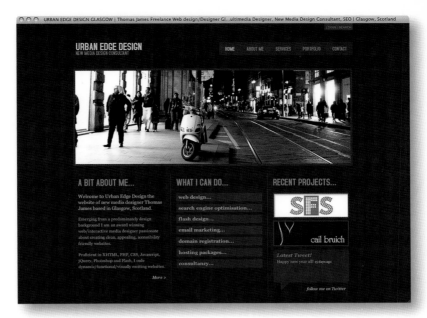

www.urbanedgedesign.co.uk
D: thomas james
M: thomas@urbanedgedesign.co.uk

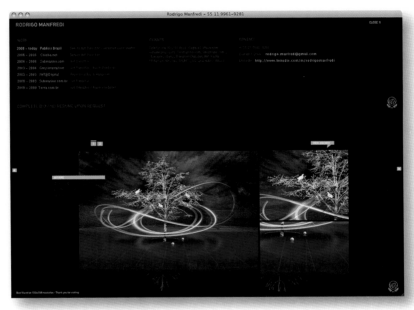

www.rodrigomanfredi.com/08
D: rodrigo manfredi C: rodrigo manfredi
P: rodrigo manfredi M: rodrigo.manfredi@gmail.com

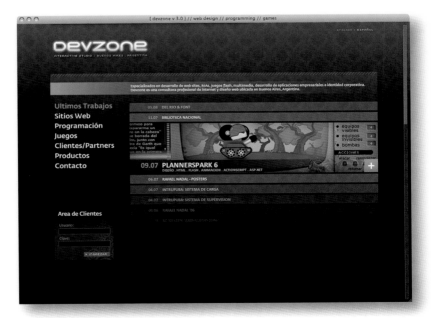

www.devzone.com.ar
D: alejandro ramos C: ariel fabian, martin dopazo
P: devzone M: info@devzone.com.ar

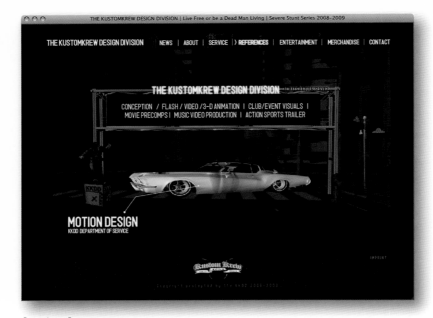

www.kustomkrew.com

D: frederik massmann C: frederik massmann
P: frederik massmann M: info@kustomkrew.com

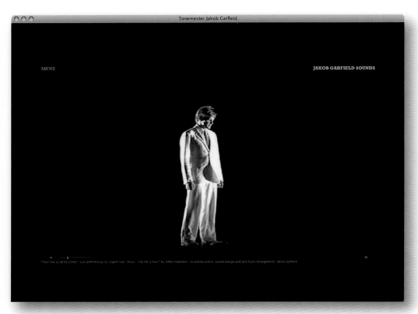

www.jakobGarfield.dk

D: lars bregendahl bro C: lars bregendahl bro
P: lars bregendahl bro M: westend.dk

www.mira-muzik.com

D: nalan alaca C: gizem onan
P: tasarim gezegeni M: info@designtrans.com

www.estudiorjdesign.com
D: rui oliveira e joão magalhães C: luís braga
P: estúdio rjdesign M: info@estudiorjdesign.com

www.osvaldas.info
D: osvaldas valutis C: osvaldas valutis
P: osvaldas valutis M: osvaldas@osvaldas.info

www.advanderwiel.nl
D: ad van der wiel C: ad van der wiel
P: avdw design M: info@advanderwiel.nl

www.mysticspa.com.ar

D: juan pablo cusnaider C: juan pablo cusnaider
P: juan pablo cusnaider M: info@kreativa.com.ar

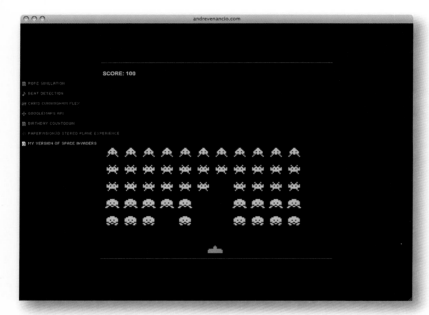

www.andrevenancio.com

D: andré venâncio C: andré venâncio
P: andré venâncio M: info@andrevenancio.com

www.tizedit.com

D: david g. bonacho C: david g. bonacho
P: tizedit s.l. M: tizedit@tizedit.com

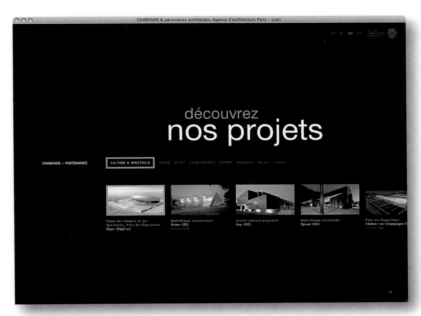

www.chabanne-architecte.fr
D: danka studio C: danka studio
P: chabanne & partenaires architectes M: danka@dankastudio.fr

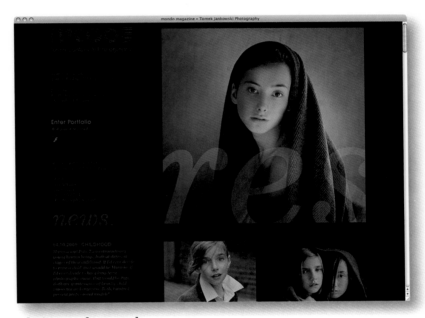

www.photo.mondo.com.pl
D: tomek jankowski C: tomek jankowski
M: tom@mondo.com.pl

www.gsenpod.com
D: christian bartsch C: martin anderle
M: hello@gsenpod.com

www.btt4all.com

D: kuattro design, luis santos C: kuattro design, luis santos
P: btt4all M: geral@btt4all.com

www.adenek.com

D: mathieu zylberait C: mathieu zylberait
M: mathieu@adenek.com

www.geishagraphic.com

D: geisha C: geisha
M: contact@geishagraphic.com

www.j-exhibit.com
D: strange corp C: ricardo sanchez
P: j exhibit M: jamie@strangecorp.com

www.holtermand.dk
D: jonas eriksson C: jonas eriksson
P: kim høltermand photography M: kim@holtermand.dk

www.runthered.com
D: salted herring C: salted herring
P: ben northrop M: ben@runthered.com

www.luigiferraresi.it

D: luigi ferraresi C: luigi ferraresi
P: luigi ferraresi M: luigi.ferraresi@gmail.com

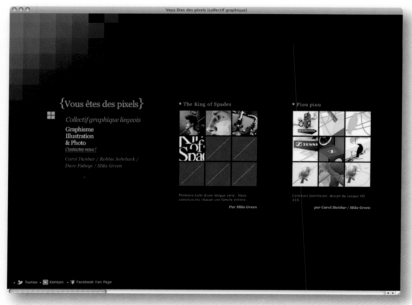

www.vousetesdespixels.be

D: vous êtes des pixels C: vous êtes des pixels
P: vous êtes des pixels M: disbonjour@vousetesdespixels.be

www.twintoe.com

D: mindaugas vaiciulis, carlos prinzc c: mindaugas vaiciulis, carlos princz
P: twintoe M: hello@twintoe.com

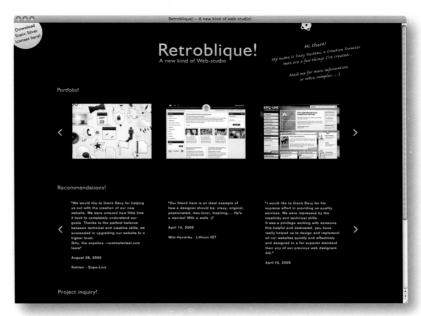

www.retroblique.be
D: davy kestens C: davy kestens
P: davy kestens M: info@retroblique.be

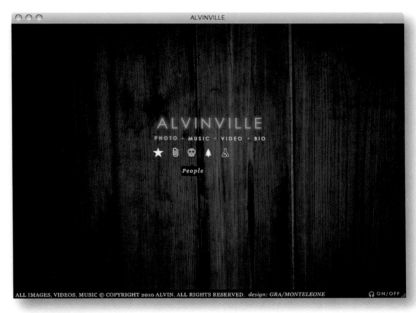

www.alvinville.com
D: graziano monteleone C: graziano monteleone
P: alvin M: gra.monteleone@gmail.com

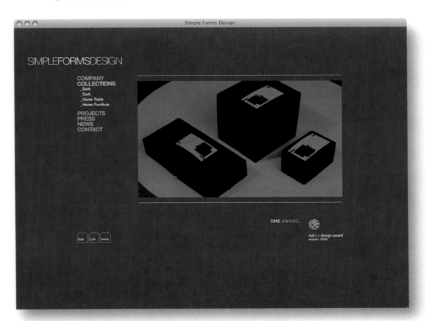

www.simpleformsdesign.com
D: carlos mendonça, ricardo santos C: ricardo santos
P: simpleformsdesign M: comercial@simpleformsdesign.com

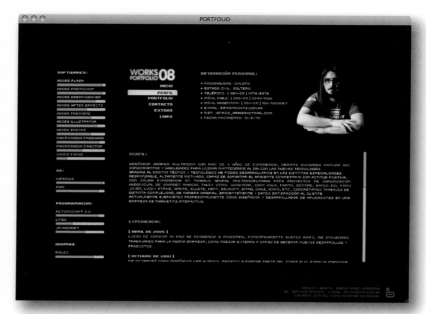

www.nachitz.com.ar/index_old.html

D: ignacio "nachitz" arias C: ignacio "nachitz" arias
P: nachito arias M: info@nachitz.com.ar

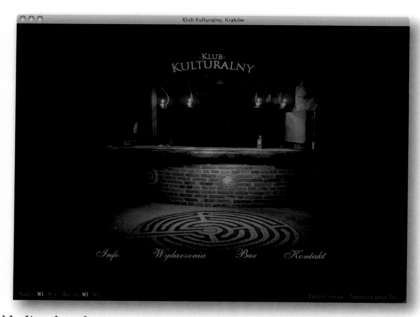

klubkulturalny.pl

D: maciek kozłowski, studio fru C: krzysztof opałka, paweł gajewski, paweł gajewski
P: klub kulturalny M: fru@studiofru.pl

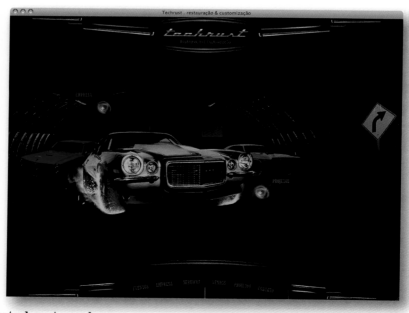

www.techrust.com.br

D: keal agência interativa, guilherme alberti C: keal agência interativa, guilherme alberti
P: techrust M: contato@keal.com.br

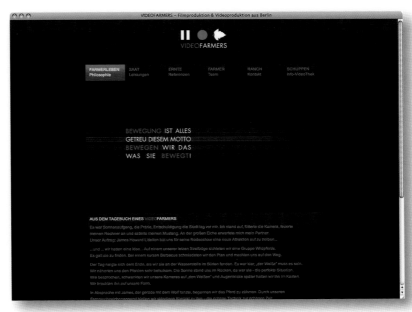

www.videofarmers.de

D: didomeso, paul-christian thiele
P: videofarmers M: info@didomeso.de

www.indi2000.com

D: mediaplan studio C: jurgen baho
P: dhimo konomi M: info@mediaplanstudio.com

www.adragnayachtdesign.com

D: elvis d'sgn
P: gianluca adragna M: contact@elvisdesign.it

www.687performance.de

D: maika paetzold C: maika paetzold
P: maika paetzold M: info@mettage-design.de

www.milena-rogulj.com

D: atrtuska.grupa C: atrtuska.grupa
P: milena rogulj M: mbjedov@atrtuska.com

www.skyscraperj.com

D: sebastian jakl C: sebastian jakl
P: sebastian jakl M: sj@skyscraperj.com

www.studiodds.it/v1

D: ideazione web srl C: ideazione web srl
P: studio dds M: info@ideazioneweb.net

www.equuslimitededition.com

D: pepijn zuijderwijk, cameron gibb C: lauren schaer
P: pq blackwell M: billie.lythberg@pqblackwell.com

www.zeebee.co.uk

D: zeebee C: zeebee
P: zeebee M: info@zeebee.co.uk

www.shskh.com/www

D: knowawall C: knowawall

P: shsk'h llc M: admin@shskh.com

www.dlvbbdo.com

D: federico pepe, stefania siani, niccolò fedrigo C: lorenzo crespi

M: n.fedrigo@dlvbbdo.com

www.dsigned-by.com

D: iva kilibarda C: iva kilibarda, ivan vlatkovic

P: d signed by M: contact@dsigned-by.com

Index of Designers

.claudioviscardi — 55
.made {by us} — 39
@Work Milano — 285
2 kilo design — 29
2FRESH — 57
2otsu — 207, 227
4060 — 221
51North — 265, 335
627b — 54, 120
804© GRAPHIC DESIGN — 118
a fish in sea ltd — 116
Abaniko Media — 299
Abanto, Kelly — 147
abc123 Web Design — 120
Abramov, Alexey — 186
Abreu, Ana — 238
ACHTUNG! — 183
Adamson, Kev — 94, 105
Aeraki, Despina — 33
Ag81designs — 41
Agrella Galván, Raquel — 220
Aguirre, Javier — 231
Aizenberg, Tom — 259
Ajjan, Fadi — 211
Akashi, Daniel — 222
Alabaz, Orkun — 59, 166
Alaca, Nalan — 340
alaCaesar — 208
Alberti, Guilherme — 311, 348
Alegria, David — 37
Alemañy, Carlos — 311
Alexander, Marius — 337
Alfdesign — 120, 249
allink.creative — 162
Aloha Studios — 176
Alongina, Marc — 141
Alraun, Joern — 63
Alvarez, Alejandro — 180
Alvarez, Alex — 180
Amaral, Adam — 136
Amaste — 33
Andrade, Julian — 223
anothergraph — 74
AQuest.it — 237
Aquini, Davide G. — 43
Arias, Ignacio — 348
Aries, Aurélien — 28
Arnold, Samuel — 319
Arôme — 265
Arroyo, Guillermo — 82
artedopera — 91
Artiles, Héctor — 44
ARTIST IN DESIGN — 110
Artrivity Disseny — 110, 177
Asencio, Andrés — 169
Aspin Interactive Limited — 160
Aspirine — 317, 92
Astafyev, Meetya — 309
Ater, Tal — 171
Atrtuska.Grupa — 350
Atsushi Yamada — 191
Attagnant, Christian-Jacques — 203
Autiello, Francesca — 117, 231
Autiello, Massimiliano — 117, 231
Avalos, Alexis — 61
Avanti Avanti — 108
Ayoub, Kardo — 301
Babekuhl — 90
Bacharach, Eran — 26, 56
Baeza Luco, Alejandro — 157
Bailhache, Samuel — 108, 318

Baker, Sean — 315
Balavoine, Agnès — 64
Balhar, Martin — 59
BALLYHOO WebDesign & Flash — 46
Balyali, Omer — 75
Banach, Micha? — 308
Bancilhon, Jeremie — 188
Bandara, Nalinda — 311
Baquero, Alejandro — 238
Barbera, Laura — 304
Barletta, Sven — 201, 328
Barnlund, Mike — 256
Barradas, Daniel — 263
Barros, Antonieta — 174
Bartel, Carl — 307
Bartsch, Christian — 343
Bascompte, Xevi Vilardell — 328
Batajic, Olivera — 54
Bates, Nigel — 302
Batista, Raphael — 43
Battais, Jules — 268
Bauer, Damon — 127
Bauer, Stefan — 73
Bèdia, Oriol — 207, 227
Bee Creations — 26, 56
Beeson, Gareth — 200
Bernal Cortes, Alexander — 179
berth99 — 240
Besada, Kike — 326
Bianchi, Tommaso — 324
Biernawski, Piotr — 41
Big Room Studios — 227
Bigwood, Rob — 316
Bingöl, Rodin Alper — 297
BitWorks — 328
Blaese, Immo — 204
Blaiseau, Laetitia — 113
Blandzinski, Steffen — 337
Blank, Christoph — 19, 31
Blend & Blink — 115
bleuceladon — 133, 172, 256
Blutvoll Media Agentur — 232, 233
Bock, Björn — 34
Boerman, Bas — 239
Boheim, Annamaria — 96
Boiano, Stefania — 72
Boidron, Camille — 250
Bolton, Jina — 114
Bonacho, David G. — 342
Borges, Inez — 30
Bosco, Kate — 56
Boulguy, Martial — 127
Bozanic, Zoran — 167
Bracq, Amelie — 251
BRANDSHAPE — 239
Bravo Montarelo, Maria — 249
Bregendahl Bro, Lars — 340
brennpunkt design — 75
Brett, Sebastien — 86
Bretzmann, Daniel — 80
Broadbent, Sam — 65
Broekaert, Ram — 248
Brokenice Interactive — 178
Brombin, Gabriele — 189
Bromenne, Josef — 291
Broothaers, Elke — 182
Brown, Rich — 309, 310
Brufani, Fabiola — 178
Brussino, Emanuele — 294
Buchberger, Sigurd — 96
Buchman, Zack — 112

Index of Designers

Buck, Spencer — 51, 200
Buckenmeyer, Miguel — 39
Burkard, Kerstin — 87
Burnside, Danny — 75
Büro für Grafik Design — 102, 279
Burtin, Maximiliano — 184
Bust, Peter — 90
Butler, Ian J. — 189, 221
Calce, Riccardo — 102
Caldeira, Nelson — 66
Calvo, Xavi — 159
Camp, Lindsay — 51
Campbell, Debbie — 125
Candotti, Luciano — 154, 253
Candullo, Brad — 273
Canora, Alex — 282
CAPICOIA — 98
Caprichoso, Joana — 149
Carino, Miguel — 225
Carozzi, Simone — 263
Carpiaux, Claudia — 297
Carra, Ricardo — 145
Caruso, Giuseppe — 60, 85
Carvalho, Nuno — 66
Carvalho, Rodrigo — 319
Cascardo, Ana Paula — 102
Cassius, Réginald — 81
Catalina, Jimena — 140
Cavalcanti, Marcello — 151
Cécile, Irene — 53, 69
cerchioperfetto — 49
Chang Jae, You — 72, 334
Chantrenne, Arthur — 108, 318
Chapo, Jesse — 158
Chejung, Lee — 289
Chen, Darryl — 81
Cheng, Jason — 306
Chew, Benny — 87
Chieng, Jason — 313
Chiucini, Michela — 246
Choe, Jenneke — 87
Choong Weng, John Woo — 55
Christian, Frederic — 248
Chuang, Hao — 136
Chumillas, Cristina — 114
Ciaffarini, Jessica — 310
Ciallella, Jack — 312, 330
Cianci, Tony — 175
Cinus, Michela — 38
Cirillo, Cristian — 150
.claudioviscardi — 55
Climent, Raul — 159
Coenen, Susanne — 218
Cole, Oli — 82
Colmo — 272
Conceição, Bruno Alexandre — 196
Conte, Tania — 212
Contentcom Interactive & Branding Design — 159
Correia, Vanda — 137, 138
Cossio, Bernardita — 281
cpeach — 143
Creathema, Nicolas Valla — 258
Creative Forward — 112
CreativePeople — 131, 209
Cross One — 197, 206
Cury, Veni — 300
Cusnaider, Juan Pablo — 342
Cuthriel, Ryan — 206
Cuttaz, Brian — 111
D'Sousa, Diego — 283

D10Studio — 181, 185
Dagobert — 119, 331
Daiute, Rhea — 227
Dall'Ara, Andrea — 77
Dalumi, Marco — 51
Dalvi, Amol — 248
Damelio — 206
Damilano, Paola — 304
Danka Studio — 202, 343
Dasai — 194
Daublebsky, Franz-Xaver — 199
De Batté, Daniele — 158
De Bellis, Luca — 70
de Concilio, Francesco — 169
de Groot, Annemieke — 193
de Korver, Elske — 90
De Visu — 167
DeBoer, Wayne — 30
Debout, Mario — 165
de Cecco, Alan — 305
Decroix, Denis — 205
Deheeger, Jean-Sébastien — 49
del Tour, Pierre — 299
Delambily, Romain — 60
Delane, Joel — 322, 99
DeLaura, Anthony — 99
Dell'Elce, Paolo — 79
Demicheli, Alessandro — 304
Design Labor — 167
Designministeriet — 189
Desoños — 36, 41
Devillers, Olivier — 190
DEVOLER Design — 222
Devorame Otra Vez — 264
Dewijngaert, Piet — 59
Dexheimer, Ricardo — 110, 21
Di Camillo, Mariano A. — 102
Di Donato, Claudia — 88
Di Meo, Nicolas — 258
Diagonal — 111, 294
diagonalmedia.com — 111, 294
Diaz, Jenaro — 329
DIDOMESO — 160, 349
die transformer — 40
Diehl, Julia — 130
Dijkmeijer Visuele Communicatie — 73
Dijkmeijer, Daan — 73
dimitra chrona — 228
dising studio "shuka" — 119, 183
Dittrich, Matthias — 255
DLDL Webdesign Lab — 137
DOMENICEAU — 29, 184
Dominici, Aldo — 143
Doms, Philipp — 181
Dorn, Bruno — 53, 74
Dornbierer, Michael — 70
Dostintas — 198, 21
Dotti, Luca — 310
DrawingArt — 208
Dreyer, Erik — 166
Drouaud, Xavier — 147, 148
Duarte, Ana — 97
Duarte, Miguel — 142, 213
Dubach, Christoph — 247
Duenwald, Gabriele — 47
Dumont, Matías — 302
dunp s.c.p.l. — 78
Duoh! — 27
Dupasquier, Loïc — 233
Durand, Allan — 60
Durmaz, Omer — 75

Index of Designers

Easynet, Laura — 276
Edouard, Domenici — 296
eedesign — 244
Eele, Tom — 90
Effective Studio di Luca Fadigati — 286
Egerter, Markus — 232
Elgard, Laurent — 225
Elvis D'sgn — 258, 349
elyron — 127
Elzenbeck, Jana — 35
England, Stephen — 144
Ennemoser, Andreas — 270
Eremko, Ivan — 197
Eriksson, Jonas — 345, 98
ERLCHI Design Company — 298
Escamot Visual — 225
Escolano, Alberto — 169
Escosura, María Jesús — 236
Espinoza Ramirez, Felix — 154
Espinoza, Felix — 241
Esteban, Gontzal — 68, 84
Estudioindex — 202
Euroart93 d.o.o. — 162, 182
Evers, Tanja — 102
Fanti, Lorenzo — 296
fantonnet gmbh — 241
Farinelli — 317
Farinelli, Gian Pietro — 92
Fedrigo, Niccolò — 352
Felicos Design Studio — 128
Ferizi, Shkumbin — 208
Fernandes, Karl Francisco — 281
Fernández, Jesús — 264
Fernández, José M. — 108
Ferraresi, Luigi — 346
Ferreira, Patricia — 207
Ferreira, Raquel — 290
Filipenkova, Ilona — 287
Fiorini, Claudio — 36
Firmorama — 113, 100
Flinsenberg, Dennis — 320
Florence, Philleep — 314
Foan82 — 206
Font, Ignasi — 322
Form+Format — 121, 126
Fraai Webdesign — 107, 116
Frades, Javier — 165, 195
Franssen, A. — 152
franzrocks.at — 199
Freitas, Rui — 103
Frías, Carmen — 91
Friedrich, Dominik — 161
Frontini, Daniele — 337
Ful-vue — 327, 42
Fung, Maria En Ai — 37
Furtner, Stefie — 243
Futterlieb, Franka — 237, 63
Fux, Andreas — 308
G2 Web Design — 265
Gagnerault, Julien — 313
Gallardo, Alejandro — 277, 278
Garcia, Júlia — 93
Gardin, Jean-Sébastien — 109
Garg, Tushar — 200, 215
Gargiulo, Gabri — 318, 319
Gasser, Gregory — 185
Gatellier, Yannick — 297
Gavrykov, Constantine — 229
Gayadin, Vinesh — 152, 199
Gebala, Tom — 137, 274
Gebhard, Frank — 143

geisha — 344
Gengler, Marlon — 75
Gentile, Samuel — 295
Gerlinger, Jannis — 195
gewest13 — 90
Giancarlo, Giacomo — 291
Gibb, Cameron — 351
Giller, Corina — 232
Gilman, Jamie — 34
giraffentoast — 240
Girardi, Stefano Maria — 260
Goldstein-Kubicki, Radek — 236
Gomes, Miguel — 304
Gómez Alcántara, Sandra Natalia — 150, 293
Gómez Caballero, Sergio — 73
Gomis, Hector — 219
González Sawicki, Fernando — 289
Gonzalez, Abraham — 183
Gonzalez, Gabriel — 84
Gonzalez, Rob — 52
Gooden, Tom — 210
Goubaidoullin, Tim — 186
Gozo, Gabrielle — 19
Grabowiecki, Tomasz — 212
Graf, Prof. Johannes — 122
Grajda, Kamil — 48, 72
Grand, Renaud — 203
Grandclement, Julien — 320, 326
Gravinese, Alessio — 164
Greco, Andrea — 140
Grooph — 56
Grunenwald — 307
Grupo Visualiza — 295
Gruppo Chorus — 318
Grus, David — 218, 218
Guadagnin, Leonardo — 312
Guapo — 281
Guillaume, Aurélien — 268
Guimaraens, Joaquin — 132
Guitana, Nuno — 83
Gun, Ray — 232
Guner, Talih Caglayan — 168
Habild, Teresa — 130
Hafling, Jay — 144
Hagan-Guirey, Marc — 93
Haggar, Emily — 240, 62
Hajduga, Stefan — 91
Hald, Christoffer — 305
Hamagami, Fumiaki — 60
Hamerlinck, Rob — 122
Hangartner, Marisa — 241
Hantoot, Ben — 147, 254
Harrington, R. — 20
Hartman, Sean — 99
Has, Fabio — 313
Hassinger, Alan — 132, 195
Hatter, Richard — 175
Hazelton, James — 210
Heijnen, Martijn — 205
Heinrich, Roman — 46
Hellmann, David — 124
Hello, Christophe — 148
Hellozeto — 65, 45
Hellwig, Jonas — 187
Hens, Joris — 187, 233
Hermoso, Carlos — 209
Herrmann, Ramona — 129
Herygers, Reg — 280, 32
hess-management.ch — 201
Heury, Adrien — 249

Index of Designers

HI(NY)	54
Hidalgo, Lizbeth	191
Hills, Daniel	303
Hoffman, Jenn	213
Hoffnungsträger	243
Holinski, Nina	38
Hollebecq, Sophie	149
Hölzinger, Pia	267
HoohaaDesign	113, 31
Hordern, Antonia	20
Hornof, Stefan	19
House Cricket	121, 161
Howie, Peter	286
Huber, Markus	232
Hudeczek, Richard	246
HUG United	320, 326
Hümmer, Bernhard	284
Hunt, Rod	186
i-creativ studio	135, 207
Ianic	297
Ibarra, Esteban	228
ICONnewmedia	117, 179
icreativa	287
id-k.com	185
Ideazione WEB srl	351
IDENTIDAD	252
Ideoma	245
Ideoma Design Studio	303, 40
iHook Creative	76
Imaginary Stroke, Co.	60
Inexor	106, 128
inezborges	30
Infinit Colours	214
Informinds Consulting	153
InHive	171
Ivankovic, Igor	333
Jahnke, Lutz	130
Jain, Ritesh	270
Jakl, Sebastian	350
Jamel Interactive	62
James, Thomas	339
jan.CASU	146
Jankowski, Tomek	343
Jansen-DESIGN	285, 43
Jansen, Daniel	285, 43
Janssen, David	225, 293
Janus NetWorks	280
Jayathilake, Himaya	311
Jentsch, Jan O.	239
Johansen, Lars	132
Johansson, Eric	194
Johnson, Mat	271
Johnson, Sean	103
Johnston, Owen	301
JonghDesign	146, 200
Joolz	242
jorislandman.com	23, 299
Jose Martinez, Maria	20
JPD Studio	271, 86
Juárez, Blai	298
Junghanns, Stephan	100
Jurado, Ivan	322
Kaczmarek, Marcin	46
Kadix, Carolina	221
Kangueven, Emeric	169
Karger, John	100, 113
Karnival Creative Management	63, 81
Karon, Kim	106
Kashiwagui, Erika	191
Kawai, Takeru	32
Keal Agência Interativa	311, 348
Ken	37
Kern, Pamela	135
Kestens, Davy	347
Khera, Amit	198
Kilfish	263
Kilibarda, Iva	352
Kingstone, Nathan	160, 217
Kishon, Renana	314
Kitchen	140, 164
Klatsidis, Daniel	329
Kleiner, Julia	32
Klerx, Merijn	115
Klijkens, Thibault	247
Klohn, Laura	233
Knowawall	352
Kock, Christoph	175, 278, 308
kofla	323, 183
Königsmayr, Andreas	167
Kopperschlaeger, Thomas	65
Kozakiewicz, Grzegorz	242
Kozłowski, Maciek	261, 348
Král, Luboš	126
Krawczyk, Oskar	269
Kreativa Studio	168
Kreatyveminds	327
Krenson, Jason	334
Kuan, Chris	306
Kuattro Design	332, 344
Kubasiak, Pawel	136
Kujundzic, Sara	246
Kuoc, Cecily	141
Kwaaitaal, B.	20
la icreativa	287
Laading, Sébastien	171
LAb[au]	67
Lab81	164
Lackmy, Frederick	225
Laetitia, Blaiseau	113
Lair, Nicolas	250
Lajarin, Ivan	299
Landa, Ibon	322
Lander, John	157
Lara Galassini, Silvia Orso	296
Laranjinha, André	93
Lartigue, David	137
Latif, Muid	213, 83
Lau, Vi Ee	150, 71
Laudati, Simon	307
Lauer, Christina	106, 163
Lauriola, Gianmarco	282
Lawless & Lotski	284, 79
Lazzeretti, Leandro	252
Lebaron, Gaëtan	93
Lee, Jong Hyuk	45, 65
Lee, Seungwon	170
Leemans, Olivier	205
Leijs, Edgar	191, 290
lepix	318, 57
les Influents	190
Letizia, Marco	338
Lia, Svein Haakon	325
Lidderdale, Angela	244
Lieverse Design VOF	289
Lieverse, Joppe	289
Lieverse, Merlijn	289
Lindemann, Lutz	39
linfacreativa.com	26
Linggawidjaja, Henricus	100, 49
Loehr Becker, Caroline	255
Lopes, Renato	142
Lopes, Sebastião	333

Index of Designers

Lopez Lopez, Anna Maria	275
Lorenz, Ludmila	138
Loukotka, Rob	254
Luján, María	124
Lum, Travis	226
Lüthi, Claude	234
Lüthi, Yves	234
Lynch, Stephen	224
M4 Media	291
MA3IOSKA	45
Machado, Tiago	24
Machiavelli, Guilherme	110
Macintosh, Adan	81
MacLeod, Alex	155
.made {by us}	39
Made In China	132
Mademoiselle lychee	251
Magalhães, João	341
Magimel, M.	47
Mai, Claudia	293
Maier, Daniel	305
Make It Move	87
Makelab Studio	36
Mäkinen, Mika	326
Malak	220
Malburet, Paul	60
Maletta, Simone	36
Malik, Aslan	322
Malle, Marko	77
MAMUS	25
Mamus, John	224
Manfredi, Rodrigo	339
Mani, Sani	316
Manning, Alan	196
Maracic, Joe	71
Marciano Studio	150, 293
Marciat, François-Xavier	216
Marinaccio, Danilo	155, 61
Marine, Intartaglia	273
Marini	178
Markham Unlimited	154
Markova, Gabriela	273
Marquette, Jamus	122
Marsono, Delia	182
Martin, Pelle	234, 243
Martínez Ballesteros, Natxo	69
Martínez Bonilla, Luis Miguel	274
Martinez, Sandra	198, 21
Martinovic, Bosko	294
Martins, Tatiana	42
Massmann, Frederik	340
Massoud, Sebastian	281
Mastrangelo, Luca	24
Mateosian, Samuel	227
matitegiovanotte.ravenna	91
Mattio, Marco	237
Mattioli, Nicolas	260
Mauro, Federico	146, 222
Maus de Rolley, Jessica	160
Maven Interactive, Inc.	163
Mazzotti, Sara	220
McCleary, Mikey	248
Meca, Pedro	147
Medeiros, Felipe	172
Mediamind.be	248
MediaPlan STUDIO	121, 349
Mendonça, Carlos	347
Mendoza, Rodrigo	204
Menezes, Douglas	126
Menshenfroind, Izaack	314
Mériot, Nicolas	320
Merkouri, Alexandra	170
Meroni, Giovanni	115
Messora, Katja	177
Meunier, Sylvie	133, 172, 256
Mewes, Florian	31, 84
Meyer, Rachelle	259
MicaGrafica	239
Micek, Pavel	273
Michel, Magali	173
Michels, Pieter	216
Mijatovic, Vladimir	23
Mikula, David	128
Millard, Ryan	209
Minatomura, Toshikazu	32
Mingati, Giovanni Carlo	40
Miolla, Chris	94
Misani, Mauela	129
Misuri, Marco	296
Mitote, Mr.	228
MODE Visual	154
Moelle, Katharina	309
Moghadam, Brian	285
Mojado, Nadine	130
Moldero, Eric	202
Moltefacce	25
Momentum Studios	329
Monaghan, James	211
Monedero González, Jordi	63, 81
Monfrini, Guido	36
Monique, Jacqueline	134
Monnoye, Sébastien	188
Monsieur Alex	216
Monteleone, Graziano	229, 347
Mooi, Jeffrey	257
More Air	50
More's 2KB	159
Morel, Julien	242
Morello, Juan Pablo	162
Morello, Mikal	239
Moreno, Angeles	157
Moreno, Carlos	103
Morgan, David	97
Morphix Design Studio	190
Mort, Sean	230
motoreacreazione.it	237
Mouse Will Play	259
Muhammed, Alaa	324
Mujico, Laura	109
Muku Studios	97
Müller, Malte	74
Multiways//E-strategies	89
Muñoz Gatica, Pablo	298
Muradyan, Vahram	277
MusaWorkLab	104
Muzhychkov, Mike	172
MWK visual e•motions	142
NALINDESIGN, Andre Weier	290
Nández, Orlando	139
Nanni, Davide	68
naplestreetstyle Creative lab.	307
Naranjo, María	321
Nat Filippini Diseño & Ilustración	142
Nelson, Christopher	295, 315
NEON Comunicazione	101
neotokio! comunicazione visiva	22, 337
Ng Wei Ta, Daniel	259, 266
Nicolaides, Kai	100
Nicolas, Stéphane	271
Ninjatranqui	338
Niyomthai, Tita	151

Index of Designers

Nobre, Alexandre	318
Nocera, Antonio	26
Nodymedia	174
Noegaard, Andrea	132
Nourddine, Sli	88
nowakstudios	267
Nowinowski, Nate	312
Nugara, Filippo	48, 85
Nunes, Maurício	172, 57
Oakes, Steven	230
Obermedia	196
Obrzut, Emilia	261
ohlala	21
Ohs, Jen	106, 173
Ohsome Inc	106, 173
Okamoto, Noriko	32
OLA Interactive Agency	252, 316
Olenik, Denis	261
Oliveira, João	292
Oliveira, Rui	197, 341
Olivera, Pablo	338
Olney, Helen	259
Ombu Lifestyle	260
On Click Creative Studio	304, 71
Only2designers	321
Outbox^ativism	330, 332
Packness, Magnus	42
Padrão, Eduardo	172
Paetzold, Maika	350
Paitre, Gary	95
Palacios, Miguel	191
Pampaneo	147
Panarese, Virgilio	88
Panda	281
Paoleri, Fabio	101
Papi, Alessio	278
Paravel	97
Pardo, Arturo	129
Parke, Danyelle	68
Parrague Ayala, Alvaro	296
Paso	143
Pauly, Vincent	153
Pedri, Ivan	305
Pedri, Marco	198
Peixer, Jackson	100, 113
Pejoska, Jana	245
Pentenrieder, Jens Nikolaus	104
Pepe, Federico	352
Pepper & Koffee	257
Pereira, Alexandre	174
Perez Leal, Mario	50
Pérez, César G.	241
Pérez, Frank	33
Perreault, François	291
Persiel, Jan	134, 64
Pes, Andrea	276
Peters, Zuzana	299
Petersen, Christian	139
Petit, Bertrand	223
Petroff, Valentin	235, 261
Petrovic, Misa	219
Petty	206
Phillips, Chris	205, 328
Phoenix Design	20
Piekut, Luks	177
Pierschek, Saskia	107
Piferrer, Coral	21
Pilz, Katja	226
Pinkham, Chris	163
Pinto, Hugo Filipe	232
Pinzon17 Disseny Carioca	151
Piradius Design Team	166
Piton, Manu	336
Pixelinglife	78
Planchon, Bertrand	22
Platfuse Interactive, LLC	215
polargold	213
Policand, Emilie	96
Polini, Lucia	62
Pons, Julien	294
Portier, Romain	93
Poscharsky, Alix	235
Potuschak, Sabine	38
Pownall, Martin	242
Poznanovic, Goran	270
Praessl, Martine	166
Prinzc, Carlos	346
Probalear	231, 94
Prolo, Karine	266
Protopapa, Francesca	67
Protopapas, Tasos	314, 48
Prugger, Philip	118
Publicis Impetu	132
Pucheux, Vincent	266
Puopolo, Fede	252
Queirós, Nuno	89
Querformat GmbH & Co. KG	123
Radenz, Tom	23
Raffelsberger, Markus	279
Ramirez, Ernesto	277, 323
Ramos, Alejandro	339
Rastagar, Ali	192
Ravazoulas, Nontas	256, 63
Ray Gun	232
Ray, Chandan	44
Real, Bruno	223
Recalde, Paula	145
Reddavid, Marco	111, 294
Reihe, Chris	334
Reimann, Anja	292
Reimer, Tylor	142
Reitano, Ornella	210, 325
Ressia, Manuel	145, 196
Reveley, Rachel	251
Revoy, Antoine	251
Ribeiro, Pedro	279
Ricca, Andrea	319
Richiardi, Lorenzo	127
Rieder, Helge	118
Riera, Santiago	331
Rigouste, Sebastien	238
Rinderknecht, Marc	107, 247
Rio, Tiago	232
Rivero, Elio	253
RIZN Design Studio	35
Roager, Kaare	85
Roberts, Gareth	123
Roch, Raül	225
Rodrigues, Robson	217
Roeder, Dierk	243
Rohé, Pascal	139
Rojwongsuriya, Peachanan	181
Roman, Dariusz	52
Romanos, Paola	176
Romão, Diana	66
Romo San Martin, Jaime Alberto	335
Root Studio	284, 302
Roque, Patrícia	61
Rosenow, Allan	156
Roser, Alberto	129
Rossi, Renato	101
Rostagno, Matteo	253

Index of Designers

Rousseau, Astrid 320, 326
Rovira, Ricard 99
Royo 295
Royo, Xavi 269
Rubikon Werbeagentur Gmbh 246
Rudd, James-Lee 113
Rui Freitas 103
Ruiz, Oscar 174
Ruiz, Pilar 91
Rüppell, Katja 194
Rusin, Niksone 280
RWM STUDIOS 266
Rybak, Malgorzata 199, 292
Sadous, Florencia 227, 39
Sadous, Santiago 39
Saints, Munich 143
Saizen Media Studios 208
Salik, Matt 224
Salinas, Cristian 28
Sallés, Santi 80
Salo, Jari 326
Salted Herring 345
Saluto Web presence provider 306
Salzmann, Eddy 28, 66
Sammut, Matthew 303
Sanabra, Pep 56
Santos, Luis 332, 344
Santos, Mário 109
Santos, Ricardo 347
saru_110 288
Sass, Robert 336
Savarerse, Dario 27
SAWDUST 52
Saxer, Andreas 35
Schaale, Hans Yorck 138
Schaefer, Markus 88
Schepps, Bryan 275
Schiaffino, Elena 34
Schiavo, Samuele 47, 86
Schick, Orane 98
Schioppa, Vincenzo 307
Schmidt, Christoph 31
Schneewolf, Anne 125
Schneider, Kristina 131
Schomburg, Käthe 125, 230
Schonhoff, Martin 40
Schoonderbeek, Jeroen 116
Schrön, Martin 145
Schuttinga, Rick 193
Schuurkamp, L. 20
Screenagers GmbH 286
Seipp, Karsten 156
Sensis Studio 282, 272
Senso Studios 226
Serrano, David 300
Serrão, Nuno 269, 272
Seven Attach Design Lab 92
Shaari, Lee 180
Sharp, Chris 257
Sherratt, Daniel 187
Siani, Stefania 352
Sieler, Silke 46
Sierra Martín, Juan Carlos 112
Sievertsen, Dea 131
Sighinolfi, Laura 170
Sigurdson, Scott 214
Sigurðsson, Guðmundur Bjarni 185
Sijlaar, Thijs 300
Simola, Simone 252
SimpleArt 268
Simpson, Brian 95

Sin Fin 260
Singh, Candy 44
Sinigaglia, Antonella 327
SiteSeeing Interactive Media 309, 88
Slepcoff, Oleg 262
Slink, Nicole 218
Smith, Josh 315
Sobańska, Barbara 184, 76
Sobrino, Eliana 204
Socio Design 302
Sodhi, Kanwaljeet 44
SOFTWAY.net 262, 80
Somos la Pera Limonera 192
Soon, Henry 178
Sorge, Audrey 270
Sorge, Matthias 270
Sossi, Davide 158
Soule, Norm 211
Spina, Leonardo 254
Spirit of Ecstasy 108, 318
Stajduhar, Stjepan 145
Starace, Christophe 70
Steuten, Eric 250
Strange Corp 324, 345
Straver, Richard 219
studio fru 261, 348
Studio graphique BeCom 118, 247
studio opensight 190
Studio9 171, 52
Studiopineapple 331
StudioSimple 176
Stüken, Raffael 102, 279
Suchard, Petra 135, 58
südostschweiz newmedia ag 201
Suelen 69
Sughi, Mario 123
Susin, Alessandro 312
Suuronen, Henric 77
Swemmer, Kim 193
Swolkien, Hubert 330
Sze, Kelly 37
takeone.es 229
Talamonti, Mauro 98
Tan, Febby 323
Tania, Volobueva 82
Tanner, Kate 188
Tapia Hurtado, Elsa 173
Tay, Vinz 71
Taylor, Leigh 317
Techakaruha, Sikan 321
Tekieli, Agnieszka 52
Telisman, Domagoj 149
Temmler, Felix 233
Ten Sheep 83
Terruzzi, Elisa 285
Tesselli, Marco 124
The Online Doc 214
The Seen 262
theGOOD 152
Thiele, Michael 40
Thiele, Paul-Christian 160, 349
Thoennes, Sebastian 148
Thomas, Andrew 188
Thomas, Kai D. 108
Thomas, Pourin 296
Tiagoc 235
Tieck, Benjamin 175
Timmermans, Berry 300
Tinter, Anja 110
Tonellato, Jan 134
Tonus, Dèsirèe 79

Index of Designers

Tot en met ontwerpen	283
Tougne, Alexandre	216
Trazo, Lendl Allen	155
Trebbin, Samuel	153
Tresso, Giovanni B.	283
Trilford, Michael	193
Trips, Tó	318
Trivino, Carmen	276
Truffa, Emanuele	64
Typejockeys	141
UbyWeb&Multimedia	215, 92
uniqrn.com	28, 66
UP3	30
upstruct berlin oslo as	130
Usta, Can	24, 333
Vaiciulis, Mindaugas	346
Valek, Pavel	267
Valiente, Claudia	114, 119
Valobra, Diego	95
Valutis, Osvaldas	341
Van Aerden, Ana	219
van Amerongen, Jorn	165
Van Belle, Ines	260, 336
Van De Weerd, Marian	32
van den Dries, Sander	104
van der Schoot, Bas	67
van der Wiel, Ad	341
van Kranenburg, Erik	78
van Olst, Stevijn	44
Van-Houten, Michael	242
Vanax	301
Vanderpol, Pierre	106, 128
Vasselli, Gianfranco	58
Vaz, Cristina	230
vbg.si	168, 332
Velcrodesign	133, 156
Venâncio, André	342
Verdiani, Orietta	51
Verdot, Christophe	111
Vereš, Jozef	335
Vergara, Santiago	275, 287
Vergara, Victor	288
Vernon, Scotty	203, 323
Verroken, Sarah	217
Verswijvel, Alex	280
Vesprini, Giulio	53
VIE studio	144
Vigo, Alessandro	115
Vijgen, Richard	65
Vijn, Yacco	152, 199
Vincent, Pierre	66
Viniacom	96
Vining, Tom	327, 50
Visser, Sietse-Jan	105
Vivek, Kumar	204
Volkov, Alexander	26
Vonach, Laurent	58
Vous êtes des pixels	346
Vrins, Benoît	158, 161
W.E.T Media	50
Wagner, Erwin	76
Walter, Lars	46
Web Creation UK Ltd	209
Weblounge	255, 274
WebTek	192
webwerk.ch	117
Webwork Studio	87
Wee, Adrian	150, 71
Weier, Andre	153
Welty, Cole	244
Werninghaus, Bianca	29
Wessel, Michael	179, 325
Wieczorek GbR	178
Wiedeck, Till	55
Wilde, Kilian	34
Willecke, Henning	117
Williams, Kwesi	317
Willmon, Jesse	27
Wills, Neil	264
Wills, Ryan	200, 51
Wirth, Christoph	291
Wischermann, Jan	270
Wolfs, Roy	140
woo theme	273
@Work Milano	285
wukonig.com	76
Wuyts, Simon	101
www.Devastudio.cl	157
Yeong, Danny	92
Yilmaz, Hüseyin	105
Yoeliawan, Edric	212
Young, Liam	81
Zagorski, Michael	279
Zaiser, Nicole	22
Zambrana Lacueva, Jose	45
Zamfir	234
Zangger, David	162
Zee Agency	171
zeebee	351
Zemach, Ido	26, 56
Ziddea Solutions	300
Zito, Marco	58
Ziviani, Matteo	245
Zoo Studio	25
Zsolt, Már	288
Zuccaro, Gaia	306, 89
Zuijderwijk, Pepijn	152, 351
Zylberait, Mathieu	236, 344

Index of URLs

10fenchurchstreet.co.uk	188
allanrosenow.com	156
andrewpinkham.com	163
artcenter.hugovoeten.org	207
barbarawille.de	53
blog.joeldelane.com	99
blog.studiovitamine.com	271
camaraclara.rtp.pt	330
camille.boidron.me	250
chapolito.com	158
chrismiolla.com	94
citymetria.ru	209
cpeople.ru	131
creativean.com	334
creativeemotions.pl	72
devonsproule.com	86
digitalnusantara.com.my	83
djabuze.de	146
essenza.bg	135
gebalatomasz.com	274
hauptschule.riegersburg.com	135
hello-mynameis.com	150
helloyou.de	55
homemade.artefakt.be	188
impactideas.be	160
inexor.se	106
jamarchitecten.nl	299
jefftimmons.com	213
jorislandman.com	23
klubkulturalny.pl	348
kreativer-kopf.de	230
lassepedersen.biz	234
liondance.lungkong.org	226
ma.tt	242
mars.fortis-watches.com	337
mesonprojekt.com	281
midiaeffects.com.br	113
mikeymccleary.com	248
mousewillplay.co.uk	259
nicole.osx.at	22
nouincolor.com	269
paravelinc.com	97
patriciaferreira.com	207
promo.kamaz.net	186
rbigwood.com	316
redfenix.pl	137
rickymontel.com	191
sarahbernhard.de	74
screenagers.com	286
shop.pettywood.co.uk	160
silviabeck.de	74
skipvine.ro	234
sophiekeledjian.net	22
sorenrose.com	243
squarefactor.com	99
stilwerk-living.de	125
sushiandrobots.com	114
sz.ffri.hr/vodic	145
theartistvisa.com	271
tiefparterre.net/thelittlethings	199
un.titled.es	99
veracorreiadesign.no.sapo.pt	137
vinners.pl/dookolaswiata	261
welearning.taipei.gov.tw	159
wet-media.de/wetsite	50
www.13flo.com	175
www.25mix.com.br	45
www.2kilo.nl	29
www.2minds1click.com	193
www.3d2a.be	324
www.4060.com.ar	221
www.4or.sk	335
www.51north.nl	335
www.687performance.de	350
www.6elementos.com.ar	39
www.a2creativos.com	169
www.abandonedclothing.com	290
www.abbeywalkgallery.com	31
www.abc123webdesign.com	120
www.accentodesign.it	312
www.aceview.nl	67
www.achtnullvier.com	118
www.acidik.net	176
www.acuisost.es	36
www.adamamaral.com	136
www.adenek.com	344
www.adragnayachtdesign.com	349
www.adrianopace.it	85
www.aduana.nom.es	326
www.advanderwiel.nl	341
www.aemde.ch	70
www.aeraki.gr	33
www.afishinsea.co.uk	116
www.ag81designs.com	41
www.agam-israel.co.il	56
www.agcontrol.gob.ar	145
www.agence-kariboo.fr	296
www.agenceunique.com	167
www.agriturismodonlucifero.it	72
www.aguardela.com	318
www.ahernlab.com	106
www.akmultimedia.fr	169
www.akzente-raumbegruenung.de	58
www.alacaesar.com	208
www.alewivesfabrics.com	227
www.alexarts.ru	186
www.aliceshouse.net	93
www.allaboutjames.co.uk	211
www.alloydesign.com.au	327
www.almadesignconsultancy.com	275
www.alvaronieva.com	229
www.alvinville.com	347
www.amaste.com	33
www.ambientsiluminacion.com	295
www.amigonstro.com	61
www.amitkhera.com	198
www.andread.it	77
www.andreaengler-axels.de	50
www.andreapes.com	276
www.andreas-saxer.com	35
www.andrevenancio.com	342
www.andyabraham.com	209
www.anecee.com	317
www.anothergraph.com	74
www.antiestatico.com	302
www.antonintesar.com	267
www.archiware.nl	20
www.aristocraticadomus.com	155
www.arrepiadovelho.com	196
www.artentiko.com	46
www.articoestudio.com	278
www.artist-in-design.de	110
www.artprophets.at	19
www.artrivity.com	177
www.artsir.net	311
www.aslan-malik.com	322
www.aspirine.co.uk	92
www.atccompany.com	101
www.ateliergmp.cz	273
www.ativism.pt	332
www.atolmag.com	245
www.atomoconsultores.com	274

Index of URLs

www.atrian.pt	89	www.cecilykuoc.com	141
www.austrade.gov.au	189	www.ceranco.com	78
www.ayakoehouse.com	134	www.cerchioperfetto.it	49
www.aziendavitivinicolacasa.it	231	www.cestosdaaldeia.pt	238
www.b-apps.net	96	www.chabanne-architecte.fr	343
www.b2online.de	34	www.christianbitz.com	42
www.babekuhl.com	90	www.christinalauer.net	163
www.baccarne.com	336	www.christophkock.com	278
www.badboyboogiez.com	308	www.ciama.net	48
www.baikal-web.ru	197	www.ciamweb.it	178
www.baldonsera.com	82	www.cienciambiental.cl	119
www.balhar.com	59	www.citroen.fr	119
www.baobabdiseno.cl	20	www.cj-atta.com	203
www.barbarasobanska.pl	76	www.clarisse-hieraix.com	318
www.barbonidilusso.it	331	www.classictita.com	151
www.barcenayzufiaur.com	84	www.clementina.net	314
www.bartrainingcenter.com	57	www.clinicario.pt	109
www.bassplayerman.com	298	www.clubbing.dj	299
www.bayco.com	285	www.coaching-wegen.com	75
www.bcandullo.com	273	www.cobalounge.com	84
www.beachbreak.nl	239	www.cocci.be	274
www.beatricerossi.com	162	www.colazionedamichy.it	246
www.beautiful2.com	315	www.colewelty.com	244
www.beb-deum.com	64	www.colmo.cz	272
www.bee-creations.com	26	www.colorgorize.com	325
www.benderillustration.com	195	www.comediedesanges.com	133
www.bendorff.es	238	www.concept007.ru	119
www.berber.com.pl	177	www.consuma.es/bobo	33
www.bgs-architekten.com	241	www.contentcom.com.br	159
www.bhzdesign.pt	174	www.contrexemple.com	270
www.bibliotecaescolardigital.es	42	www.converse.es	71
www.bienenstich-band.de	233	www.coolormedia.com	198
www.bieraria.ch	144	www.coppaboston.com	147
www.bigbossstudio.com	70	www.cowsinjackets.com	165
www.bigelows-rvc.com	25	www.creathema.fr	258
www.bikeworld.com.pt	332	www.creativeforward.com	112
www.bilderzoo.com	293	www.cristinavaz.com	230
www.bildschoen-konzept.de	166	www.crittercreative.com	211
www.binisilvia.it	164	www.crossone.de	206
www.biomax.it	30	www.crswebstudios.com	331
www.birnendenkmal.de	130	www.csharpdesign.co.uk	257
www.bl4nk.eu	248	www.cucinaorientale.com	306
www.blankschmidt.com	31	www.cuttingmat.co.nz	301
www.bleed.no	325	www.d10studio.com.mx	181
www.bluealmonds.com	199	www.damaged-duchess.com	97
www.blutvoll.de	232	www.damonbauer.com	127
www.bodaalavista.com	141	www.daniel-ng.com	266
www.boogie-men.nl	283	www.danielhills.co.uk	303
www.bosstrendcolours9.be	248	www.dankastudio.fr	202
www.bozhinovskidesign.com	235	www.Danstyled.com	187
www.brandshape.de	239	www.dariosavarese.it	27
www.brownmusic.de	91	www.dasai.es	194
www.brunocaruso.com	165	www.davidenanni.com	68
www.brunoreal.com/grooveit	223	www.davidhellmann.com	124
www.btt4all.com	344	www.davidjanssen.fr	293
www.burnedbrain.com	252	www.davidkeuning.com	31
www.bystroom.com	131	www.davidmikula.com	128
www.c-jardin.fr	247	www.davosklosters.ch	201
www.cadabra.pl	330	www.davylinggar.com	100
www.cafenoir.it	296	www.dayshop.jp	32
www.candoti.com.ar	154	www.dcdecorators.com	284
www.cantori.it	337	www.deborahbrider.com	66
www.capicoiadesign.com	98	www.deineschoenewelt.de	243
www.carlosalonsobodas.com	293	www.demotive.com	271
www.carloshermoso.com	209	www.denisolenik.com	261
www.carolinagomez.net	287	www.denkdifferent.de	129
www.carsons.it	304	www.deppischarchitekten.de	135
www.cartelle.nl	44	www.derpixelist.de	329
www.casagilda.com	195	www.dersya.net	191
www.casserosalute.it	164	www.deshop.es	282
www.cath-immod.com	265	www.designausdeutschland.de	243

www.designbysenso.com	226	www.evodence.com	210	
www.designexquis.com/luis	57	www.ex-t.it	278	
www.designfee.com	29	www.explose.lu	88	
www.designministeriet.se	189	www.ezqualo.com	150	
www.devia.be	27	www.fabiohas.com.br	313	
www.devisu.com	167	www.fabrikagency.com	206	
www.devoler.com	222	www.fachwerkstatt-coenen.de	218	
www.devzone.com.ar	339	www.faithfashion.eu	286	
www.dextrum.es	63	www.fakestudio.tv	322	
www.diagonalmedia.com	111	www.fanfreluches.it	212	
www.dickiebirds.com	212	www.fatalimpact.no	290	
www.didiermassard.net	310	www.felicosdesign.com	128	
www.diegodsousa.com	283	www.ffyeah.gr	48	
www.diegutgestalten.de	270	www.filipponugara.com	48	
www.digidecal.com	217	www.firmorama.com	100	
www.diginet.be	46	www.flash-web-stranice.com	306	
www.digitmotion.com	208	www.flipinmental.info	236	
www.dijonmusic.com	126	www.floklo.com	164	
www.disturbmedia.com	205	www.flowexperience.pt	213	
www.djbattle.co.nz	193	www.foolcompany.it	26	
www.djchrislegrand.com	280	www.force5.ch	111	
www.djmattmendez.com	174	www.formandformat.com	121	
www.djnr.net	329	www.fperreault.ca	291	
www.dliteventi.it	127	www.fraai-webdesign.com	116	
www.dlvbbdo.com	352	www.francescorussotto.it	310	
www.dmportfolio.com.ar	305	www.franziskadonath.com	85	
www.doitdifferent.net	25	www.freikirchliche.com	153	
www.domgartenhof.de	285	www.frieschevlag.nl	183	
www.doomernik.com	79	www.frigeriosalotti.it	337	
www.dotcom.lu	297	www.fritz-quadrata.de	161	
www.douglasmenezes.com	126	www.ful-vue.com.au	42	
www.dreamaccent.com	212	www.funkyheroes.gr	176	
www.dreamstormdesign.co.uk	196	www.FurryPuppet.com	112	
www.drukkerij-vaes.be	284	www.fwhotel.tw	306	
www.ds3.citroen.com	331	www.g-raz.com	229	
www.dsigned-by.com	352	www.g2webdesign.com.br	265	
www.dspcreativity.com	241	www.gabrielebrombin.com	189	
www.dua-collection.com	102	www.gabrieleduenwald.com	47	
www.duelpurpose.com	95	www.gabriellegozo.com	19	
www.e-hitman.jp/wthc	191	www.gamesforherbyyou.com	317	
www.e2sproduccions.com	114	www.gary-web.com	95	
www.easycut.es	231	www.geishagraphic.com	344	
www.ecosfalsos.com.br	222	www.gekode.eu	140	
www.ecta.org	161	www.gettingcrazy.info	101	
www.edeas.hk	37	www.giambalvoenapolitano.com	146	
www.edgarleijs.nl	290	www.gianluigipesce.it	34	
www.egidiocarlomagno.it	237	www.gianmarcolauriola.com	282	
www.elcuartel.es	91	www.giovannitresso.com	283	
www.elkebroothaers.be	182	www.giuliovesprini.it	53	
www.elusivetuesday.com	235	www.glamupeventi.com	117	
www.elysiumburns.com	315	www.go-on-web.com	188	
www.emilyhaggar.com	62	www.goodbytes.be	233	
www.emmebidesign.com	22	www.gooddogdesign.com	210	
www.emmeffeonline.it	64	www.grafik.rs	23	
www.emotionslive.co.uk	172	www.grapharts.cz	218	
www.encian.hr	162	www.graphicdesign.bg	261	
www.enet.it	276	www.graphicsgirardi.com	260	
www.entropiads.com	330	www.graphik3.com	180	
www.equuslimitededition.com	351	www.graphito.net	80	
www.ericj.se	194	www.greenanysite.com	171	
www.ericsteuten.nl	250	www.greenfreshweek.com	269	
www.erikdreyer.de	139	www.greentree.it	237	
www.erlchi.com	298	www.groupedunes.net	54	
www.escamotvisual.com	225	www.grueni.ch	201	
www.esperantozorg.nl	193	www.gruny.net	307	
www.estudioindex.com.ar	202	www.grupochevere.eu	41	
www.estudiorjdesign.com	341	www.gsenpod.com	343	
www.etoilemecanique.com	32	www.guapo.tv	228	
www.etu.uvsq.fr	148	www.gummisig.com	185	
www.europebydesigners.com	320	www.guysfromthecaravan.com	263	
www.evacollini.com	285	www.gzh.hr	182	

Index of URLs

www.hairxtensions.info	184
www.halilakdeniz.com	75
www.hassingermultimedia.com	132
www.hebikwatvanjouaan.nl	78
www.hellozeto.com	65
www.henricsuuronen.com	77
www.hibriden.com	241
www.hinydesign.com	54
www.hiredgunscreative.com	175
www.hirumchi.com	200
www.holtermand.dk	345
www.hoohaadesign.co.uk	113
www.i2fly.com	204
www.iamawesome.nl	200
www.ianic.fr	297
www.ibelieveinbritney.com	127
www.iconestudio.es	112
www.iconnewmedia.de	117
www.ideascreative.org	211
www.ideeinluce.it	47
www.ideen-im-blut.de	267
www.identidad.tv	252
www.ideoma.pt	40
www.idfoundation.it	55
www.idity.nl	116
www.ihookcreative.com	76
www.ikonos-design.com	89
www.ilovebonus.com	168
www.ilovecolors.com.ar	253
www.ilovetucanourbano.be	247
www.ilpistrice.com	67
www.imchar.com	103
www.imfinethankyou.de	105
www.imjonas.com	98
www.incredibox.fr	60
www.incrime.nl	90
www.indi2000.com	349
www.indzen.com	92
www.inezborges.com	30
www.infinitcolours.com	214
www.informinds.com	153
www.inmmnd.com	229
www.insidepiet.com	59
www.insiemeperibambini.it	129
www.instantadlegend.com	246
www.intecnainteriores.es	298
www.inteko.it	245
www.interno2.com	79
www.ioadv.it	115
www.irenececile.com	69
www.isaiaquinta.com	25
www.isola-menti.it	150
www.j-exhibit.com	345
www.jakobGarfield.dk	340
www.jamel.pl	62
www.james-meakin.com	324
www.jamoor.com	144
www.jamusmarquette.com	122
www.janaelzenbeck.de	35
www.jannis-gerlinger.de	195
www.jarisalo.com	326
www.jasonkrenson.com	334
www.jayhafling.com	144
www.jensnikolaus.co.uk	104
www.jessewillmon.com	27
www.jjmaes.be	219
www.jmfernandez.de	108
www.jobysessions.com	50
www.joeldelane.com	322
www.johnmamus.com/brightcolors	224
www.johnnyddesign.net	312
www.jonnekjonneksson.com	314
www.julesb.fr	268
www.julianandrade.com	223
www.julienpons.fr/clio	294
www.jungeenergie.com	192
www.jvparquitectos.pt	80
www.jynx.com.br	172
www.k-netica.be	336
www.kadix.com.br	221
www.kalafilm.com	24
www.kardoayoub.co.uk	301
www.karencatering.com	80
www.kaser.com.ar	162
www.kboscodesign.com	56
www.keal.com.br	311
www.kelmurphy.com	251
www.ken.es	37
www.kevadamson.com	94
www.kiluka.ch	233
www.kind-of-girl.com	132
www.kingcolebar.com	154
www.kingscooty.com	323
www.kinso.fr	320
www.kitchen.es	140
www.klauseichler.de	232
www.klipzensored.de	201
www.klon2.dk	305
www.kokhostalets.com	328
www.koksmaat.nl	90
www.komodelar.es	94
www.konfastockholm.se	128
www.kongamsterdam.com	199
www.kontoreins.com	64
www.kopfstand.ch	185
www.kornelius.info	138
www.krailing.com	117
www.kristinaschneider.com	131
www.krizalidstudio.com	109
www.ksqrdesign.com	106
www.kubasiak.pl	136
www.kuhboom.com	264
www.kulturbanause.de	187
www.kunayala.de	194
www.kunstbox.net	40
www.kustomkrew.com	340
www.laalala.nl	53
www.lab-au.com	67
www.labelm.es	61
www.laboheim.com	96
www.lacompetencia.es	227
www.ladupla.net	277
www.ladyflower.org	220
www.lafactoriagrafica.com	68
www.lafamedicamilla.com	324
www.lahuellasonora.com	108
www.laicreativa.com	287
www.lamayor.com.uy	132
www.lambertocurtoni.com	215
www.lamiecahuete.com	255
www.laroshel.cz	218
www.lastnightadjsavedmylife.com	236
www.laufair.hu	176
www.lauramujico.com	109
www.laurasighinolfi.it	170
www.lcgsa.com.ar	196
www.ldeventos.com	157
www.le198bis.com	273
www.leandrosapucahy.com.br	151
www.lecaid.com	226
www.lendlallenvtrazo.com	155
www.leonardospina.com	254

Index of URLs

www.lepetitdeslices.com	223	www.momu.com	272
www.lesnuitsslaves.com	190	www.mondongorecords.com	183
www.letterbirdlane.com.au	182	www.montag-architekten.de	29
www.libredesprit.com	242	www.monticellodesigns.com	71
www.librerianos.com	275	www.moody-cat.com	294
www.licornpublishing.com	268	www.mooiemondenmijnogengroen.nl	
www.lijiangvisionsingapore.com	178		300
www.linesoundstudio.com	139	www.moritz.com.au	286
www.lisacarletta.be	250	www.morphix.si	190
www.lisbonid.com	104	www.moscatrailer.com	294
www.liverpoolshop.com	105	www.mot8.org	60
www.lnfdesign.com	72	www.mountain-factory.com	249
www.loadingdesign.net	66	www.movoeste.pt	138
www.loshijosdejackson.com	264	www.mrmitote.com.mx	228
www.loudegg.com	71	www.mrsm.org.my	55
www.loufonq.ch	234	www.mschroen.de	145
www.loukotka.com	254	www.muabologna.it	291
www.lucamastrangelo.it	24	www.muammeryanmaz.com	333
www.luigiferraresi.it	346	www.mukustudios.com	97
www.luisafesta.com	319	www.mullervantol.nl	84
www.m1-design.de	139	www.multiways.com	89
www.ma3ioska.com	45	www.muralsbyclara.com	180
www.madebysawdust.co.uk	52	www.mwk.pt	142
www.mademoisellelychee.com	251	www.mysticspa.com.ar	342
www.mag-online.it	38	www.na3.it	40
www.magicmushroom.co.in	44	www.nachitz.com.ar	348
www.magneticfotostudio.com	70	www.namikokitaura.com	244
www.maison78.com	43	www.nandoesteva.com	269
www.maitevega.com	276	www.nandogs.com.ar	289
www.makeitmove.com.au	87	www.naplestreetstyle.com	307
www.makelab.it	36	www.natfilippini.com.ar	142
www.malak.be	220	www.natural-basics.de	43
www.malasangre.com	44	www.natxomartinez.com	69
www.mamieboo.fr	173	www.neglige.it	62
www.mamparasdoccia.es	321	www.nereis.it	318
www.mandryl.cl	61	www.nerosunero.org	123
www.marcozito.com	58	www.neskoncept.com	49
www.maredagrupa.hr	168	www.net-e-be.fr	113
www.mariafung.com	37	www.netoexperience.com	174
www.marialujan.es	124	www.netontwerp.com	101
www.mariamare.com	198	www.nexprochile.cl	28
www.marzsolt.com	288	www.nicolasdimeo.ch	258
www.masernicka.cz	171	www.nicolawalbeck.com	138
www.massimilianopugliese.com	338	www.nihodesign.de	38
www.matitegiovanotte.biz	91	www.niksone.com	280
www.matscordt.com	309	www.nimmingned.com	123
www.matthiasdittrich.com	255	www.notecomaslamanzana.com	240
www.mattsalik.com	224	www.notoveruntilitsdone.com	39
www.maven-interactive.com	163	www.nowinowskidesign.com	312
www.maxiburtin.com.ar	184	www.nugg.ad	63
www.mc3.com.au	221	www.nunoguitana.com	83
www.mediamedics.nl	219	www.objectivo2015.org/atequando	338
www.medium.com.ar	102	www.ohlala.cat	21
www.mellowmushroom.com	154	www.olainteractiveagency.com	316
www.mentagrafica.com	159	www.olevaca.com	45
www.menuiseriebeaudry.be	216	www.olicole.com	82
www.messora.ch	177	www.olive3.gr	256
www.meumoveldemadeira.ind.br/		www.ombulifestyle.com	260
pensenafrente	161	www.onder-anderen.nl	65
www.miguelbuckenmeyer.com	39	www.only2designers.com	321
www.miguelcarino.com.br	225	www.oqueeufiznasferias.com.br	21
www.mijnpassieineenkassie.nl	259	www.organicadg.com	249
www.mikael-lafontan.com	172	www.originalsource.co.uk	157
www.mikikosatogallery.com	28	www.orioneonline.it	51
www.milena-rogulj.com	350	www.osobo.co.uk	309
www.minsic.com	263	www.osvaldas.info	341
www.mintsmind.com	110	www.ottokasper.de	307
www.mira-muzik.com	340	www.outofmedia.com	253
www.mitosurbanos.org	272	www.outsideincompany.com	75
www.moj.ch	130	www.oxfamnovib.nl	152
www.momentumstudios.co.nz	329	www.ozarkhenry.com	216

Index of URLs

URL	Page	URL	Page
www.pabloolivera.com.ar	338	www.rex.b92.net	54
www.paje.biz	153	www.rgacom.com.br	57
www.pampaneo.es	147	www.rintalaeggertsson.com	79
www.pandacomunicacion.cl	281	www.ristorantefalalella.com	102
www.panelfly.com	224	www.rizn.info	35
www.paradisodellanotte.it	327	www.rjvisuals.com	270
www.passievoorpuurcatering.nl	165	www.robson.art.br	217
www.passionpeople.de	46	www.rodhunt.com	186
www.pejola.com	245	www.rodinalper.com	297
www.pepgay.com	207	www.rodrigomanfredi.com	339
www.pepperkoffee.com	257	www.rogergrasas.com	81
www.pereslegin.com	183	www.roland-holz.de	179
www.persiel.com	134	www.room1011.com	88
www.petokata.com	263	www.rootstudio.co.uk	302
www.philippdoms.com	181	www.rotumatica.com	277
www.philippe-voncken.com	216	www.rougetomate.be	149
www.philipprugger.at	118	www.roywolfs.com	140
www.philleep.com	314	www.rsapps.de	336
www.pho-grill.com	173	www.runthered.com	345
www.phoenixdesign.com	20	www.ryszardgorecki.de	184
www.photo.mondo.com.pl	343	www.s3design-studio.com	204
www.phunkn.com	313	www.sa-design.co.uk	319
www.pigeonandpigeonette.com	217	www.saizenmedia.com/FFIV	208
www.pirolab.it	95	www.sambroadbent.co.uk	65
www.pixcept.de	87	www.samueleschiavo.it	86
www.pixelplanet.it	249	www.sandrobianchi.com	56
www.pizublic.com	220	www.sanimani.com	316
www.pizzaza.ca	252	www.santodomingoanimation.com	129
www.pizzerialastazione.it	143	www.sapotage.at	38
www.platfuse.com	215	www.saru110.com	288
www.playout.pt	24	www.scena.fm.pl	292
www.plazaarte.com.ar	253	www.schema.gr	228
www.point39.com	215	www.scheppsdesign.com	275
www.pointdevue.eu	148	www.schokolombo.at	246
www.polargold.de	213	www.scottsigurdson.com	214
www.pormenor.net	303	www.seanjohnson.net	103
www.portaldamaquiagem.com.br	300	www.sebastienbrett.com	86
www.porteimic.com	325	www.sebastienrigouste.com	238
www.postermedia.com.mx	185	www.secondfloor.be	205
www.potatofarmland.com	259	www.segelschein.de	179
www.pottporus.com	279	www.selector-radio.com	230
www.pradal.ch	107	www.seminaregraf.de	122
www.pranzodiferragosto.it	222	www.seniorenwohnwelt-meine.de	107
www.prolographie.com	266	www.senseidj.com	335
www.pugcreative.com	68	www.sensis-studio.com	282
www.puppetbrain.com	87	www.serrex.com	137
www.pushcollection.com	73	www.sesey.com	219
www.qu-arch.com	32	www.sethturner.de	66
www.quanto70.com	149	www.shalama.com	313
www.quetengoenlanevera.com	323	www.sheldonfarmbaskets.com	239
www.quiquejoyeros.es	300	www.shoppingcuritiba.com.br	121
www.r-art.dk	85	www.shskh.com	352
www.rachelreveley.co.uk	251	www.shysport.com	295
www.radekal.de	236	www.siffertspa.it	210
www.radicallow.com	280	www.siggi-mertens.de	291
www.raphaelbatista.com	43	www.simonplestenjak.com	332
www.raposresorthotel.com	121	www.simpleart.com.ua	268
www.raum22.at	167	www.simpleformsdesign.com	347
www.raumfabrikweil.de	58	www.sinela.es	21
www.ray-gun.pt	232	www.SintraBTT.com	103
www.rebers-pflug.de	125	www.siturbandesign.com	133
www.redkitecreative.com	125	www.sixoclocktea.com.ar	227
www.reg-book.com	81	www.skinnywrists.co.uk	315
www.remar.ru	26	www.skyscraperj.com	350
www.renatomancini.com	124	www.sl-design.com.pt	333
www.renaudgrand.com	203	www.slickmill.com	254
www.rentahess.ch	247	www.smsend.it	78
www.rentstudiocologne.com	267	www.sociodesign.co.uk	302
www.resatlantico.pt	197	www.sogam.ch	98
www.respireliberdade.com.br	110	www.solidshops.com	187
www.retroblique.be	347	www.somoslaperalimonera.com	192

Index of URLs

www.souldeepdesigns.com	287
www.southlakewebdesign.net	295
www.sozialamt-fuer-gestaltung.de	240
www.sphinxisdesign.com	231
www.spijkersite.com	260
www.spiraldesign.ca	256
www.spiritofecstasy.cc	108
www.splore.net	152
www.springhill.com.tw	136
www.squeezy.de	143
www.sst-machine.com	289
www.stefanbauerdesign.com	73
www.stefanobartolini.com	143
www.stefanogiovannoni.com	305
www.steirischerherbst.at	76
www.stellaforest.fr	244
www.stoked.cl	296
www.studio13.fr	93
www.studio72.net	41
www.studioadinteractive.com	179
www.studioaiko.com	321
www.studiobecom.net	118
www.studiodds.it	351
www.styleattitude.net	134
www.suelen.org	69
www.suna.com.co	266
www.superemotion.com	170
www.svenbarletta.com	328
www.sylvainprunenec.fr	256
www.sympozium.fr	225
www.synyster.nl	320
www.tablesxl.com	289
www.takeshape.it	158
www.tamioe.de	175
www.taniasilva.com	160
www.taniavolobueva.ru	82
www.taptapdesign.com	333
www.tat-tarag.com	303
www.taxistudio.co.uk	51
www.teamjamie.co.uk	34
www.techrust.com.br	348
www.tensheep.nl	83
www.terrecottemc.it	51
www.textiles-wohnen.de	237
www.thechocolatebullet.com	265
www.thefalconhaslanded.com	334
www.thegood.com	152
www.thegraphictree.com	180
www.theminimart.com	93
www.theonlinedoc.com	214
www.thepapilion.com	49
www.thepeachdesign.com	181
www.thereverse.net	258
www.theseen.biz	262
www.thesize.es	36
www.theskylinemusic.com	310
www.thirdway.it	115
www.thisisclinic.com	156
www.thomashenriot.com	326
www.tiagoc.com	235
www.tienditaelencanto.cl	114
www.tier-couch.de	19
www.tierraviva.net	157
www.tisophoto.com	262
www.tizedit.com	342
www.tomasghiorzo.com.ar	281
www.tomorrowsthoughtstoday.com	81
www.tomradenz.com	23
www.tomscholte.com	107
www.tomvining.co.uk	327
www.ton.cz	52
www.tontorino.com	149
www.topino.be	158
www.totalcreation.nl	122
www.tower42.com	308
www.traverse-designedinfrance.fr	133
www.triggerfish.nl	104
www.triplesky.pt	304
www.trippl-krippl.net	126
www.trix.pt	206
www.tsumac.jp	60
www.turneadv.it	169
www.twigital.co.uk	328
www.twingroup.it	317
www.twintoe.com	346
www.tylorjreimer.com	142
www.typejockeys.com	141
www.uarchitects.com	73
www.umbralfunk.com	202
www.umek.si	168
www.underdog.tv	155
www.underwires.net	28
www.unowhy.com	171
www.uppercut.es	173
www.upstruct.com	130
www.urbanedgedesign.co.uk	339
www.urbanmofo.com	257
www.uvsq.fr	147
www.vahrammuradyan.com	277
www.valencestudio.com	279
www.vanax.nl	301
www.vanderveerdesigners.nl	146
www.vanessabenellimosell.com	92
www.vanhavere.be	255
www.vantoo.com	52
www.vargoworld.com	197
www.vassiliszoulias.com	170
www.vazoliveira.com	292
www.vectordefenders.com	304
www.verloopinnovatie.com	115
www.via-repubblica.com	120
www.victorscomics.com	288
www.victorsworld.de	156
www.videofarmers.de	349
www.viniacom.fr	96
www.visiophone-lab.com	319
www.visualboxsite.com	311
www.visualbytes.gr	63
www.visualgroove.net	323
www.vivid-display.com	242
www.vousetesdespixels.be	346
www.vsb.com.tr	166
www.watt-you-want.de	148
www.waynedeboer.co.uk	30
www.webdesigner-freelance.eu	111
www.webidea.pl	308
www.webtek.cz	192
www.weise.eu	123
www.whyatr.com	47
www.wieczorekonline.com	178
www.wildflame.co.uk	203
www.williescacao.com	200
www.wirsindsmyk.de	100
www.wmas.us	59
www.wohlklang.com	284
www.wonowmedia.com	240
www.woo-life.com	151
www.yannmarquis.com	120
www.yarkamiller.com	264
www.yuna.nl	205
www.zafferano.pt	262
www.zartherb.es	292

Index of URLs

www.zaum.co.uk	309
www.zeebee.co.uk	351
www.zheng.com.my	166
www.zhfcn.com	190
www.zietze.nl	105
www.zipfer.at	77
www.zonkzone.net	204
www.zoomart.net	88
www.zoukvision.com	279
www.zuzanapeters.de	299